PRINTS AND POSTERS OF

Ben Shahn

102 GRAPHICS, INCLUDING 32 IN FULL COLOR

BY
KENNETH W. PRESCOTT

DOVER PUBLICATIONS, INC.
NEW YORK

To Emma-Stina

CONTENTS

Copyright © 1982 by Kenneth W. Prescott.
All rights reserved under Pan American and International Copyright Conventions.

Published in Canada by General Publishing Company, Ltd., 30 Lesmill Road, Don Mills, Toronto, Ontario.
Published in the United Kingdom by Constable and Company, Ltd., 10 Orange Street, London WC2H 7EG.

Prints and Posters of Ben Shahn: 102 Graphics, Including 32 in Full Color is a new selection of works by the artist, to which Dr. Prescott has added a new introduction ("Ben Shahn, 1898–1969"), Biographical Outline, Exhibitions and Bibliographic References. The Commentary is adapted from Dr. Prescott's *The Complete Graphic Works of Ben Shahn,* published in 1973 by Quadrangle/ The New York Times Book Company.

Manufactured in the United States of America
Dover Publications, Inc.
180 Varick Street
New York, N.Y. 10014

Library of Congress Cataloging in Publication Data

Shahn, Ben, 1898–1969.
 Prints and posters of Ben Shahn.

 Bibliography: p.
 1. Shahn, Ben, 1898–1969. I. Prescott, Kenneth Wade, 1920– . II. Title.
N6537.S5A4 1982 760'.092'4 81-17253
ISBN 0-486-24288-9 (pbk.) AACR2

ACKNOWLEDGMENTS

It always gives me pleasure to acknowledge my debt to the artist Ben Shahn. I knew him for a number of years before his death, and the vivid discussions we had in and out of his studio about his own work and other matters, together with the Shahn retrospective exhibitions in this country and abroad which I organized in the years to follow, have served to enrich my life greatly. During all of these years, Shahn's gracious wife, Bernarda Bryson Shahn, has shared with me her knowledge of the artist and his work, which began when they first met in the late thirties, and through her research, continues to grow unabated today.

Over the years I have also turned to Mr. Morris Bressler, a Roosevelt, N.J., neighbor of Shahn's, to draw on his recollections of the artist. It was he who suggested many of the Hebrew themes which found expression in Shahn's prints and posters. His son, Martin Bressler, Shahn's lawyer and subsequently the executor for the Shahn estate, insisted that this book be written and arranged for me to meet with Dover Publications' president, Hayward Cirker. An admirer of Shahn's work, Cirker was enthusiastic about publishing a book with the very best color reproductions which the state of the art could offer. He and vice-president and managing editor Clarence C. Strowbridge have been helpful at all stages. So has my editor, James Spero, who in his considerate ways has convinced me that he has found the assignment rewarding.

Mr. Lawrence A. Fleischman, director of Kennedy Galleries, who has represented the artist before and after his death, at this time courteously allowed me to research the galleries' records, an invaluable asset in documenting the artist's work. Mrs. Leah Sloshberg, director of New Jersey State Museum, where the definitive collection of Shahn's graphic work is housed, generously allowed color reproductions to be made directly from the works of art. Where some original works were unavailable, color reproductions were made from transparencies, taken by Geoffrey Clements, fine-arts photographer.

I am also grateful to my secretary, Mary Jane Coughlin, who typed the manuscript for this book and who has spoiled me with her efficiency to absorb ever more demands on her nimble fingers. But other than to the artist, I am most indebted to my wife, Emma-Stina Prescott, who is a critical reader and invaluable co-worker. Without her guidance and assistance, this book could not have come to fruition.

KENNETH W. PRESCOTT

BEN SHAHN, 1898–1969

Ben Shahn lived through a period of United States history that saw the country veer from isolationism to involvement in four wars. He was a witness to America's industrialization and saw the nation plunge from economic prosperity into depression. He watched the working class unite and rise to power and viewed with compassion the struggle by minorities for a better place in society. He observed here and abroad the triumph of modernism in art of which he was part and advocate, although always maintaining his own distinctive views and integrity.

Although the present book deals with a selection of Shahn's graphic works, the artist did not restrict the imagery which we see here to graphic media alone. His images are repeated and reinterpreted in all the artistic processes in which he was engaged: drawing, painting, printmaking and the design and production of murals, tapestries and stained glass. He was a storyteller, and his "visual literature," as his wife Bernarda so poignantly has termed his work, is rich in allusions and meanings. Motifs and subjects appear and reappear in new settings and altered circumstances.

Born in 1898 in the city of Kovno, Lithuania, where he spent the first eight years of his life, Shahn received an education consisting mostly of Bible studies. Surrounded by Jewish rites and symbols, he was first introduced to the joy of verse and music by the Old Testament's prayers and psalms. The lettering used in copies of the Old Testament provided the model for his own first attempts at lettering, and as he copied its stories, he came to know its towering figures until they seemed a part of his ancestry as well as of his daily life. From this seemingly timeless existence, he was jolted into the noisy and confusing world of New York City when his parents emigrated to the United States in 1906. He quickly adjusted, and while his interests for many years were molded by his impressions of the New World, he would in his mature years return to that timeless Old World of his childhood. Its memories, enriched by the wisdom accumulated through a long life, would find their expression in his art (see *Decalogue*, plate XXVII; *Praise Him with Psaltery and Harp*, plate 49).

Young Ben finished elementary school at the age of fourteen and, coming from a family of craft practitioners, it seemed natural that, with his talent for drawing and lettering, he should enter a lithographer's shop as an apprentice and complete his high-school education at night. While painstakingly learning the craft of lettering, Shahn impatiently waited for the time when, as a master lithographer, he would do the drawing on the stone. It was during these crucial years, 1913–17, that he acquired the skills which earned him not only a union card and an income but also the discipline and draftsmanship which would be inherent in all his future work. His respect for technical skill never diminished. "Craft is that discipline which frees the spirit; and style is the result,"[1] he said many years later.

During the next few years Shahn practiced his trade as a lithographer while attending New York University, City College and the National Academy of Design. Early in the 1920s he married Tillie Goldstein, and soon thereafter they left for an extensive trip to North Africa and Europe, an undertaking which they repeated only a couple of years later. The visual feasts that filled Shahn's mind during these trips were invaluable, and echoes from the travel sketchbooks would appear in many future works (see *Birds Over the City*, 1968, plate 59; *Levana*, 1966, plate 46, which had earlier appeared on the cover of Shahn's first portfolio, *Levana and Our Ladies of Sorrow*, 1931). During these years, his paintings reflected the influence of the Postimpressionist masters, and while he would tell himself that his work was good and based on a solid academic training, the "inner critic" within this highly intelligent and sensitive artist would not be silenced. His work, he said later, "did not contain the central person which, for good or ill, was myself."[2] It was not until he had freed himself from the bondage of looking through the eyes of the early twentieth-century European masters that his inner critic was mollified.

Shahn's own view of life at this time was influenced by the political ferment he experienced in Europe during the twenties and later in America during the early thirties. Spending part of his time in the studio and part in the mainstream of life, he observed the strengths and frailties of human character and viewed with a critical eye the relationship of man to society. His concerns moved him easily into the realm of activism, and he was eager to have his art feed directly into the tributaries that alter and quicken society's meandering flow. When he focused on the ills of society, it was not in bitterness but in the hope of eradicating these obstacles to the fulfillment of the American dream. In this he was but one of a number of artists—Social Realists, as they came to be called—who focused on a significant moment or a dramatic event in the lives of ordinary people and on the pathos, indignity or

[1] Ben Shahn, *The Shape of Content*, Cambridge, Mass., 1957, p. 107.
[2] *Ibid.*, p. 35.

tragedy of the persons involved. It might be inhuman working conditions or the greed of those in power that was depicted, not as mere observations, but with the intent of effecting change. Shahn's work, particularly in the thirties, fits comfortably into the Social Realist tradition that includes the great French caricaturist and satirist of the nineteenth century, Honoré-Victorin Daumier; the biting political foe of Nazi Germany, George Grosz; and, in our own country, Philip Evergood, William Gropper and Jacob Lawrence. Although much of Shahn's work after the forties expressed a more meditative and personal realism, some of his graphic work never ceased to reflect overtly his feelings about important issues of the day (see *Thou Shalt Not Stand Idly By*, 1965, plate 40; *We Shall Overcome*, 1965, plate 41).

It was as a Social Realist that Shahn first received recognition, and it all began with a small book on the Dreyfus case, which he had picked up in Paris. In addition to injustice, the case had overtones of mystery and prejudice. Falsely accused and found guilty of treason around the turn of the century, Dreyfus was sentenced to life imprisonment. Although Dreyfus was subsequently found innocent, the heat and passion of the trials, the related publicity and the suggestion of anti-Semitism (Dreyfus was a Jew) excited Shahn as he read the story. In preparation for a 1931 exhibition that he arranged with his friend the photographer Walker Evans, he painted a series of portraits of the principals of the Dreyfus case, lettering underneath, in his best lithographic tradition, the name and role of the principals. Although he made no prints of these paintings (there is now in preparation a limited edition of fine pochoir reproductions), they are mentioned here because they represent an important change in his work. His interest in the affair prompted him to render his subjects with a new directness, and this manner of depiction opened up a new avenue of expression which came to bear on his future artistic direction.

Like the Dreyfus paintings which centered on a single theme, but even more important in the development of Shahn's career and in the forging of a style of utmost simplicity, indicative both of the artist's role as an observer and his emotional feelings for the subject, was a series of paintings he did in the early thirties, based on the famous Sacco and Vanzetti case. "I was not unmindful of Giotto," Shahn wrote in 1957, "and of the simplicity with which he had been able to treat of connected events—each complete in itself, yet all recreating the religious drama, so living a thing to him."[3] Here, in the eyes of many, was a present-day crucifixion. Sacco and Vanzetti were poor immigrants who, in the early twenties, had been accused of robbery and murder and sentenced to death. The case dragged on with intellectuals taking up the defense of the condemned. When the two were finally executed in 1927, many felt that they had been sacrificed for their radical ideas and not for guilt beyond doubt. Popular demonstrations protesting the death sentence broke out in Europe and were given wide press coverage. Shahn had observed one street demonstration from his hotel window in Paris,

where his interest in the case was first aroused. Upon his return to the United States, he resurrected the case from news clippings and produced his series of paintings. When placed on exhibition at the Downtown Gallery in New York in 1932, Shahn's highly individual interpretation brought the trial back to the public forum, and his treatment of the two immigrants rekindled the martyrs' flame. People different from the ordinary gallery crowds came to see an art they could understand and a subject with which they could sympathize. Shahn had accomplished what he set out to do, to present "the two anarchists as the simple, gentle people they essentially were." In so doing, he later maintained, "I increased the conviction of those who believed them innocent."[4] But the argument was not put to rest, and writers even at this late date are turning to the case to reconsider the characters' guilt or innocence. In 1958, during a period rich in graphic production, Shahn also returned to the theme of Sacco and Vanzetti, and three serigraphs which he produced touched a responsive chord in a later generation of viewers. The antecedent work to the serigraph *Passion of Sacco and Vanzetti* (plate 13) is a tempera painting in The Museum of Modern Art, *Bartolomeo Vanzetti and Nicola Sacco*, 1931–32. The text is directly quoted from an article, written by reporter Philip Stong, who had interviewed the condemned men in prison just prior to their executions. When Shahn once spoke of portrait painting, he pointed to the mere likeness of an individual as a discipline which could be learned, but "the knowledge of the position of a human being in the world, the compassion with that human being, the sharing of . . . [his] loneliness, the accord with his thinking . . . these perceptions are not art school courses."[5] The quick brush strokes, the jagged line (a gesture left from the artist's days as a lithographic engraver) employed by the artist in the portraits, had by 1958 become a signature. Here it rendered a physical likeness which, in its childlike directness, revealed the artist's understanding of his subjects. The lettering is a Shahn invention, which he referred to as his "folk alphabet." Inspired by amateur signboards, it defies all the conventions of lettering, which he knew so well.

The success of the Sacco and Vanzetti paintings was followed during the next two years by other series of paintings on a theme, much in the same vein. It was at this time that Shahn met and began to work with Bernarda Bryson, an artist and writer, who was to become his wife. At this time he also became an assistant to Diego Rivera, who was then working on his controversial mural, *Man at the Crossroads*, for New York City's Rockefeller Center. When it was discovered that the mural contained a portrait of Lenin, public outcry resulted in its removal before completion. The assignment introduced Shahn to fresco painting, and a lifelong interest in the creation of murals had commenced. In pursuit of visual material for mural commissions, he roamed around New York with his camera and collected images of street life and architectural scenes and details—the beginnings of an important photographic

[3] Shahn, *op. cit.*, pp. 37–38.

[4] Selden Rodman, *Conversations with Artists*, New York, 1961, p. 225.
[5] *Statens Konstsamlingars Tillväxt och Förvaltning*, Stockholm, 1962, p. 90.

oeuvre. These photographs, together with his drawings, provided Shahn with a wealth of images and raw material to which he turned for visual reference and stimulus in the years to come.

One of Shahn's earliest prints was inspired by such a photograph. Jobless workers, such as those seen in *Seward Park*, 1936 (plate IV), whiling away endless hours on street corners and benches, were a common sight during the depression of the thirties. The lithograph follows closely his style of painting of the period.

In line with his interest in "the little people" were the later 1941 serigraphs *Immigrant Family* (plate 2) and *Prenatal Clinic* (plate V). In that year, when Shahn studied the technique of fresco painting at the Art Students League, he also learned the art of silk-screen printing from a fellow student, a medium he would master and use, admirably, as an important means of expression during the rest of his life. *Immigrant Family* is his first known serigraph and depicts three generations of a family, arranged much as they might be in a family photograph. It was a scene familiar to Shahn from his early childhood in Brooklyn, then teeming with immigrants. In contrast to the flatness of this serigraph and its neutral background is the contemporary *Prenatal Clinic*, whose background adds depth to the meaning as well as to the perspective. Two pregnant women, each alone in her thoughts, are seated in a hospital waiting room, facing in opposite directions. The white, undulating arms of the chairs repeat the forms of their swollen bodies and also serve as barriers between them. In the background a sign reads, "Do I deserve prenatal care?", speaking to the problem of health care, an issue still hotly debated today. The ambience is one of resignation and a complete absence of communication, indicative of the inability of some people to reach out and "touch" each other, as it were.

The Great Depression of the thirties reached from the cities to the drought-stricken farmlands that had been the breadbasket of America. Although the farm income during the depression had become negligible, the farmers had been able to survive on the food they grew and the stock they raised. Then came the destructive dust storms that roared through the South and Midwest, causing erosion of such magnitude that it left huge areas devastated and their people destitute. In 1935, President Franklin D. Roosevelt created the Resettlement Administration to relocate impoverished farmers from their barren lands to areas less seriously affected by the ravages of drought and wind. Soon thereafter, Shahn was employed by the agency as artist, designer and photographer. He traveled through the South and Midwest, assembling remarkable documentation in photographs of the nation's poor. From this period comes *Years of Dust*, 1936 (plate X), which is one of Shahn's earliest and most effective posters. The government's broad and benevolent intent is announced in the legend, "Resettlement Administration/Rescues Victims/Restores Land to Proper Use" (not reproduced in this volume), but Shahn encapsules the individual farmer's dilemma in his pictorial message. The farmer sits, slumped over a newspaper draped over his knee, and ponders the region's disaster as proclaimed in the headlines. His child, pale-faced, peers through the closed window. A wire fence, extending deep into the background, points to another farmhouse about to be enveloped by approaching dust clouds. What will the farmer's decision be? Will he take his family and flee his homestead for the unknown, or will he stay in hopes of surviving against the elements? In this poster, as in *Seward Park* of the same year, we observe a strong linearity and attention to architectural details, tendencies present to an even greater degree in Shahn's later graphic work. Notice also the farmer's strong and bony hands. By the time we finish our journey through Ben Shahn's imagery, we will have observed frequent use of the hands as conveyors of emotion. Increasingly, distortion will also serve as an expressive tool.

In and out of government employment during the next few years, Shahn pursued his interest in mural painting and received several important commissions. He also continued easel painting and produced a number of pictures that he called his "Sunday paintings" because they were executed during his days off from work. Some of these reflect his experience with the rural life of America and are among his most sensitive and charming works. His paintings had by now been shown in galleries and important museums. His reputation as an artist was firmly established.

When America became involved in World War II, Shahn went to Washington, D.C., where he worked as an artist in the Office of War Information. Here he had access to classified photographs and other documents that were being sent back from the theaters of war. He was horrified by the destruction, desolation and brutality that were revealed to him. His poster art from this period may well represent the best of his career but from his production only two were published by the government. *We French workers warn you*, 1942 (plate VI), is conceived as an appeal from the French workers to oppose the Vichy government, presumably with the particular aim of arousing the sympathies of the American blue-collar workers, who were in increasing numbers manning our war-production plants. Here again, Shahn is effectively rendering the workers' hands as a means of expression. An "official" Vichy decree, lettered in English, is posted on the wall directly behind the workers. The message within the message is by now a familiar device, employed to enhance the impact of the imagery.

This is Nazi brutality, 1942 (plate VII), the only other of his posters published by the government, is difficult to forget. A hooded and handcuffed man, who fills much of the picture space, is surrounded by massive, oppressive walls and a dark, threatening sky. The poster was prompted by a chilling message made by the Nazis themselves on June 11, 1942, the very day that they had destroyed the village of Lidice, Czechoslovakia. Shahn printed the news release in block letters, much as it would have appeared on ticker tapes in newsrooms around the world, effectively using the Nazi proclamation itself as the artist's instrument of war against the perpetrators.

Years later, Shahn commemorated another Nazi atrocity, that of the systematic liquidation, in 1942, of the Jews of the Warsaw ghetto, where deportees had been herded in the hundreds of thousands to add to the already existing population. In 1943, when only some 40,000 remained, the

Jewish underground, formed in desperation, offered resistance. The Nazi's superior military machine leveled the ghetto with tanks and flamethrowers and only a handful survived. It is to the resistance fighters and their courage that Shahn pays homage in the 1963 *Warsaw 1943* (Plate 29). Tragedy and futility, recurring themes with Shahn, consume the sparse figure in this print, his face hidden by fists clenched in anguish. The reduced artistic means, masterful line alone depicting the infinite sorrow of the mourner, offers an interesting contrast in style and approach to the equally moving *This is Nazi brutality*, where gloomy colors enhance the direct and hard-hitting message. The Hebrew calligraphy spells out a prayer taken from the Musaf service for Yom Kippur, and based on a legend of the execution of ten Hebrew sages by the second-century Roman emperor Hadrian: "These martyrs I will remember, and my soul is melting with secret sorrow. Evil men have devoured us and eagerly consumed us. In the days of the tyrant there was no reprieve. . . ."

At some point in the late thirties, Shahn had lent his hand to the production of union posters (plates II and III), but his artistic renderings, which were not to be tampered with, had not been to the liking of the officials and were thus never published. During 1945–46 he was, however, engaged as a director of graphic art by the CIO Political Action Committee, and a flurry of graphic activity began. As artist, Shahn worked with the Committee in developing a broad, intensive program for mobilizing union members into a political force. The emphasis was on encouraging them to exercise their constitutional right to vote. Many of the most compelling images found in these posters date from his years with the Office of War Information, where they had been rejected as failures for the purpose of enlisting the citizens' patriotism in the war effort. One such image was *We Want Peace*, 1946 (plate XV), where the pallid features of a begging child epitomize the despair and hunger existing in Europe at the time. "We want peace" is printed across his emaciated body; below is an exhortation to register and vote. The combination of the haunting figure and text may suggest the importance of citizens' participation in a democracy to help determine the course of events.

Welders, or, *For full employment after the war*, 1944 (plate VIII), also dates from Shahn's agency days and had originally been designed to serve the cause of antidiscrimination. It readily lent itself, with the same appeal, to the voter-registration campaign of the CIO. The two dignified figures, intent on their tasks, with only the sky as background and with red girders reflected from up high in protective glasses, bring a quality to art aimed for practical use that Shahn never abandoned.

In those days of heady political activity, it was not surprising that Shahn would lend his talents to the candidates of his choice, something he continued in future years. *Our Friend*, 1944 (plate IX), was the first of several political posters. Designed in support of President Roosevelt's bid for a fourth term, it reveals Shahn's admiration for the magnetic president who had led the country through depression and war. Looming large to the right are the fatherly and benevolent features of the candidate amid a

sea of upstretched arms, balanced to the left by a child (Shahn's son Jonathan) held high by a soldier. A multitude of details symbolically attests to the universal approval of the incumbent. Enlargements of this poster were exhibited on billboards around the country. Bernarda Shahn recalls that Shahn was amused by the "improvements" that a craftsman had made on his original painting, which he had left at the lithography shop with careful instructions. Fingers had been "brought up to standard" with softer curving, leaving the hands less vigorous. Shahn, the master lithographer, considered it a joke on himself and refused to have the posters reprinted. Time may also have been an element in that decision.

The next time around, Shahn did not like either of the major parties' candidates and went to work for the Progressive Party. From this encounter comes *A Good Man Is Hard to Find*, 1948 (plate XVI), lampooning with considerable wit the traditional parties' choices. We laugh with Shahn at Truman, the amateur pianist, "tickling" the keys with a flair. The grinning Dewey, draped on top of the piano, is dressed in his evening's best and appears to have stepped directly out of *Vandenberg, Dewey, and Taft* (plate 3), an early serigraph of 1941. Dressed in their elegant evening clothes, these three gentlemen from the Republican Party are able to enjoy a splendid time together at a time when "the little man," subject to decisions by politicians such as these, was still suffering from the depression in addition to his fears of an impending war.

Glancing through Ben Shahn's political posters, one might easily draw the conclusion that after the Roosevelt campaign, his feelings *against* a candidate were often stronger than those *for* his preference. Or—what was more likely—he had more fun lambasting the opposition. The scrawny nag in the broadside *Watch out for The Man on a White Horse!*, 1952 (plate 8), has not only to carry the burden of candidate Eisenhower but his liabilities as well, which adorn the horse's hide like a leopard's spots. The position of the vice-presidential candidate's name, carefully lettered on the rear haunch, was no doubt carefully considered. Shahn's last political poster was for candidate Eugene McCarthy, at a time when the divisive issue of the Viet Nam war was much on Shahn's mind. The colorful *McCarthy Peace*, 1968 (plate XXXII), with its dovelike bird of peace, was his contribution to the forces engaged in protest to end the war.

During the forties, while Shahn's graphic art had mostly been aimed at affecting the issues of the day, his painting had, as mentioned earlier, taken a new direction, resulting in works of a more contemplative and lyrical quality. This quality would also be reflected in his prints. Later yet, allegories and allusions increasingly informed his works, sometimes making them approachable on a level more spiritual than rational. Shahn himself now saw his work as infused with a truth that was of himself but not necessarily subject to easy analysis. According to his own account in *The Biography of a Painting*, he could no longer reconcile the social dream of the thirties with his "private and inner objectives of art." The change had come gradually as Shahn had "crossed and recrossed many sections of the country, and had come to know well so many people of all kinds

of belief and temperament, which they maintained with a transcendent indifference to their lot in life. Theories had melted before such experience." His own painting "turned from what is called 'social realism' into a sort of personal realism."[6] He came to view the function of art as a means "to broaden and enrich the human spirit."[7]

Throughout Shahn's life, much of his most enduring imagery originated from commercial assignments which aroused his interest and busied his brush. In 1947 he was asked by *Harper's* magazine to illustrate the story of a tragic fire in Chicago which involved the death of several children. As he worked on this assignment, memories of two fires during his own childhood, which had left indelible impressions on Shahn, triggered a multitude of vivid images on his drawing board. One such image was a beast head, seen in a different context in the 1950 serigraph *Where There Is a Book There Is No Sword,* (plate 7). The formalized flames surrounding the beast head were destined to reappear in many forms and settings. The text is from a Talmudic saying which translates: "The man of the sword is not a man of the book." From time to time Morris Bressler, his friend and neighbor in Roosevelt, N.J., assisted Shahn with Hebrew texts. One suggestion resulted in this beautiful lettering. Shahn, fascinated with script from early childhood, as he himself so charmingly related in *Love and Joy About Letters,* had increasingly begun to use lettering as an integral part of his compositions. He now began to apply his deft hand to a free interpretation of the intricate shapes of the Hebrew alphabet, which would enhance many of his future works. And like the illuminations in the early manuscripts, which eventually left the text to take their independent place in the world as separate works of art, so the letters of Shahn's Hebrew alphabet left their union with the image and eventually appeared as a single aesthetic entity in *Alphabet of Creation,* 1957 (plate 12). When visiting Japan in 1960, Shahn was presented with a "chop" (a seal), made from this alphabet, which he used as a signature on many of his prints.

From the 1947 illustrations for another story, a mine disaster of immense dimension and tragedy, came many important paintings and later the 1956 serigraph *Mine Building* (plate XX). Shahn had long been fascinated with buildings and the story they tell of the people who inhabit them. He was struck here by the changing pattern of colors of the painted mine buildings, coated with years of soot. The colors are hand-applied and vary considerably on the prints in the edition. In many of Shahn's prints, the colors are applied by hand, and at times he enlisted his family to assist him.

One of Shahn's wartime associates, William Golden, had in the meantime become the art director of CBS, and a fruitful collaboration between the two began in 1948, when Shahn was asked to illustrate a folder promoting radio programs. From the ensuing works came *Silent Music,* 1950 (plate 6), one of Shahn's best-known prints and the first one planned by him to be produced in a limited edition. By now we are familiar with Shahn's characteristic line drawing which, in all its simplicity, has the power to en-

capsule a whole multitude of symbols, allusions, moods and details. Here it portrays the nearly tangible quietude present after the music has ceased and the players have left the stage. Shahn humorously referred to this print as "Local 802 [the musicians' Union] on Strike," which brings a less ethereal interpretation to its empty chairs. Still later CBS assignments are reflected in *Supermarket,* 1957 (plate XXI), and the 1958 *Wheat Field* (plate 15). While some of this imagery had appeared earlier in drawings and paintings, it is in the wider distribution of prints that they have become well known. This is particularly true of the wheat field. Gracefully nodding heads of mature grain, reaching toward the sun on slender stems, was a motif that Shahn had turned to as early as 1950, inspired, perhaps, by memories of undulating fields in the Lithuania of his childhood, but certainly a scene encountered on his journeys through the American farmlands. Soft hues of color, like sunlight dispersed by unseen prisms, are hand-applied on the serigraph.

While Shahn was not a landscape painter, he was by no means uninterested in nature and had at one time entertained the thought of becoming a biologist. His sensitivity towards nature's beauty is evident in the exquisite rendering of flowery motifs included in some of his paintings and seen in his floral illustrations for the 1964 *Love Sonnets* edited by Louis Untermeyer. In *The gestures of the little flowers* (plate 55), we can observe his tender treatment of fragile wild flowers. This print is a component of *The Rilke Portfolio,* or *For the Sake of a Single Verse,* 1968, the last one completed before his death, which consisted of 23 lithographs, each one drawn by Shahn to accompany a phrase—on the opposite page—derived from a paragraph in Rainer Maria Rilke's *The Notebooks of Malte Laurids Brigge:*

For the sake of a single verse, one must see many cities, men [plate 53] and things [plate 54], one must know the animals, one must feel how the birds fly and know the gesture with which the little flowers open in the morning [plate 55]. One must be able to think back to roads in unknown regions, to unexpected meetings and to partings one had long seen coming; to days of childhood that are still unexplained, to parents whom one had to hurt when they brought one some joy and one did not grasp it (it was a joy for someone else); to childhood illnesses that so strangely begin with such a number of profound and grave transformations, to days in rooms withdrawn and quiet and to mornings by the sea, to the sea itself, to seas, to nights of travel that rushed along on high and flew with all the stars—and it is not yet enough if one may think of all this. One must have memories of many nights of love [plate 56], none of which was like the others, of the screams of women in labor, and of light, white, sleeping women in childbed, closing again. But one must also have been beside the dying, must have sat beside the dead [plate 57] in the room with the open window and the fitful noises. And still it is not yet enough to have memories. One must be able to forget them when they are many and one must have the great patience to wait until they come again. For it is not yet the memories themselves. Not till they have

[6] Ben Shahn, *op. cit.,* p. 40.
[7] *Ben Shahn,* ed. John D. Morse, New York, 1972, p. 203.

turned to blood within us, to glance and gesture, nameless and no longer to be distinguished from ourselves—not till then can it happen that in a most rare hour the first word of a verse arises [plate 58] in their midst and goes forth from them.

Shahn had first read the *Notebooks* in Paris in 1926 and immediately felt a kinship with the author. No wonder he would return to them again. To Shahn, art was not just color, line and form on the flat surface of paper or canvas. Art was nothing if not infused with life itself.

During the decades of the fifties and sixties, the champions of such movements as Abstract Expressionism, Pop Art and Op Art became the favorites of art critics and museum curators. Shahn, although allowing that many visually and intellectually exciting works had emerged from nonobjective art, never deviated from adherence to his world of images. Thus when he learned what Maximus of Tyre, a Platonist of the first–second century A.D., had said about images, he again found a kindred spirit and saw in his words revealed, "not so much the case for images as the soul and true meaning of images."[8]

He wove the ancient words in with his own visual language in painting, in mural design, in book form and in prints. We find them in *Maximus of Tyre*, 1963 (plate 28), where they form the background to an authoritative figure with piercing eyes and knitted brow. His upstretched arm commands attention and somber hues in browns and grays reinforce the expression of severity. We see fragments of them in the 1965 *All That Is Beautiful* (plate XXIV), poetically joined with lovingly depicted architectural details from the New York Shahn knew as a child, details which by then were fast disappearing to make room for invasions of glass and concrete.

With prevailing interest in humanistic values, which he nourished by reading in a wide range of subjects, Shahn gave serious thought to the artist's role in society, which he saw historically as a great civilizing and unifying force. Based on an image from the fifties, the 1968 lithograph *Flowering Brushes* (plate XXXI) is a portrayal of a pensive artist coupled with the question posed by the great Jewish scholar Hillel the Elder: "If I care only for myself, what am I?" "My credo is," said Shahn, "that the artist, in the very business of keeping his integrity, begins to supply some of the moral stamina our country needs. I think that any good art is directly a product of the spirit. If we, the artists, can contribute even a little to the enrichment and awakening of the country, we have done a good thing indeed." [9]

During the two last decades of Shahn's life his production of prints increased as he reached for a wider audience than he could with his paintings. An erudite man, he was sought after as speaker and writer and spent the 1956–57 academic year at Harvard as the Charles Eliot Norton Professor of Poetry. Themes and elements of his work now began to reflect the sciences as they impinged on man, his values and his moral predicaments. From this period dates

the 1957 *Scientist*, an abstract delineation of a scientist who contemplates the mysteries of the molecule, here represented by a conventional wire-and-ball atomic model. A variation on it appears as *Many Things* (plate 54). The model is also present in the 1958 *Lute and Molecule, No. 2* (plate 14), where science and art intertwine to satisfy the cravings of the human mind and spirit. Shahn's conscience was disturbed by his apprehension of what science without moral evaluation could do to mankind. A tragic view is indicated in his *Blind Botanist*, 1961 (plate 21), derived from a drawing of the early fifties. This print contains the essence of several pictures, in which the recurring image is that of a seated, sightless botanist, partially obscured by a large, thorny plant, victim of his own pursuits. The text is taken from the *Micrographia* of 1665 by the English scientist Robert Hooke.

As we have seen, Shahn had for some time communicated through his art in a profound, at times even cryptic manner, but by no means did he live in an ivory tower, nor had he turned his back on those unfortunate people who suffered injustice or persecution. In the sixties he openly supported the civil-rights movement. Shahn described *Psalm 133*, 1960 (plate 21), as a "hopeless pleading for people to get together." In *I Think Continually of Those Who Were Truly Great*, 1965 (plate 35), he pays tribute to the young civil-rights martyrs whose names appear in the background like a visible pattern left from the flutter of the dove in midflight. In the same year he produced and donated three portfolios to minority causes. *Frederick Douglass, II* (plate 37) and *We Shall Overcome* (plate 41) both originate from these portfolios. In 1965 he also painted a portrait of Martin Luther King for the March 19 cover of *Time* magazine. The following year he collaborated with a young printmaker and neighbor, Stefan Martin, who executed an edition of wood engravings of the martyred leader, *Martin Luther King* (plate 48).

For many years, Shahn's work had been collected by museums and patrons and his paintings had traveled widely in exhibitions here and abroad. Some of his most vivid images are contained in the posters announcing his own exhibitions. One of the most beautiful is *Phoenix* (plate XVII). Out of the flames has risen the phoenix of ancient lore. Its colorful plumage is here depicted in a crescendo of horizontal stripes, an image Shahn would return to many times. *Pavillon Vendôme*, 1954 (plate XIX), picks up another recurring theme. Paterson is a city in New Jersey where dyemaking was once a big industry. The multicolored dye patterns that could be seen in the windows inspired Shahn to a visual translation of the poem *Paterson* by William Carlos Williams:

without invention nothing is well spaced
. . . the old will go on
repeating itself with recurring
deadliness. . . .

In 1961–62 a comprehensive exhibition of Shahn's work, organized by New York City's Museum of Modern Art, circulated through museums in Europe. Among the several posters from this tour came *Ben Shahn Graphik Baden-*

[8] Ben Shahn, *Maximus of Tyre on the Dispute About Images*, New York, 1964, Introduction, unnumbered p. 1.
[9] *Paragraphs on Art by Ben Shahn*, New York, 1952, unnumbered p. 1.

Baden (plate 25), where the "immortal words" from *Passion of Sacco and Vanzetti* had been superimposed over two pages of the *New York Times*. According to Bernarda Shahn, the artist often made trial proofs on newsprint, and in this case he liked the result well enough to make it part of his composition.

A reproduction of a 1969 portrait of Dag Hammarskjöld, *Ben Shahn en amerikansk kommentar* (plate XXVIII), announced an exhibition in Stockholm in 1963. Shahn had undertaken the portrait commission of the then Secretary-General of the United Nations, whom he knew and admired, with a great deal of concern. "I wanted to express [his] loneliness and isolation, his need, actually, for such remoteness in space that he might be able to carry through . . . the powerful resolution to be just. His unaffiliated kind of justice, it seems to me, held the world together through many crises that might have deteriorated into world conflicts. . . . I must mention, too, the threat that hung over him as it hung over the world. . . . All this is my mood in doing this piece of work."[10]

But Shahn, deadly serious about his work, was also a man of great wit and charm. In the self-portrait of the 1956 *Ben Shahn Fogg Art Museum* (plate 9), he has caught himself in a moment of indecision as he contemplates where the next crucial brush stroke should be applied. *Ben Shahn January 18 to February 12*, 1964 (plate XXIX), presents him as entertainer, a jester riding high atop his horse. This, as well as the image of the somewhat sad-looking clown in the 1965 *Spoleto Festival dei Due Mondi* (plate 32), had appeared earlier in works of the fifties. In her book *Ben Shahn*, Bernarda Shahn traces the origin of the multifaceted man whom we see in *Ben Shahn Graphics Philadelphia Museum of Art*, 1967 (plate XXX). Shahn had been making sketches of a young man dancing under dim lights that caused unusual shadows to appear on his body as he moved. From these patterns of light and dark, set down on paper, emerged later torsos, on which colors like those in stained-glass windows replaced the shadows.

Shahn's felicitous posters also reached into other activities in the arts. In *Ballets U.S.A.*, 1959 (plate XXII), the bold lettering of his "folk alphabet" is superimposed on the colorful rectangles we have already encountered in *Pavillon Vendôme*, and the name of Martha Graham fairly dances its cursive path across the sheet in *Martha Graham Dance Company*, 1963 (plate 27). Many were the fund-raising events to which Shahn generously contributed his art. *Walden School Art Exhibition*, 1960s (plate 18), is such a one, and here the image is taken from a drawing done by Shahn for CBS, announcing the 1956 film *Ambassador Satchmo*.

While it is true that many images in Shahn's prints had appeared in earlier paintings, this is by no means always the case. When it happened, the transition seemed natural, because Shahn, a superb draftsman, informed his mature statements in *all* media with his inimitable line, the result of endless observations and studies. Moreover, many of

his late religious works first saw life in drawings that were destined for the graphic media.

In her introduction to Shahn's posthumous *Hallelujah Suite*, Bernarda Shahn speaks of her husband's return to religious themes: "He rediscovered myth and story and holy spirit . . . that he could now depict . . . with affectionate tenderness."

In *Pleiades*, 1960 (plate XXV), the muted colors and gold leaf in celestial bodies are hand-applied to a gray serigraphic image of lines defining the constellation, all combining to achieve an effect of ethereal beauty. Across the firmament, in the rhythmic richness of Hebrew calligraphy, a quotation from the Book of Job 38:31–38 reads: "Canst thou bind the chains of the Pleiades. . . ."

The prismatic 1965 *Menorah* (plate XXVI) combines silk-screened lines and colors with hand-applied gold leaf. Shahn used this theme in other works, including the frontispiece for his 1965 book *Haggadah for Passover*.

The graceful and classical figure in *Praise Him with Psaltery and Harp*, 1966 (plate 49), was inspired by Psalm 150:3. This serigraph was commissioned by the Benrus Corporation and produced in a limited edition to be presented to selected customers during the December holidays. Psalm 150, a hallelujah chorus, proved to be a seemingly endless source of stimulation to Shahn during his last year, when his health was failing. The result can be seen in a posthumous edition of lithographs, *Psalm 150*, of 1969–70, which includes *Man Playing Cithara* (plate 65) and *Man Sounding Horn* (plate 66). The drawings from which these lithographs stem were originally meant for a mosaic mural. Just prior to his death, Shahn finished the drawings for the fifty lithographs included in the *Hallelujah Suite*, also posthumously published, in 1970–71. From there comes the *Dancing Virgin* (plate 68), echo of an ancient image in art as well as from biblical poetry. The suite begins with "hallelujah" in beautifully arranged Hebrew letters and ends with its counterpart in English, comprising an evocative epitaph for a great American artist, whose full and active life, spanning almost 71 years, had begun in Kovno, where nine hours a day were devoted to "learning the true history of things, which was the Bible. . . ."[11]

In the end, Shahn was saddened by the decay of moral values he saw around him but looked with hope to the redemptive power of the arts. "If man has lost his Jehovah, his Buddha, his Holy Family, he must have new, perhaps more scientifically tenable beliefs, to which he may attach his affections. . . . But in any case, if we are to have values, a spiritual life, a culture, these things must find their imagery and their interpretation through the arts."[12] "[It] is through the arts, through the symbolizing of the great legends, the religious stories, the images of compassion and great emotion created in painting, sculpture, literature, and other arts that civilizations have acquired and retained values in common."[13]

[10] *Statens Konstsamlingars Tillväxt och Förvaltning*, p. 87.

[11] Ben Shahn, *Love and Joy About Letters*, New York, 1963, p. 5.
[12] *Paragraphs on Art by Ben Shahn*, unnumbered p. 4.
[13] *Ben Shahn*, ed. Morse, p. 179.

BIOGRAPHICAL OUTLINE

1898 Born September 12, Kovno, Lithuania.

1906 Emigrates with family to Brooklyn, N.Y.

1913 Employed as lithographer's
−17 apprentice at Hessenberg's lithography shop on Beekman Street in Manhattan; attends high-school night classes.

1919 Attends New York University
−22 and City College of New York; leaves City College to study at the National Academy of Design and later at the Art Students League.

1922 Marries Mathilda (Tillie) Goldstein.
Travels with wife to North Africa, Spain, Italy, Austria, Holland and France, settling in Paris.

1926 Returns to U.S.; spends summer painting in Truro, Mass.

1927 Returns to Paris; spends most
−29 of one year on the island of Djerba, off Tunisia.

1929 Returns to America, living on Willow Street in Brooklyn Heights and painting during the summer at Truro; shares studio on Bethune Street with photographer Walker Evans.

1930 First group and first one-man exhibition, The Downtown Gallery, N.Y.

1931 Publishes first fine-art prints (lithographs), the *Levana* portfolio.

1932 Meets artist-writer Bernarda Bryson, who is to become his second wife; The Downtown Gallery exhibits 23 small gouache paintings and two large panels on the Sacco and Vanzetti trial; The Harvard Society of Contemporary Art, Cambridge, Mass., exhibits the Sacco and Vanzetti gouaches and 13 watercolors of the Dreyfus trial; The Museum of Modern Art, as part of a group show, exhibits two tempera studies for a Sacco and Vanzetti mural (used in 1967 for a mural for Syracuse University).

1932 Works included in "First Bien-
−33 nial Exhibition of Contemporary American Painting,"

Whitney Museum of American Art, N.Y.

1933 The Downtown Gallery exhibits 15 gouache paintings and one tempera panel on the Mooney trial, with catalogue foreword by Diego Rivera; works as assistant to Diego Rivera on Rockefeller Center murals.

1935 Produces first signed poster, *We Demand the National Textile Act.*
Employed by Resettlement Administration as artist, designer and photographer; travels through the South and Midwest photographing rural and urban scenes of poverty.

1937 Completes first mural, a fresco,
−38 for the community center of a federal housing development at Roosevelt, N.J.

1938 With Bernarda Bryson, com-
−39 pletes 13 large egg-tempera fresco panels for a mural for the Central Annex Post Office, Bronx, N.Y.

1939 Establishes residence at Roosevelt.

1941 Prints first serigraph, *Immigrant Family*; work included in exhibition circulated in Latin America by The Museum of Modern Art.

1942 Designs posters for the Office
−44 of War Information, Washington, D.C.

1944 Joins the Political Action Committee of the CIO and produces posters urging members to register and vote.

1946 Work included in group exhibition of American painting, Tate Gallery, London, and included in "Watercolor—USA," an exhibition circulated in Latin America by the National Gallery of Art, Washington, D.C.

1947 Teaches at Boston Museum summer school; circulates ten paintings to galleries in London, Brighton, Cambridge and Bristol, under auspices of the Arts Council of Great Britain.

1947 Retrospective exhibition of
−48 paintings, drawings, posters, illustrations and photographs, The Museum of Modern Art.

1948 Designs posters and campaign material for Henry Wallace's "Third Party"; selected by *Look* magazine as one of America's ten leading painters.

1950 Teaches summer session at University of Colorado at Boulder.

1951 Three-man show with Willem de Kooning and Jackson Pollock, Arts Club of Chicago, October 2–27; teaches at Brooklyn Museum Art School and Black Mountain summer school.

1952 Sketches convention activities while attending Democratic Convention in Chicago.

1953 Five works exhibited at the
−54 Bienal of the Museu de Arte Moderna, São Paulo, Brazil; wins cash award.

1954 Represents the United States with Willem de Kooning at the Venice Biennale.

1956 Elected member of the National Institute of Arts and Letters; awarded the Joseph E. Temple Medal Award by the Pennsylvania Academy of Fine Arts; travels in Europe and studies mosaics in Italy.

1956 Teaches at Harvard University
−57 as Charles Eliot Norton Professor of Poetry.

1958 Work included in Venice Biennale exhibition, "American Artists Paint the City"; awarded American Institute of Graphic Arts Gold Medal; designs sets for Jerome Robbins' ballet *New York Export—Opus Jazz.*

1959 Elected member of American Academy of Arts and Sciences; receives annual award at North Shore Art Festival, Long Island, N.Y.

1960 Travels to Far East, including Japan.

1961 Work included in exhibition, "Posters Against Nazism," Galleria dell'Obelisco, Rome; designs sets for e. e. cummings' play *him*, and for Jerome Robbins' ballet *Events.*

1969 Dies, March 14.

SELECTED EXHIBITIONS, 1930 – 1980

One-Man Exhibitions

1930 The Downtown Gallery, N.Y., April 8–27, "Paintings and Drawings, Ben Shahn."

1932 The Downtown Gallery, April 5–17, "The Passion of Sacco–Vanzetti."
Harvard Society of Contemporary Art, Cambridge, Mass., October 17–19, "Ben Shahn."

1933 The Downtown Gallery, May 2–20, "The Mooney Case by Ben Shahn." Catalogue foreword by Diego Rivera.

1940 The Julien Levy Gallery, N.Y., May 7–21, "Sunday Paintings."

1944 The Downtown Gallery, November 14–December 2, "Shahn Paintings."

1947 The Downtown Gallery, April 1–26.
Mayor Gallery, London, England, May, "Ben Shahn." Circulated in England by the Arts Council of Great Britain, June–July.
The Museum of Modern Art, N.Y., September 30, 1947–January 4, 1948, "Ben Shahn."

1949 The Downtown Gallery, October 25–November 12, "New Paintings and Drawings."

1951 The Downtown Gallery, May 22–June 8.

1952 The Downtown Gallery, March 11–29, "Ben Shahn Paintings."

1953 Minneapolis Institute of Arts, November 8–December 6.

1955 The Downtown Gallery, January 18–February 12, "Ben Shahn: Paintings and Drawings."

1956 Fogg Art Museum, Harvard
–57 University, Cambridge, Mass. December 4, 1956–January 19, 1957, "The Art of Ben Shahn."

1957 American Institute of Graphic Arts, N.Y., March 1–28, "The Graphic Works of Ben Shahn."

Institute of Contemporary Art, Boston, April 10–May 31, "Ben Shahn: A Documentary Exhibition."

1959 Leicester Galleries, London, England.
Katonah Gallery, Katonah, N.Y.
The Downtown Gallery, March 3–28, "Ben Shahn."

1960 The Downtown Gallery, December 8–24, "Ben Shahn. Silkscreen Prints, 1950–1959."

1961 The Downtown Gallery, October 10–November 4, Ben Shahn, "The Saga of the Lucky Dragon."
The International Council of The Museum of Modern Art, N.Y., December 22, 1961–June 24, 1962, "The Works of Ben Shahn." Circulated to: Stedelijk Museum, Amsterdam, December 22, 1961–January 22, 1962; Palais des Beaux-Arts, Brussels, February 3–25; Galleria Nazionale d'Arte Moderna, Rome, March 31–April 29; Graphische Sammlung Albertina, Vienna, May 22–June 24.

1962 The International Council of
–63 The Museum of Modern Art, August 20, 1962–June 16, 1963, "Ben Shahn Graphics." Circulated to: Kunsthalle, Baden-Baden, August 20–September 26; Galerije Grada Zagreba, Zagreb, November 6–30; Moderna Galerije, Ljubljana, December 10, 1962–January 7, 1963; Moderna Museet, Stockholm, February 16–March 10; Lunds Konsthall, Lund, March 16–April 15; Bezalel National Museum, Jerusalem, May 25–June 16.

1964 Leicester Galleries, London, June–July.

1966 Galleria Ciranna, Milan, Italy, April 20–May 21, "Disegni e Serigrafie."
The Saint Paul Art Center. February.

1967 Santa Barbara Museum of Art, July 30–September 10, "Ben Shahn." Circulated to: La Jolla Museum of Art,

October 5–November 12; Herron Museum of Art, Indianapolis, December 3, 1967–January 3, 1968. Philadelphia Museum of Art, November 15–December 31, "The Collected Prints of Ben Shahn."

1968 Museum of African Art, Washington, D.C., Spring, "Ben Shahn on Human Rights."
Kennedy Galleries, N.Y., October 12–November 2. "Ben Shahn."

1969 New Jersey State Museum, Trenton, September 20–November 16, "Ben Shahn: A Retrospective Exhibition."
Kennedy Galleries, November 5–29, "Ben Shahn."
Fogg Art Museum, Harvard University, October 29–December 14, "Ben Shahn as Photographer."

1970 The National Museum of Modern Art, Tokyo, Japan, May 21–July 4, "Ben Shahn: Retrospective Exhibition." Circulated to: Ishibashi Art Museum, Kurame, April 16–May 10; Imai Department Store Galleries, Sapporo, July 14–26; Osaka City Museum, August 4–30; Hiroshima City Museum, September 19–October 4.
Nantenshi Gallery, Tokyo, May 22–June 13, "Ben Shahn."
Kennedy Galleries, October, "The Drawings of Ben Shahn."

1971 Kennedy Galleries, November 6–27, "Ben Shahn (1898–1969)."
Gallery Ann, Houston, May, "Paintings, Drawings, Prints and Posters."

1972 Joseph Devernay-Berhen and Co., N.Y., December 5–30, "Ben Shahn: Drawings, Watercolors, Paintings."

1973 Kennedy Galleries, March 20–April 21, "Retrospective Graphics Exhibition."
Joseph Devernay–Esther Begell, Washington, D.C., October 8–November 16, "Ben Shahn: Drawings, Watercolors, Paintings."
Kennedy Galleries, October

26–November 17, "Retrospective Graphics Exhibition."
New Jersey State Museum, Trenton, December 1, 1973–January 27, 1974, "Ben Shahn Prints."

1974 Joseph Devernay Schloss Remseck, International Art Fair, Basel, Switzerland, June 19–24, "Paintings, Watercolors, Drawings."

1975 Allentown Art Museum, January 12–February 29, "Ben Shahn Graphics and Paintings."
Galerie Schloss Remseck, Neckarrems-Stuttgart, West Germany, May–June.

Joseph Devernay Begell, Washington International Art Fair '76, D.C. National Armory, May 12–17, "Paintings, Drawings, Graphics."
Kennedy Galleries, May 14–June 4, "The Drawings of Ben Shahn."

1976–78 The Jewish Museum, New York, October 20, 1976–January 2, 1977, "Ben Shahn: A Retrospective 1898–1969." Circulated to: Georgia Museum of Art, The University of Georgia, Athens, January 27–March 17; The Maurice Spertus Museum of Judaica, Chicago, April 11–May 29; University Art Museum, The University of Texas, Austin, June 23–August 11; Cincinnati Art Museum, September 5–October 24; Amon Carter Museum, Fort Worth, November 17–January 15, 1978.

1979 Kennedy Galleries, February 21–March 17, "Ben Shahn Drawings."

Group Exhibitions

1931 Art Institute of Chicago, "Eleventh International Watercolor Exhibition," April 30–May 31.

1932 The Museum of Modern Art, N.Y.

1932–33 Whitney Museum of American Art, N.Y., November 22, 1932–January 5, 1933, "First Biennial Exhibition of Contemporary American Paintings."

1934–35 The Museum of Modern Art, N.Y., November 20, 1934–January 5, 1935, "Fifth Anniversary Exhibition."

1935 Wadsworth Atheneum of American Art, Hartford, January 29–February 19, "American Painting and Sculpture of the 18th, 19th and 20th Centuries."

1936 WPA Federal Art Project Gallery, N.Y., December, "Documentary Photographs from the Files of the Resettlement Administration."

1939 Whitney Museum of American Art, N.Y., September 13–December 4, "20th Century Artists."

1941 The Museum of Modern Art, N.Y. Circulated to Latin America.

1943 The Museum of Modern Art, N.Y., February 10–March 21, "American Realists and Magic Realists."

1944 Walker Art Center, Minneapolis, August 18–September 11, "Second Annual Purchase Exhibition."

1945 St. Louis City Art Museum, February 10–March 12, "38th Annual Exhibition."
Art Institute of Chicago, April 27–June 28, designs for Container Corporation of America.

1946 Tate Gallery, London, July 15–August 5, "American Painting from the 18th Century to the Present Day."

1947 Brooklyn Museum, N.Y., April 8–27, "International Water Color Exhibition: Fourteenth Biennial."

1951 The Arts Club of Chicago, October 2–27, "Ben Shahn, Willem de Kooning, Jackson Pollock."

1952 Museum of Art, Santa Barbara; California Palace of the Legion of Honor, San Francisco; Los Angeles County Museum of Art, Los Angeles; June–August, "Paintings by Lee Gatch, Karl Knaths, Ben Shahn."

1953–54 Museu de Arte Moderna de São Paulo, Brazil, December 1953–February 1954, "Bienal."

1954 Art Institute of Chicago, October 21–December 5, "Sixty-first Annual Exhibition."
Contemporary Arts Museum, Houston, January 10–February 11, "Four

Americans from the Real to the Abstract."
Institute of Arts, Detroit, March 9–April 11, "Ben Shahn, Charles Sheeler, Joe Jones."
XXVII Biennale Internazionale d'Arte, Venice, "2 Pittori: de Kooning, Shahn; 3 Scultori: Lachaise, Lassaw, Smith."

1958 XXIX Biennale Internazionale d'Arte, Venice, "American Artists Paint the City."

1959–60 Art Institute of Chicago, December 1, 1959–January 31, 1960, "Sixty-third Annual American Exhibition."

1961 Galleria dell'Obelisco, Rome, May, "Posters Against Nazism."

1963 The Jewish Museum, N.Y., February 18–March 23, "The Hebrew Bible in Christian, Jewish and Muslim Art."

1966 New Jersey State Museum, Trenton, April 8–June 12, "Art from New Jersey."

1967 Art Center, New School For Social Research, N.Y., October 24–December 2, "Protest and Hope: An Exhibition of Contemporary American Art."

1968 Galería Colibrí, San Juan, P.R., March 7–April 2, "Rilke Portfolio Lithographs."

1972 Art Center, New School For Social Research, October 25–December 19, "Human Satire and Irony."
Brooklyn Museum, March 22–May 14, "A Century of American Illustration."

1975–76 The Jewish Museum, N.Y., October 14, 1975–January 25, 1976, "Jewish Experience in the Art of the Twentieth Century."

1976 Hirshhorn Museum and Sculpture Garden, Washington D.C., May 20–October 20, "The Golden Door, Artist-Immigrants of America, 1876–1976."
Grey Art Gallery, New York University, N.Y., May 24–July 8, "Images of an Era; The American Poster 1945–75."

1980 Chrysler Museum at Norfolk, October 16–November 30, "American Figure Painting, 1950–1980."

SELECTED BIBLIOGRAPHIC REFERENCES

Writings by Ben Shahn

Paragraphs on Art, The Spiral Press, N.Y., 1952.

The Biography of a Painting, Fogg Art Museum (Fogg Picture Book No. 6), Cambridge, Mass., 1956. Reprinted with additional illustrations in 1966 by Fitz Henry and Whiteside, Ltd., Don Mills, Ontario, Canada, and Paragraphic Books, N.Y.

The Shape of Content, Harvard University Press, Cambridge, Mass., 1957; Vintage, N.Y., 1960.

Alphabet of Creation, Schocken Books, N.Y., 1963; Schocken Paperback, 1965, 1967.

Love and Joy About Letters, Grossman, N.Y., 1963.

Works Illustrated by Ben Shahn

A Partridge in a Pear Tree, The Museum of Modern Art, N.Y., 1949, revised 1951 and subsequent printings.

The Cherry Tree Legend, The Museum of Modern Art, N.Y., 1953 and subsequent printings.

The Alphabet of Creation, An Ancient Legend from the Zohar, by Edmund Fleg, The Spiral Press, Pantheon Books, N.Y., 1954.

Thirteen Poems by Wilfred Owen, Gehenna Press, Northampton, Mass., 1956.

Sweet Was the Song, The Museum of Modern Art, N.Y., 1956.

I Sing of a Maiden, private ed. by Ben Shahn, Roosevelt, N.J., 1957.

The Sorrows of Priapus, by Edward Dahlberg, New Directions, N.Y., 1957.

A Portion of Jubilate Agno, A Poem by Christopher Smart, Fogg Art Museum (Fogg Picture Book No. 8), Cambridge, Mass., 1957.

Ounce Dice Trice, by Alastair Reid, Little, Brown, Boston and Toronto, 1958.

Kay Kay Comes Home, by Nicholas Samstag, Ivan Obolensky, Inc., N.Y., 1962.

Maximus of Tyre, Ben Shahn, The Spiral Press, N.Y., 1964.

November Twenty-Six, Nineteen Hundred Sixty-Three, by Berry Wendell, George Braziller, N.Y., 1964.

Love Sonnets, Louis Untermeyer (ed.), The Odyssey Press, N.Y., 1964.

Ecclesiastes or, The Preacher, Ben Shahn, The Spiral Press, N.Y., 1965.

Haggadah for Passover, Ben Shahn and Cecil Roth, Little, Brown, Boston, and Trianon Press, Paris, 1965.

Kuboyama and the Saga of the Lucky Dragon by Richard Hudson, Thomas Yoseloff, London, 1965.

A Christmas Story, by Katherine Anne Porter, The Delacorte Press, N.Y., 1967.

Books About Ben Shahn

Ben Shahn, by James Thrall Soby, The Museum of Modern Art and Penguin Books, N.Y., 1947.

Portrait of the Artist as an American, Ben Shahn: A Biography with Pictures, by Selden Rodman, Harper, N.Y., 1951.

Conversations with Artists, by Selden Rodman, The Devin-Adair Co., N.Y., 1957; Capricorn Books, N.Y., 1961.

Ben Shahn. His Graphic Art, by James Thrall Soby, George Braziller, N.Y., 1957.

Ben Shahn, by Mirella Bentivoglio, De Luca Editore, Rome, 1963.

Ben Shahn Paintings, by James Thrall Soby, George Braziller, N.Y., 1963.

Ben Shahn, by Antonio Guerico, Editori Riuniti, Rome, 1964.

Ben Shahn Collected Prints, Philadelphia Museum of Art, Philadelphia, 1967.

Ben Shahn, John D. Morse (ed.), Praeger Books, N.Y., 1972.

Ben Shahn, by Bernarda Bryson Shahn, Harry Abrams, N.Y., 1972.

The Complete Graphic Works of Ben Shahn, by Kenneth W. Prescott, Quadrangle/New York Times Co., N.Y., 1973.

Ben Shahn, Photographer, Margaret Weiss (ed.), Da Capo Press, N.Y., 1973.

The Photographic Eye of Ben Shahn, Davis Pratt (ed.), Harvard University Press, Cambridge, 1975.

Ben Shahn: A Retrospective 1898–1969, by Kenneth W. Prescott, The Jewish Museum, N.Y., 1976.

COMMENTARY

1. Wear Goggles. 1937. 20″ × 14″. Poster lithographed in colors. Published by the Resettlement Administration. Printed by the U.S. Government Printing Office. Apparently Shahn's third poster, this has a less painterly quality than the others of the period.

2. Immigrant Family. 1941. 19¼″ × 25¼″. Serigraph in colors. In this portrait grouping, which reflects his early painting style, Shahn sympathetically presents three generations of an immigrant family in the New World. As the first serigraph made by the artist, *Immigrant Family* is extremely important, for he had then mastered a new print-making technique, with which he would experiment widely in the years ahead. It allowed him to express himself without the aid of assistants and opened almost unlimited possibilities for him personally to produce multiple images of chosen themes with the option of making variations in the individual prints.

3. Vandenberg, Dewey, and Taft. 1941. 19¼″ × 25¾″. Serigraph in colors. This early serigraph follows Shahn's painting style of the period. He good-naturedly satirized the omnipresent professional smiles of politicians by giving these men rows of too perfect teeth set in frozen, grinning faces. Political themes occur frequently in Shahn's work.

4. Register . . . The Ballot is a power in your hands. 1944. 39¾″ × 29⅞″. Poster photo-offset in colors. In the fall of 1943, the CIO established the Political Action Committee. It was much concerned with the 1944 national elections, and in March. 1944, it started a nationwide drive to register voters—particularly CIO members and their families. It was complacency among the workers that the Political Action Committee was fighting against, using posters like this one to get the message across. Shahn's succinct, visual statement is superb. The foreshortened muscular arm with its powerful worker's hand combines with the message to make a compelling command for action.

5. Silent Night. 1949. 12¼″ × 18⅜″. Serigraph in black. The careful lettering on the music in this print is an example of Shahn's love of older, classical forms. Shahn made at least two different drawings on this theme. He and his wife Bernarda used this print as a Christmas card, apparently for the holiday season of 1949.

6. Silent Music. 1950. 25¼″ × 38⅝″. Serigraph in black. This is undoubtedly the best-known of Shahn's prints, thanks in large part to the success that followed the first appearance of a version called *The Empty Studio*, one of a series of drawings commissioned in 1948 by William Golden of the Columbia Broadcasting System to illustrate a four-page folder promoting the radio network. *The Empty Studio* was reproduced on two pages above a printed message. Left of the fold was the title "The empty studio . . ." and on the right-hand page were the words which inspired the drawing: "No voice is heard now. The music is still. The studio audience has gone home./But the *work* of the broadcast has just begun. All through the week . . . *between* broadcasts . . . /people everywhere are buying the things this program has asked them to buy. . . ." Selden Rodman, art critic and collector, recalls Shahn's laughing comment about *Silent Music*: "Don't you know the real title of that one? No? Well, it's 'Local 802 on Strike!'" In other comments on the absence of musicians, Shahn explained that "the emotion conveyed by great symphonic music happens to be expressed in semi-mathematical acoustical intervals and this cannot be transposed in terms of ninety portraits or caricatures of performers." This serigraph was the first one planned by Shahn as a limited edition.

7. Where There Is a Book There Is No Sword. 1950. 21″ × 14½″. Serigraph in black. The beast is the result of a number of drawings with which Shahn experimented as he struggled to portray the horror he felt at the death of the four Hickman children in a Chicago ghetto fire in the late 1940s. Out of one group of sketches emerged a lion-like head. "I made many drawings, each drawing approaching more nearly some inner figure of primitive terror which I was seeking to capture. I was beginning to become most familiar with this beast-head. . . . I incorporated the highly formalized flames from the Hickman story as a terrible wreath about its head. . . . In the beast . . . I recognized a number of creatures. . . . The stare of an abnormal cat . . . that had devoured its own young. . . . The wolf . . . the most paralyzingly dreadful of beasts." Shahn returned repeatedly to the image of the fire-beast. Morris Bressler, Shahn's friend and neighbor, recalls a conversation he had with Shahn during the 1948 Henry Wallace campaign in which he quoted to the artist this old and popular Talmudic saying: The man of the sword/Is not a man of the book. Shahn asked to see it written in Aramaic. A few days later, he had combined the quotation, written in old Aramaic script, with the fire-beast.

8. Watch out for The Man on a White Horse! 1952. 14⅜″ × 10″. Photo-offset in black. Published by Volunteers for Stevenson, Roosevelt, N.J. At times, Shahn's brush revealed a biting, satirical side of his nature. This cartoon treats the Republican candidate for president, General Eisenhower, unkindly, to be sure, but the location of the vice-presidential candidate's name on the horse is even less

flattering. The horse itself, a far cry from a high-stepping military charger, more closely resembles the wooden merry-go-round variety. Although Shahn by this time had turned from what he called "social realism" to a more "personal realism" in his art, he by no means had isolated himself from society; rather, he relished being in the mainstream.

9. Ben Shahn Fogg Art Museum. 1956. 11″ × 9″. Photo-offset with hand coloring. This poster depicting the artist was issued in connection with the Fogg Art Museum's exhibition "The Art of Ben Shahn," a major exhibition that was arranged during Shahn's term (1956–57) as Charles Eliot Norton Professor at Harvard University. One of the men who helped mount the show, George Cohen, has recalled that it was "an exacting job," particularly in regard to preparing the posters. The printed portion included the circles on the palette, to which Shahn, Cohen, and others later applied the gouache colors by hand.

10. Einstein. 1950. 17⅞″ × 12″. Photo-offset in black. Shahn's drawing of the late Albert Einstein was used to illustrate the great scientist's article "On the Generalized Theory of Gravitation" in the April, 1950, edition of *Scientific American*. The image in this reproduction is identical to the drawing, now in a private collection.

11. Abraham Lincoln. 1955. 16⅛″ × 12¼″. Photo-offset in black. The sure brush strokes delineating the facial features in this strong and sympathetic portrait of Abraham Lincoln have the unmistakable characteristics of a work by Shahn. The portrait was commissioned by Charles Pfizer & Co., the pharmaceutical firm.

12. Alphabet of Creation. 1957. 38¾″ × 27¼″. Serigraph in black. Shahn's "alphabet" is an extremely effective and original arrangement of calligraphic forms, incorporating the 22 letters of the Hebrew alphabet which Shahn designed for his 1954 book, *The Alphabet of Creation.* In *Love and Joy About Letters,* Shahn talks about his lifelong interest in calligraphy, which began with his apprenticeship to a lithographer and subsequently was expressed in many of his drawings and paintings: "All letters, of course, were once pictures. Can one still discern the head of the ox in Aleph and Alpha and A? Can one see the house in Beth and Beta and in B? Why does every Greek letter so resemble the Hebrew equivalent in its name—was that its origin? Have they a common origin? All this while one works painstakingly, almost painfully, the lip fixed between the teeth, contemplating, wondering about the mysteries, the mystic relationship of the letters growing under one's hands." When Shahn with his wife Bernarda visited Japan in 1960, he acquired a chop, or seal, made from a modified version of his "alphabet." It produced a charming design when stamped in the traditional oriental orange-red color. Before placing it on a print, Shahn would pause a few moments, considering the design as a whole, before choosing the correct spot.

13. Passion of Sacco and Vanzetti. 1958. 30½″ × 22⅝″. Serigraph in black with brown text. Nicola Sacco and Bartolomeo Vanzetti attracted attention by their "radical" strike activities and their flight to Mexico in 1917 to evade the draft. In 1920, they were arrested and charged with the murder of a Massachusetts paymaster. Although witnesses claimed that the two were miles away at the time, and although there were other weaknesses in the case, Sacco and Vanzetti were found guilty and were executed on August 23, 1927. In 1930, reflecting upon this tragedy, Shahn began a series of 23 gouache paintings based on the trial. This series and earlier paintings, depicting the main participants in the Dreyfus case, marked Shahn's emergence from traditional painting to a more personal style. A 1932 exhibition of the Sacco and Vanzetti works created quite a stir. "Mr. Shahn is henceforth someone to be reckoned with," wrote a reviewer. Three serigraphs produced in 1958 testify to Shahn's continuing interest in this highly emotional issue. This print combines the portraits and text which are the components of all three. The text is based on a transcription made during the trial by reporter Philip Stong. The spelling, grammar, and the folk alphabet have been combined by Shahn to immortalize the words of Bartolomeo Vanzetti. One of the recurrent themes which Shahn regarded as characteristic of his work, the "indestructability [sic] of the spirit of man," is poignantly reflected in this portrayal of two condemned men.

14. Lute and Molecule, No. 2. 1958. 25¼″ × 38½″. Serigraph in black with hand coloring; white version. Compared with another of this theme, a brown version, this print has a light and airy feeling. In both, the vibrating, calligraphic forms on the soundboard fairly dance.

15. Wheat Field. 1958. 27⅜″ × 40⅝″. Serigraph in black with hand coloring. The clear sky in this print allows for full appreciation of the delicacy and beauty of the tall and slender stalks of wheat, their heads bowing with the weight of ripe grain. The touches of color contribute to make this one of the most appealing of Shahn's hand-colored serigraphs. In his *Ecclesiastes,* Shahn included an illustration of a sensitively colored wheat field. A wheat field is also a major element in other prints.

16. Cat's Cradle. 1959. 20½″ × 29⅛″. Serigraph in black. I have only seen two examples of this print, and both were printed on cream-colored composition board. Shahn applied the chop and signed his name on this example in his studio, in 1968. Shahn rarely signed an entire edition at one time. When preparing prints for sale or exhibition, he applied the missing signatures as he selected the prints.

17. Trees. 1960s. 4⅜″ × 6¼″. Letterpress in black. In this winter scene the stark, black forms outlined against the clear paper give an immediate impression of cold, leafless trees emerging from deep snow. Bernarda Shahn recalls that she and her husband used this small holiday card in the 1960s.

18. Walden School Art Exhibition. 1960s. 10⅞″ × 14⅝″. Photo-offset in colors. A note adjacent to the signature indicates that the design for this poster was taken from a drawing. The single image in the drawing, which was part of the exhibition, was multiplied in colors for the

poster. The image closely resembles one of a series commissioned by CBS for the 1956 film *Ambassador Satchmo*.

19. Who is God? 1960s. 7″ × 12″. Photo-offset in black. Tony Schwartz asked Shahn to design this holiday card to be distributed by his firm along with a small phonograph recording called "Christmas in New York." The recording included the voices of various children expressing their thoughts on Christmas. Shahn combined their phrases to complement his image of a soulful young boy pondering the eternal question, "Who is God?" In lettering this card Shahn again used the style that had grown out of his interest in what he called a "folk alphabet." Usually, as in this example, his lettering is an integrated part of the composition, of equal importance to the image.

20. Poet. 1960. 40⅝″ × 27½″. Serigraph in shades of brown. Shahn seems to have given his brush free range in creating the poet's wealth of hair. The fine and intricate lines, printed in light brown, contrast with the heavy and darker brown of the fiercely furrowed brows and wide-open eyes, giving the composition and interesting balance of opposites. The impression is of a man aroused and deeply concerned. As one studies the apparently random lines of the hair, a leafy stem emerges at the side. Could it be laurel ascending to the crown of the poet?

21. Psalm 133. 1960. 20½″ × 26½″. Serigraph in colors. In choosing the subject for this print, Shahn described his motivation as a "hopeless pleading for people to get together." Here coupled with the doves, symbols of peace, Psalm 133 is a beautiful poem on the theme of brotherly love. By presenting one dark dove and one white, Shahn may have tried to relate the psalm's message to the struggle for racial harmony.

22. Blind Botanist. 1961. 39⅞″ × 25⅜″. Serigraph in black with green calligraphy. The botanist, a theme that intrigued Shahn, is sparsely outlined, the few details centered on hands and face. A furrowed brow emphasizes the emptiness of blind eyes. The thorny plant is a maze of twisted branches, and its dark fibrous roots draw attention to the bottom of the composition, where the calligraphy, a quote from Robert Hooke's *Micrographia* of 1665, conforms to the curve of the botanist's arm. Handwritten on the screen and printed in a soft green color, the calligraphy does not compete with the elongated botanist and his thorny bush.

23. Boston Arts Festival. 1962. 44″ × 27⅞″. Serigraph in black, gray and red. This is one of Shahn's many variations on the theme of balancing acrobats. Here the tumbler balances on his head atop a thin pole. In positioning the arms, Shahn introduced an eerie sense of momentary loss of balance.

24. Ben Shahn Galleria Nazionale d'Arte Moderna. 1962. 39¼″ × 27⅜″. Photo-offset in black and red. Printed by Istituto Grafico Tiberino, Roma. Some years ago The Museum of Modern Art, N.Y., organized a comprehensive exhibition, *The Works of Ben Shahn,* which was circulated abroad by the museum's International Program. To those familiar with Shahn's work, the hands seen here are so characteristic that the identification, lettered across them, seems redundant.

25. Ben Shahn Graphik Baden-Baden. 1962. 33⅞″ × 24″. Photo-offset in black. According to his wife Bernarda, Shahn often printed proofs on whatever paper was closest at hand. In this poster, newsprint became a part of the design, whether or not this was the original intent. The newspaper is a double-page spread of a *New York Times* want-ad section, but there does not seem to be any special significance attached to the choice. The quotation is from *Passion of Sacco and Vanzetti.*

26. Lincoln Center for the Performing Arts. 1962. 46″ × 30″. Photo-offset in black and serigraph in colors. Shahn's love of music, musicians and instruments, modern as well as ancient, is reflected in his many works dealing with musical themes. The graceful swirls of the angel organist's feathery wings and his trancelike, ecstatic posture have that eye-arresting quality so important in poster art. This poster, announcing the opening of Philharmonic Hall in the new Lincoln Center for the Performing Arts in New York City, was the first to be commissioned by the Center.

27. Martha Graham Dance Company. 1963. 30″ × 20⅛″. Photo-offset in black, green and gray. The broadly brushed black script printed over the bright green tree simply and strongly proclaims the name of the famous American dancer.

28. Maximus of Tyre. 1963. 36″ × 26¼″. Serigraph in black with hand coloring. The image in this print is one that Shahn frequently used in original works and as reproductions in books: the authoritative figure with the upraised arm. Stephen S. Kayser speaks of "leitmotifs like the 'mighty hand' and the 'outstretched arm,' the powerful symbols of Divine liberation." The quotation chosen by Shahn for this print was a favorite of his. Shahn lettered and illustrated a book in 1964, *Maximus of Tyre,* Spiral Press, which is a rich elaboration of the theme.

29. Warsaw 1943. 1963. 36¾″ × 28⅛″. Serigraph in black with brown calligraphy. It was the tragedy of the Warsaw Ghetto—the incredible courage of the Warsaw Jews and the futility of their resistance—that Shahn commemorated with this print in 1963. The Nazis could announce, as they did in 1943, that Warsaw was at last free of Jews. But the tortured hands in Shahn's print remain to remind us of these acts of barbarism. Shahn, a man of great compassion, whose abhorrence of violence was well known in his lifetime, chose to accompany the anguished figure with the thirteenth-century prayer he had used earlier in *Martyrology.*

30. O Lord our Father. 1964. 21¾″ × 16⅝″. Letterpress in black. The drawing of this crowd of faceless men, supported by crutches and aided by canes, first appeared in the 1956 book, *Thirteen Poems by Wilfred Owen.* On one of my visits to Shahn's studio early in 1964, he showed me the original drawing, explaining that he was receiving contributions from those who sympathized with its sentiments, and that when he collected enough money he intended to have the drawing printed full-page in *The New*

York Times. This he subsequently did. The ad appeared in the *Times* on May 29, 1966.

31. Say No to the No-Sayer. 1964. 28¼″ × 22″. Photo-offset in black and red. To the voters in the 1964 presidential campaign, this head was easily recognized as that of Senator Barry Goldwater. The message on this poster lists the issues that the Senator had voted against, but which Shahn considered of great importance to the country. The word "against" is printed in red, isolated and emphasized by its color; the poster is otherwise executed in black ink.

32. Spoleto Festival dei Due Mondi. 1965. 39¼″ × 27⅝″. Photo-offset in colors. The expressive quality of this gaily attired promoter of the festival is characteristic of Shahn's work of these years. The delicately drawn fingers support the sign that bears the announcement printed in Shahn's superb calligraphy.

33. Maimonides with Calligraphy. 1965. 14½″ × 10½″. Wood-engraving in black and sepia. Printed by Stefan Martin. The turbaned and bearded man in this portrait is Maimonides, the twelfth-century Jewish philosopher and master of rabbinical literature. The Hebrew inscription is from Ecclesiastes 1:1–2 and reads, in the King James Version: "The words of the Preacher, the son of David,/king in Jerusalem./Vanity of vanities, saith the Preacher,/vanities of vanities; all *is* vanity."

34. Gandhi. 1965. 40⅛″ × 26″. Serigraph in black. It is not surprising that Shahn wanted to pay his respects to this great man, the prophet of nonviolence. Through the magic of his inimitable brush line, Shahn has imbued the seated Gandhi with a quiet grandeur. The figure commands attention. The curved line of the head, the wrinkles of the brow, lead directly to the steady gaze of the eyes. The thin legs, abnormally small feet, and the bony hand emphasize the elongated torso of the figure, seated in the cross-legged position of meditation. The erect back suggests controlled strength and perhaps, by implication, a moral and ethical strength as well.

35. I Think Continually of Those Who Were Truly Great. 1965. 26½″ × 20¾″. Serigraph in brown and white with hand wash and hand coloring. The blurred contours in this print suggest the softness and delicacy of the dove, and the spread feathers of wings and tail give an illusion of suspended flight. Shahn used the white of the paper for the dove, defining the form with a gray wash, which he applied by hand in varying densities. He painted the eye black and ingeniously created the bright orange beak by dipping a pointed eraser in paint and pressing it to the paper. Shahn intended this print as a tribute to ten civil-rights martyrs. Written in a childlike hand across the heavens and around the dove of peace, the ghostly names contrast in form and color with the more formally lettered title and text. Perhaps the handwriting is meant to signify the youth and innocence of the victims.

36. And Mine Eyes a Fountain of Tears. 1965. 23⅞″ × 17⅞″. Serigraph in red with black Hebrew calligraphy. In presenting this subject, Shahn used a somewhat heavier brush stroke than usual. It is similar to that he would later use in such prints as *Skowhegan*. The exquisitely balanced head of the woman and the eye left empty impart a feeling of boundless suffering. The Hebraic calligraphy is in keeping with the classic dignity of this print. Shahn's quotation in translation is from Jeremiah 9:1: "Oh that my head were waters, and mine eyes a fountain of tears, that I might weep day and night for the slain of the daughter of my people!"

37. Frederick Douglass, II. 1965. 22″ × 16¾″. Photo-silkscreen in black and raw umber. Published by the Museum of African Art, Frederick Douglass Institute, Washington, D.C. In 1965 Shahn executed a portfolio of four portraits of Frederick Douglass depicting this great historic leader, for whom the artist had great admiration, in the different stages of his life. Beardless, but with a generous moustache, Douglass is here revealed as a confident man of the world. An active supporter of the struggles of the Negro minority in the North and South, Shahn allowed the portfolio to be reproduced and sold for the benefit of the Frederick Douglass Institute of Negro Arts and History.

38. James Chaney. 1965. 21⅞″ × 16¾″. Photo-silkscreen in black and umber. When three young civil-rights workers were murdered in Mississippi in the summer of 1964, Shahn reacted with characteristic compassion and energy. A portfolio of the three martyrs, the Human Relations Portfolio, was his way of expressing his shock and anger, and just as importantly, a means of furthering the cause for which they had died. The proceeds from its sales benefited the Human Relations Council of Greater New Haven, Connecticut. This portrait of the 21-year-old Chaney shows him with a slight moustache. The eyes and frozen expression give an impression of impending doom.

39. Andrew Goodman. 1965. 21⅞″ × 16¾″. Photo-silkscreen in black and umber. In this, another portrait from the Human Relations Portfolio, Shahn chose to stress the youth of the 20-year-old student.

40. Thou Shalt Not Stand Idly By. 1965. 22″ × 16¾″. Photo-offset lithograph in black and burnt sienna. Published by the Lawyers Constitutional Defense Committee of the American Civil Liberties Union, New York. "I hate injustice. I guess that's about the only thing I really do hate," Shahn once remarked. The nine works that comprise the Nine Drawings Portfolio testify to his deep personal commitment to the cause of social justice, and reflect what he felt to be the "realities of human relationships, of man's emotional and spiritual life, the reality of political decency, of social injustice . . . which affect men's lives, personality, and sensitivity." The portfolio was published and distributed as part of a fund-raising effort. All through his life Shahn regarded the hands as major tools of human expression. Here he used the subject of hands coupled with an admonition to action, bearing witness to his belief in the cause of racial justice. The title is taken from Leviticus 19:16: "Thou shalt not go up and down as a talebearer among thy people: neither shalt thou stand idly by the blood of thy neighbor."

41. We Shall Overcome. 1965. 22″ × 16¾″. Photo-offset lithograph in black and burnt sienna. Published by the Lawyers Constitutional Defense Committee of the American Civil Liberties Union, New York. In this work from the Nine Drawings Portfolio, the determined features of this handsome young man and the affirmation "we shall overcome" suggest the strength and confidence of the 1960s civil-rights movement.

42. Skowhegan. 1965. 16¼″ × 12⅛″. Wood-engraving in black. Engraved and printed by Stefan Martin. Shahn made the drawing for this print for a benefit exhibition for the Skowhegan School and the Lenox Hill Hospital. Shahn entrusted his friend Martin with the engraving and printing of the *Skowhegan* edition. Following Shahn's drawing, Martin cut the block and pulled the prints in his Roosevelt studio.

43. Alphabet and Warsaw. 1966. 35″ × 23½″. Serigraph in black with watercolor and conté crayon rubbing. This unique print combines two previous images. Using a cardboard cutout of *Alphabet of Creation* (plate 12), Shahn applied the conté crayon rubbing over the printed image of *Warsaw 1943* (plate 29). The opaque rubbing obscures much of the figure. Shahn left exposed what he considered to be the main point of interest: the clenched fists.

44. Andante. 1966. 18½″ × 23¾″. Serigraph in black. In September, 1966, the Olivetti Company commissioned Shahn to do a serigraph of which the company distributed copies as holiday gifts. Contrasting with the complete lack of detail in face and clothing, the elaborately outlined shoelaces draw attention to the adventure on wheels.

45. Credo. 1966. 26½″ × 20⅞″. Serigraph in black and blue. Several prints and drawings reflect Shahn's interest in the writings of Martin Luther. Here Shahn manipulates several images and calligraphy. The text is taken from Luther's testimony at the Diet of Worms, 1521. The concept presented in Luther's manifesto—that the individual conscience is the highest moral authority—is still heatedly debated. For Shahn it was as important an affirmation as his statements of political conviction. The fire-beast had been created previously (plate 7). The dramatic association of the beast with Martin Luther's great statement of moral conviction is curious. Is Shahn perhaps implying the terror of fire and the burning at the stake that threatened Luther? The very fact that Shahn perceived this statement as a credo and one with significance in his lifetime, illuminates our understanding of Shahn, the philosopher-artist.

46. Levana. 1966. 30″ × 22⅛″. Lithograph in black. The *Levana* in this print dates back to the 1931 portfolio of the same name, where exactly the same image is found in gold outline on the cover. It is vastly different in style from the lithographs of that series. Levana, a Roman goddess of childbirth, held Shahn's interest over a span of many years.

47. Ecclesiastes. 1966. 26½″ × 20½″. Serigraph in black with sepia calligraphy. Three human and three beast heads merge in this print into one complex image representing the three ages of man. The quotation, printed in Hebrew calligraphy, is from Ecclesiastes 11:9: "Rejoice, O young man, in thy youth;/and let thy heart cheer thee in the days of thy youth,/and walk in the ways of thine heart,/and in the sight of thine eyes:/but know thou, that for all these things/ God will bring thee into judgement."

48. Martin Luther King. 1966. 25″ × 20⅛″. Wood-engraving in black. Published by the International Graphic Arts Society, Inc., New York. When faced with the task of presenting Martin Luther King, Shahn chose to portray him as a strong and dramatic orator. Taken from the Shahn drawing for a cover of *Time* magazine of March 19, 1965, this wood-engraving by Stefan Martin is a work of excellent craftsmanship.

49. Praise Him with Psaltery and Harp. 1966. 24″ × 24¾″. Serigraph in black. Although this print is devoid of calligraphy, it was inspired by Psalm 150:3, "Praise him with the sound of the trumpet: praise him with the psaltery and harp." There is a timeless beauty in this classically robed and seated figure, holding an ancient cithara in her lap. The lines indicating the folds of the garment lead to the gracefully elongated hands. This serigraph was commissioned by the Benrus Watch Company.

50. Ecclesiastes Woman. 1967. 15⅛″ × 11⅛″. Lithograph in red. This print and *Ecclesiastes Man* are based on drawings Shahn made for his 1967 handwritten and illustrated book *Ecclesiastes*. They are characteristic of the work of his late period. Here the curving lines masterfully define the female figure.

51. Ecclesiastes Man. 1967. 15⅛″ × 11⅛″. Lithograph in red. The sparse figure against the empty background seems to epitomize the uniqueness and loneliness of man.

52. Ben Shahn Santa Barbara Museum of Art. 1967. 19⅝″ × 10¾″. Photo-offset in colors. This poster was reproduced from a 1958 watercolor, *Conversations*, now in the Whitney Museum of American Art, N.Y. The presence of the masks is indicative of Shahn's continued interest in the many faces of man.

53. Many Men. 1968. 22½″ × 17¾″. Lithograph in black and gray. Printed by Atelier Mourlot Ltd., New York. It was in Paris, in 1926, that Shahn first read Rainer Maria Rilke's novel *Notebooks of Malte Laurids Brigge*. He was just beginning to doubt his own traditional style of painting and was seeking for more personal expressions, when he found in Rilke the same searching, probing and slow emergence of forms characteristic of his own experience. Much later, retaining memories of these early impressions, Shahn again turned to Rilke's *Notebooks* for inspiration, choosing for the theme of his 1968 Rilke Portfolio a section that applied to both artists, the poet and the painter: "For the sake of a single verse, one must see many cities, men and things, one must know the animals, one must feel how the birds fly and know the gesture with which the little flowers open in the morning. . . . One must have memories of many nights of love, . . . But one must also have been beside the dying, must have sat beside the dead. . . . not till then can it happen that in a most rare hour the first

word of a verse arises in their midst and goes forth from them." The anonymous group of men depicted here, tall, narrow and faceless, their outlines blurred, automatically brings to mind the phrase coined by Shahn's contemporary David Riesman in the title of his book *The Lonely Crowd*. The only sign of tension in the smoothly moving group is the one detailed hand, dark against the white background, with fingers stiffly spread.

54. Many Things. 1968. 22½″ × 17¾″. Lithograph in black. Printed by Atelier Mourlot Ltd., New York. This work from the Rilke Portfolio is a variation of the 1957 serigraph *Scientist*.

55. The gestures of the little flowers. 1968. 22½″ × 17⅝″. In this selection from the Rilke Portfolio, Shahn's love for wild flowers, expressed in many of his works through the years, is sensitively demonstrated.

56. Memories of Many Nights of Love. 1968. 22½″ × 17¾″. Lithograph in black. Printed by Atelier Mourlot Ltd., New York. Shahn's ability to express emotion in hands is wonderfully affirmed in this print from the Rilke Portfolio. The hands of the lover tenderly holding the beloved's head, and her equally gentle hands, responding, are sensitive symbols of affection and intimacy.

57. Beside the Dead. 1968. 22½″ × 17¾″. Lithograph in black and gray. Printed by Atelier Mourlot Ltd., New York. The helpless attitude of this man in deep sorrow contrasts with his size and physical strength. In this composition from the Rilke Portfolio, Shahn again employed the hand as a major expressive component, reminiscent of his moving image in *Warsaw 1943*. Black and gray give density to the figure. The outline and details are overprinted in black. Black and gray dots of color extend out to all margins.

58. The First Word of Verse Arises. 1968. 22½″ × 17¾″. Lithograph in black. Printed by Atelier Mourlot Ltd., New York. Here the hand is seen as man's supreme tool. How fitting to end the Rilke Portfolio with a drawing of the artist's hand, confident fingers in control of the brush transferring to paper the images born in his fruitful mind!

59. Birds Over the City. 1968. 29″ × 21⅝″. Lithograph in colors. Printed by Atelier Mourlot Ltd., New York. This is an interesting and effective combination of Shahn motifs. The building and its colors are similar to *Byzantine Memory*, the man's features are essentially those of the frontispiece to the Rilke Portfolio, and the flying doves are similar in feeling to those in Louis Untermeyer's *Love Sonnets*. In this print, the gray and softly rounded doves seem to be floating in the air, in contrast to the heaviness of the other two major elements, which are outlined in black. The varying sizes of the doves give an illusion of depth to the white background.

60. Culture. 1968. 26½″ × 20¾″. Serigraph in black with brown calligraphy. Shahn made several satirical drawings indicating his disdain for academic verbosity and pomposity. The elegantly gowned "bird" in this print is wearing what appears to be a traditional scholar's robe adorned with an erminelike collar. The line connecting the empty eyes suggests a pair of wire spectacles. The hands, always conveyors of Shahn's thoughts, are piously folded, quite befitting someone who is about to deliver a learned definition of culture. The satirical quotation is from "The Nature of Cultural Things" by Marvin Harris.

61. Headstand on Tricycle. 1968. 36¼″ × 24⅜″. Lithograph in black. Published by Kennedy Graphics, Inc., New York. Printed by Atelier Mourlot Ltd., New York. This image of a boy doing a headstand on a tricycle is essentially that in the serigraph *Boy on Tricycle*, which Shahn distributed as a Christmas card in 1947.

62. Oppenheimer. 1970. 40¼″ × 28⅝″. Photo-offset in colors. The reproduction of Shahn's 1954 brush drawing of J. Robert Oppenheimer was one of three posters announcing a major Shahn retrospective exhibition in Japan.

63. Owl No. 1. 1968. 26⅜″ × 20⅜″. Lithograph in black. Printed by Atelier Mourlot Ltd., New York. Channel 13, a nonprofit, educational television station serving the New York–New Jersey area, was one of the many institutions and causes to which Shahn donated his time and talents. Shahn created a design based on Channel 13's emblem, an owl. With a minimum use of lines, he captured the principal characteristics of a horned owl: the widely opened eyes, the hooked beak, the powerful yet softly rounded body. When examined, the squiggles filling in the plumage turn into "Channel Thirteen."

64. Epis. 1969. 27⅛″ × 41⅛″. Lithograph in black. Published by Kennedy Graphics, Inc., New York. Printed by Mourlot Graphics Ltd., New York. The graceful swirls of lines representing clouds in this print were preceded by Shahn's development of formalized flames. Jacques Mourlot told me that it was he who proposed the French name *Epis*, meaning heads of grain.

65. Man Playing Cithara. 1969–70. 40⅝″ × 25⅞″. Lithograph in black. Published by Kennedy Graphics, Inc., New York. Printed by Mourlot Graphics Ltd., New York. In the late sixties, Mr. and Mrs. Robert H. Smith and Mr. and Mrs. Robert P. Kogod invited Shahn to create a mosaic mural for a Jewish community center in Rockville, Md. They gave him free rein in selection of theme, design, and installation of the mural. Shahn responded enthusiastically and prepared a series of magnificent drawings of musicians with ancient instruments, inspired by the exultant lines in Psalm 150. Unfortunately, the plans for the mural never went beyond the drawing stage because of Shahn's untimely death in 1969. However, the executors of the Ben Shahn Estate authorized the posthumous publication of a series of eight lithographs taken from the mural drawings. The lithographs, together with the Hallelujah Suite, add an important concluding dimension to the graphic work of Ben Shahn. In this print there is an almost mysterious unity of musician and instrument. In the outline of his hair and clothing the deeply attentive musician seems to reflect the very vibrations of the instrument.

66. Man Sounding Horn. 1969–70. 20⅛″ × 25½″. Lithograph in black. Published by Kennedy Graphics, Inc., New York. Printed by Mourlot Graphics Ltd., New York. The heavily gowned and turbaned man from the Psalm 150 series is playing a large curved horn with finger holes, of the type found in Eastern Europe and Persia. In another version, *Man Sounding Shofar*, included in the Hallelujah Suite, the horn is shown without finger holes and therefore is more like the old Hebrew shofar.

67. Hebrew Hallelujah. 1970–71. 16¼″ × 35″. Lithograph in black. Published by Kennedy Graphics, Inc., New York. Printed by Mourlot Graphics Ltd., New York. Just prior to his death, Ben Shahn completed all 50 drawings for the Hallelujah Suite and arranged them in a mock-up, indicating in detail how he wished to have them produced and assembled. In preparing the suite, Shahn used many of the same motifs as in the drawings for the unfinished mural design illustrating Psalm 150. However, most of the Hallelujah Suite drawings differ markedly from the earlier versions and are particularly important because they represent Shahn's last work. Bernarda Bryson Shahn has said of her husband's return to religious themes, "During the later years of Ben's life there was a certain resurgence of religious imagery in his work. It seemed to me that, since he had rather emphatically cast off his religious ties and traditions during his youth, he could now return to them freely with a fresh eye, and without the sense of moral burden and entrapment that they once held for him." Here, in his rendering of the Hebrew title, Shahn arranged the characters into a handsome design, which reminds the viewer of his deep and lasting love affair with calligraphy.

68. Dancing Virgin. 1970–71. 16½″ × 35″. Lithograph in black and yellow. Published by Kennedy Graphics, Inc., New York. Printed by Mourlot Graphics Ltd., New York. This young maiden in the Hallelujah Suite may have put the timbrel aside for a moment while she lifts her gossamery shawl and whirls in her dance.

69. Young Man Playing Double Oboe. 1970–71. 16¼″ × 35″. Lithograph in black and yellow. Published by Kennedy Graphics, Inc., New York. Printed by Mourlot Graphics Ltd., New York. More than most images in the Hallelujah Suite, this oboist conveys the charm and grace with which Shahn endowed his musicians in the drawings for his unfinished mural design.

70. English Hallelujah. 1970–71. 16¼″ × 35″. Published by Kennedy Graphics, Inc., New York. The design for the cover of the Hallelujah Suite, illustrated here, was taken from the English title page, which was lithographically printed in black by Mourlot without Shahn's signature.

Color Plates

I. We Demand the National Textile Act. 1935. 41⅛″ × 27½″. Wood-engraving and letterpress in colors. Printed by the Globe Poster Corp., Baltimore, Md. In all likelihood this example of an apparently never-published poster is unique. Bernarda Shahn remembers the difficulty she and Shahn had in trying to locate an old-fashioned wood-engraver to cut the blocks for this poster. Inquiries finally brought forth the name of a craftsman in Baltimore who made posters in the old manner. During this period Shahn experimented with the use of old type to print messages on his posters. Here, the word "Organize," slightly undulating in the black smoke against the azure sky, calls out for action. The message is reinforced by the banners being paraded beneath the empty windows of a textile mill.

II. Organize? With 1,250000 Workers Backing Us. Late 1930s. 40″ × 29⅞″. Original painting for poster. The painting makes a forthright and instant impression, a basic requirement for poster art. The worker has been given a particular sense of alertness by the white applied to the eyes around the irises. Shahn was capable of a great range of expression in his treatment of hands. Here they are dominant and indicative of the worker's strength. One, however, is partially obscured by the text. The protective glasses are not made a point of interest in this poster, as they are in plate VIII.

III. Steel Workers Organizing Committee. Late 1930s. 40″ × 29⅞″. Original painting for poster. This is the third of three original poster paintings (plate II) that Shahn designed to further union organizing activities. All feature a strongly masculine worker, exuding an air of confidence, and in all the message is "organize." None, however, were printed as posters. They were rejected by one high union leader because the faces and figures were "too ugly to appeal to workers."

IV. Seward Park. 1936. 15¾″ × 22¾″. Lithograph in colors. *Seward Park* follows closely the style of Shahn's paintings of this period. It reflects Shahn's lifelong compassion for the "little" people who are the first to suffer in a depression. Jobless wage earners, like these, congregated on street corners and park benches in the 1930s, sharing tales of their misfortunes. Shahn has captured and preserved for us a mood of the times.

V. Prenatal Clinic. 1941. 15⅛″ × 23⅜″. Serigraph in colors. This, Shahn's second serigraph, is similar in technique to the other serigraphs of the 1940s, resembling his early paintings rather than his later line drawings. The two women in the setting of a dreary, sickly green waiting room indeed seem resigned to wait endlessly without any overt expression of objection. The thick undulating lines of the chairs enclose each patient and add to the impression of separation and loneliness. Shahn wrote, "My type of social painting makes people smile. The height of the reaction is when the emotions of anger, sympathy, and humor all work at the same time."

VI. We French workers warn you. 1942. 28¼″ × 39¾″. Photo-offset in colors. Published by War Production Headquarters, WPB, Washington, D.C. Printed by the U.S. Government Printing Office. This was Shahn's first war poster. He had been invited to work in the Office of War Information and later recalled the evolution of this poster:

"Our first round concerned a war poster. We sat together through a session or two and discussed what a war poster ought to be. It must be neither tricky nor smart. Agreed. The objective is too serious for smartness. It has to have dignity, grimness, urgency. . . . Once I had begun to put our poster idea into image form, I became acutely aware of fallacies in it that would never have emerged in a simple conversation. I played around a little with the idea, then came up with a new one, totally different, that was visual and not verbal."

VII. This is Nazi brutality. 1942. 37⅞″ × 28¼″. Photo-offset in color. Published by the U.S. Office of War Information, Washington, D.C. Printed by the U.S. Government Printing Office. The enormity of the Nazi crime against the citizens of Lidice, Czechoslovakia, was made known to the peoples of the world by official German announcement on June 11, 1942, the very day of the destruction of the village. Shahn let the chilling and brazen announcement tell its own story of inhumanity by printing it as if it were a ticker tape. The hooded prisoner, cornered and chained, has no means of escape from the finality of the horrifying message. The small section of blue sky above is dark and ominous and adds to the atmosphere of doom. But this unforgettable portrayal of a great tragedy was too vivid. The order of 40,000 copies for distribution by a Czechoslovakian-American organization was canceled by a civilian morale expert on the grounds that the message was too violent.

VIII. Welders, or, for full employment after the war. 1944. 29¾″ × 39⅜″. Lithograph in colors. Published by the CIO Political Action Committee. *Welders* was one of the posters Shahn designed while working for the Office of War Information. It was originally meant to serve the cause of antidiscrimination, but was rejected by the OWI. Selden Rodman points out that when *Welders* was subsequently issued by the CIO's Political Action Committee as a poster for the 1944 presidential campaign, it was well received. The worker's protective goggles are used with great effect, reflecting the blue of the sky and the outlines of what appear to be metal girders.

IX. Our Friend. 1944. 30″ × 39¾″. Lithograph in colors. Published by the National Citizens Political Action Committee. This poster was used in the hotly contested 1944 campaign in support of Franklin D. Roosevelt's fourth term. Shahn presented Roosevelt as a warmly sympathetic man, whose visage looms father-like above the crowd. As one examines the poster one is amazed at the number of symbols included in the composition: buttons for the AFL and the CIO, hat tickets for the Grand Lodge and the National Farm Bureau, a soldier's hat, the hands of the black and white races, the red and white stripes of the flag, and a child symbolizing the nation's future. The blue sky above is undoubtedly meant to be a good omen. Bernarda Shahn recalls that for the printing he left the original painting with an experienced lithographer. He was later amazed to discover that many of the details had been "improved" by the craftsman, who had detected "flaws" in Shahn's

original. However, Shahn considered the changes a joke on himself and refused to have the posters reprinted.

X. Years of Dust. 1936. 38″ × 24⅞″. Photo-offset in colors. Published by the Resettlement Administration. Printed by the U.S. Government Printing Office. In 1935, President Franklin D. Roosevelt created the Resettlement Administration to relocate destitute or low-income families from rural areas who had been stranded on barren, unproductive farms. At the time, erosion constituted a serious threat to the livelihood of great numbers of American farmers. Shahn, who had joined the government-sponsored Public Works of Art project in 1934, moved to the Resettlement Administration at its creation. Later he became one of a group of photographers who took some 270,000 photographs for the historic archives of the Farm Security Administration. During the period 1935–38 Shahn traveled through the South and Midwest, recording with his camera what he observed. He often returned to these photographs in his future work. There is no doubt that the vivid realism of this poster can be linked to these photographs. Shahn poignantly preserved the ominous, dust-laden clouds overhead, the barren and drifting soil surrounding the farm buildings, and the despair of the farmer and of the members of his family, who are just barely visible in the window. The original painting for the poster, without the text, is a 1936 gouache, *Dust*.

XI. From workers to farmers . . . Thanks! 1944. 39½″ × 29¾″. Photo-offset in colors. Published by the CIO Political Action Committee. In words and images this poster transmits the desire of the CIO to stress the common bond between worker and farmer as a means of achieving united political action. The former governor of Minnesota, Elmer A. Benson, referred to it as "one of the finest, strongest, and most effective gestures in the direction of goodwill made by labor toward farmers."

XII. Break Reaction's Grip. 1946. 41¼″ × 29″. Photo-offset in colors. Published by the CIO Political Action Committee. The one arm, dressed in coat sleeve and shirt cuff, with hand clasping a colorful map of the United States, represents the country's supposedly small, but powerful, reactionary forces. The poster suggests that, however strong, their power could be broken by the greater strength of the progressive forces, as represented by the larger, sleeveless arm. The command "Register . . . Vote" directs the way to remedial action.

XIII. Warning! Inflation means Depression. 1946. 41⅛″ × 27¾″. Photo-offset in colors. Published by the CIO Political Action Committee. The antecedent work of this poster is a 1943 tempera, *1943 A.D.* According to Bernarda Shahn, her husband did the painting during his stay in the Office of War Information, basing his work on a photograph of a farmer he had taken in the thirties while traveling through Arkansas. Engaging his subject in conversation, Shahn found out that the farmer estimated the value of his crop at one dollar and fifty cents. The farmer in the meantime had sent out his two boys with a shotgun and two shells to hunt for their dinner. In the poster, the

blue-shirted worker seems fearful and confused. The image of this troubled man lingers with the viewer and takes on a meaning far beyond the intent of the poster message. His facial expression suggests even deeper anxieties, which may be explained by the fact that the painted image first originated during a period in Shahn's life when the cruelties of the Second World War were foremost in his mind.

XIV. For all these rights we've just begun to fight. 1946. 28⅞″ × 38¼″. Lithograph in colors. Published by the CIO Political Action Committee. The militant posture of the orator in this poster attests to the CIO's championing of the various workers' rights enumerated on the colorful banners. This demonstration of union activity on behalf of the workers is coupled with the exhortative message "Register . . . Vote." According to Bernarda Shahn, the title is from a campaign speech of Franklin D. Roosevelt.

XV. We Want Peace. 1946. 41⅜″ × 26⅞″. Lithograph in colors. Published by the CIO Political Action Committee. The painting, *Hunger*, from which this poster derives, was painted and rejected during Shahn's sojourn with the Office of War Information. Later used by the CIO, it represents, perhaps, the best of Shahn's poster work. One cannot soon erase the memory of the hollow-eyed young face begging for peace. Nowhere is Shahn's genius for drawing more evident than in the thrust of the pleading hand. Its sickly pallor, matching that of the face and emphasized by the dark surrounding hues, tells of cruel deprivation and suffering. Regrettably, such sights had become familiar to our nation's soldiers, who were returning to their homes. Using the image of this child in the context of an election campaign seems to say that in a democracy the first step toward healing the ravages of war is to exercise one's right to vote.

XVI. A Good Man Is Hard to Find. 1948. 43⅝″ × 29¾″. Lithograph in colors. Published by the Progressive Party, New York City. In 1947, while discussing politics and the coming presidential election, Shahn remarked that "some work is going to have to be done about it." His intent was to present the two major parties as indistinguishable, with only the Progressive Party offering the voters a bid for change. In describing the 1948 watercolor, *Truman and Dewey*, which is the prototype of this poster, James Thrall Soby's words are much to the point: "The two candidates are ingeniously placed, . . . Details are handled with remarkable acuteness . . . Yet distortions and elisions are just as important, as in the aggrandizement of the two politicians' heads and the subtle way in which Truman's eyeglasses are left blank and the teeth of both men are frozen in bright evenness."

XVII. Phoenix. 1952. 30¾″ × 22⅜″. Serigraph in black with hand coloring. Shahn once pointed out that this serigraph "was the first of those prints that I made (and make) in which I painted in color and then printed an image in black, registering that with the colors painted. This was to obtain a richness that I felt could not be achieved through simple color printing. Although members of his family sometimes helped Shahn with the hand coloring, he did the *Phoenix* himself.

XVIII. Triple Dip. 1952. 34⅜″ × 27¼″. Serigraph in black with hand coloring. *Triple Dip* is one of the most colorful and appealing of Shahn's prints. As in *Phoenix*, the bright colors were first painted on the paper and then the black, serigraphic lines were overprinted. Shahn drew the image directly on the screen rather than tracing it from his prepared drawing. The partial outline of the boy's head, the look of complete concentration, the spindly legs and arms compared to the immense size of the ice-cream cone, all suggest that on a hot summer's day, a triple dip can be the most important thing in a child's world.

XIX. Pavillon Vendôme. 1954. 25¼″ × 17½″. Photo-offset in colors. Printed by Les Presses Artistiques. The building in this poster is related to two 1953 serigraphs *Paterson*. Shahn's work on this theme was inspired by a passage from the poem *Paterson*, by William Carlos Williams: "Without invention nothing is well/spaced/. . . the old will go on/repeating itself with recurring/deadliness. . . ." Shahn was fascinated by the dye patterns in the windows of the Paterson buildings. (Dye-making was an important industry in the town.) The bright colors reflect Shahn's impression of the variegated patterns in the windows.

XX. Mine Building. 1956. 22⅜″ × 30¾″. Serigraph in black with hand coloring. Shahn loved to experiment and to find different ways of expressing his artistic objective. Here the colors were applied first, in heavy layers, and then the black areas of the building were printed over the painted surface. To emphasize the colors, Shahn let the clear white paper show through in the upper center of the building. Shahn referred to the ambience of this work as resulting from "the dismal and sick beauty that accrues to those dark sooty mine buildings that had once been painted, and that take on strange efflorescences." It is related to the series of drawings Shahn made in 1947 when asked to illustrate a *Harper's* magazine article on a mine tragedy in Centralia, Illinois.

XXI. Supermarket. 1957. 25¼″ × 38⅝″. Serigraph in black with hand coloring. *Supermarket* is one of four motifs based on drawings that Shahn was commissioned to do for CBS. The colors, applied to selected sections of the baskets, result in a vibrancy that is lacking in the uncolored version.

XXII. Ballets U.S.A. 1959. 31⅜″ × 21⅜″. Serigraph in colors. Memories of the colorful dye patterns in the windows of Paterson, N.J. (plate XIX), lingered on with Shahn and were a frequent source of new and vibrant inspirations. In this poster the pulsating pigments parading behind the bold, black letters communicate a sense of the vital energy of a ballet performance.

XXIII. Stop H Bomb Tests. 1960s. 43⅜″ × 29⅝″. Serigraph in colors. The devil mask was a motif used by Shahn several times. Frightening, it suggests the evil consequences of hydrogen-bomb tests. The red "stop," overprinted on the black mask, acts as a barrier between the viewer and the mask, visually suggesting that the evil can be averted.

XXIV. All That Is Beautiful. 1965. 26″ × 38¾″. Serigraph in colors with hand coloring. Shahn's love of history and respect for the art of ancient civilizations are reflected in the text of this print. With the quotation from *Maximus of Tyre*, he has effectively juxtaposed the past and the present—a modern city being built through destruction of the old. Shahn describes the inspiration for this print as: "The pain of seeing the city I grew up in being covered by the new wave of concrete and glass." Living far from New York City, in rural Roosevelt, Ben Shahn created a work that reflects fond memories of his youth and poignantly portrays one of the dilemmas of the contemporary American scene.

XXV. Pleiades. 1960. 20½″ × 26½″. Serigraph in black and gray with hand coloring and gold leaf. The beautiful Hebrew calligraphy, boldly black against the white background, seems suspended against the outline of the Pleiades. The quotation is from the Book of Job 38:31–38, beginning "Canst thou bind the chains of the Pleiades, /Or loose the bands of Orion?" Regarding this print, Shahn once remarked that, "whereas scientists present their own theories regarding the origins of life, when Job was unconsoled he challenged God himself."

XXVI. Menorah. 1965. 26⅜″ × 20½″. Serigraph in black and gray with hand coloring and applied gold leaf. The printed portions of this serigraph are the black outline of the menorah and the gray lines which subdivide the multicolored areas. The various shades of blue and purple were painted in by Shahn at a later time. The colors differ somewhat from print to print, and the application of the gold leaf is not consistent. Consequently, each print is unique, and each carries with it Shahn's special affection. Made up of beautifully colored geometric shapes, the menorah was used by Shahn in other works.

XXVII. Decalogue. 1961. 40″ × 26¹⁄₁₆″. Serigraph in dark green and gray with hand coloring and applied gold leaf. The composition represents the two "tables" of commandments given to Moses on Mount Sinai. Shahn tenderly painted the flowers and applied the gold leaf by hand. The Hebrew letters are the initial letters of each commandment. The letter *lamed*, from the word *lo* ([thou shalt] not) appears seven times. Shahn avoided monotonous repetition by varying the letter's graceful, gazelle-like form.

XXVIII. Ben Shahn en amerikansk kommentar. 1963. 30¾″ × 19¾″. Photo-offset in colors. Printed by J. Olséns Litografiska Anstalt. This poster shows a color reproduction of Shahn's 1962 tempera portrait, *Dag Hammarskjöld*, commissioned and owned by the National Museum of Sweden. Shahn seated Hammarskjöld in his U.N. office. Overhead, an ominous atomic cloud threatens. On the desk, running across and spilling over a notepaper, Shahn lettered excerpts from Hammarskjöld's famous resolution concerning the role of the U.N. in relation to large and small nations. In a letter Shahn described how he approached his subject: "I did not like the notion of a conventional portrait. That seemed to me a commonplace. I wanted to express his loneliness and isolation. . . ."

XXIX. Ben Shahn January 18 to February 12. 1964. 28½″ × 22½″. Photo-offset in colors. Published and printed by the Shorewood Press, Inc., New York. This colorful and gay poster was taken from the 1955 watercolor, *Clown*, and probably designed for the one-man exhibition that marked Shahn's twenty-fifth year of association with The Downtown Gallery.

XXX. Ben Shahn Graphics Philadelphia Museum of Art. 1967. 45″ × 30⅛″. Photo-offset in colors. Published and printed by Posters Original Limited, New York. The forlorn-looking multisectional man is closely related to an elongated figure in Shahn's *The Biography of a Painting*. Both have the curious tendonlike delineation of the arms, the extension of the rib cage to the right arm, the uneven juxtaposition of the shoulders, and the segmented stomach. This unusual anatomical concept is found in other Shahn works.

XXXI. Flowering Brushes. 1968. 39⅝″ × 26⅝″. Lithograph in colors. Published by Kennedy Graphics, Inc., New York. Printed by Atelier Mourlot Ltd., New York. This is one of several versions Shahn developed of "the artist" absorbed in thought, his chin in one hand and a colorful paintbrush "bouquet" in the other. The Hebrew quotation is one of the famous sayings of Hillel the Elder. Morris Bressler's translation of the passage reads: "He [Hillel] used to say: If I am not for myself, who is for me?/ If I care only for myself, what am I? If not now, when?"

XXXII. McCarthy Peace. 1968. 38⅛″ × 23″. Photo-offset in colors. Published by Health Professions for McCarthy. Printed by Lincoln Graphics. New York. 1968 was another presidential election year and again Shahn responded to the political situation by supporting a candidate by means of his art. His choice, not surprising to those who knew his views on the Viet Nam war, was Senator Eugene McCarthy, who, as an opponent of the war, captured the energies and loyalties of many young persons. The dovelike bird with its colorful stripes brings to mind the equally striking serigraph *Phoenix*.

ALPHABETICAL LIST OF PLATES

All references are to plate numbers. Works are listed alphabetically by the first word of their titles. Color plates, indicated by a roman numeral, are to be found following black-and-white plate 6.

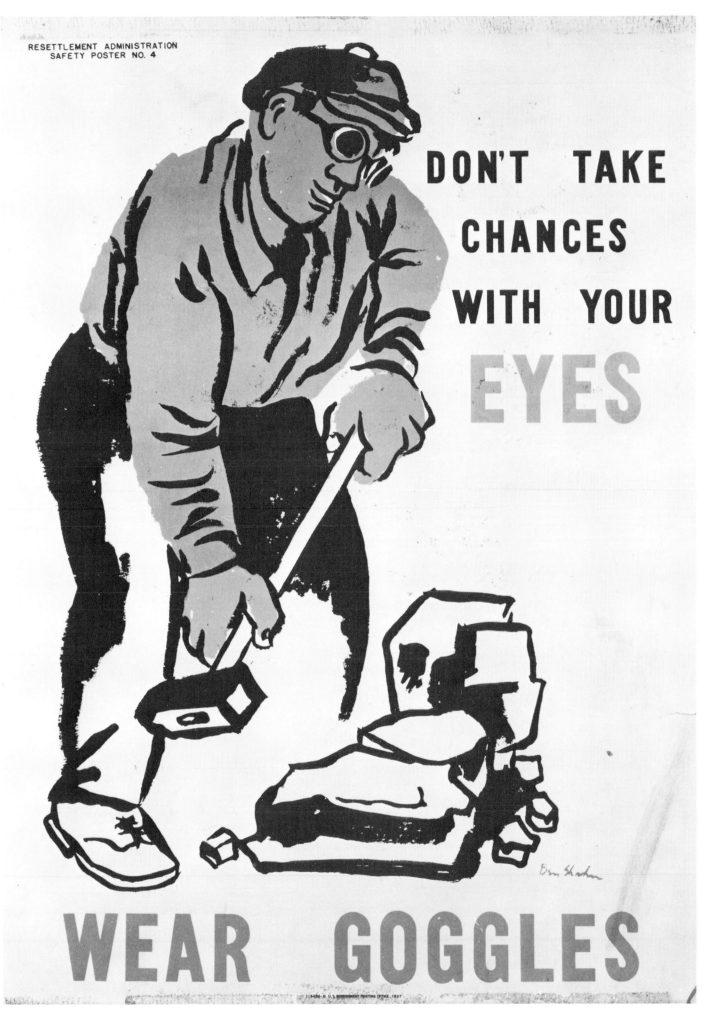

1. Wear Goggles. 1937. 20″ × 14″.

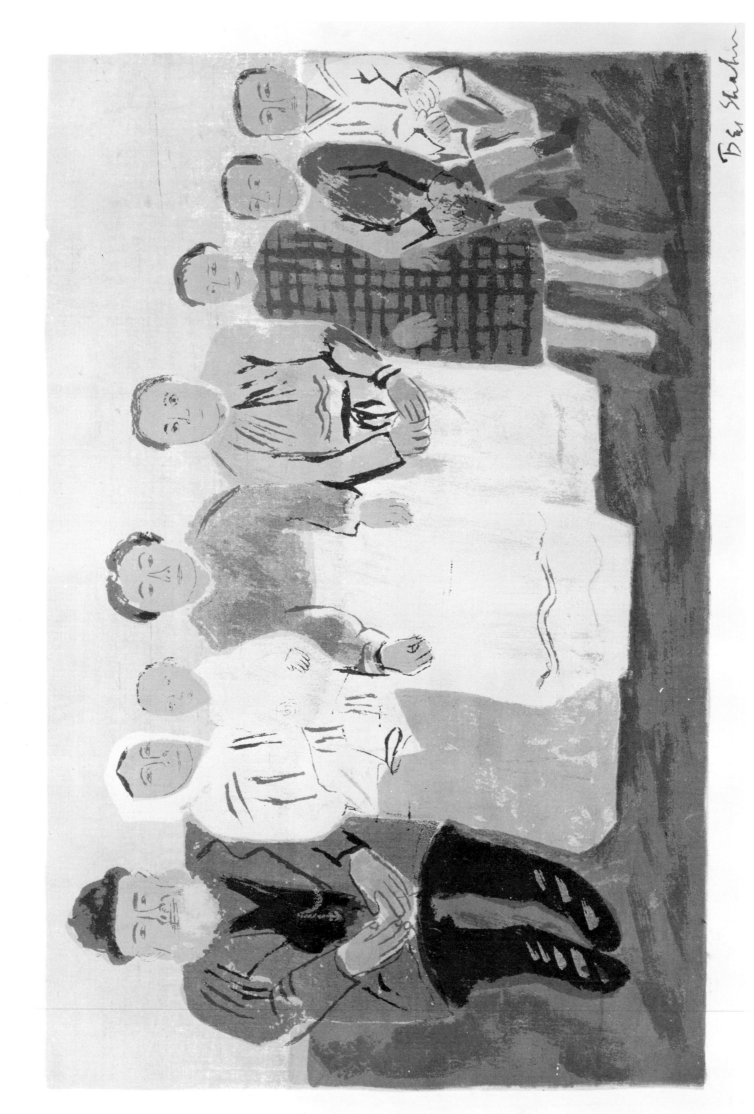

2. Immigrant Family. 1941. 19¼" × 25¼".

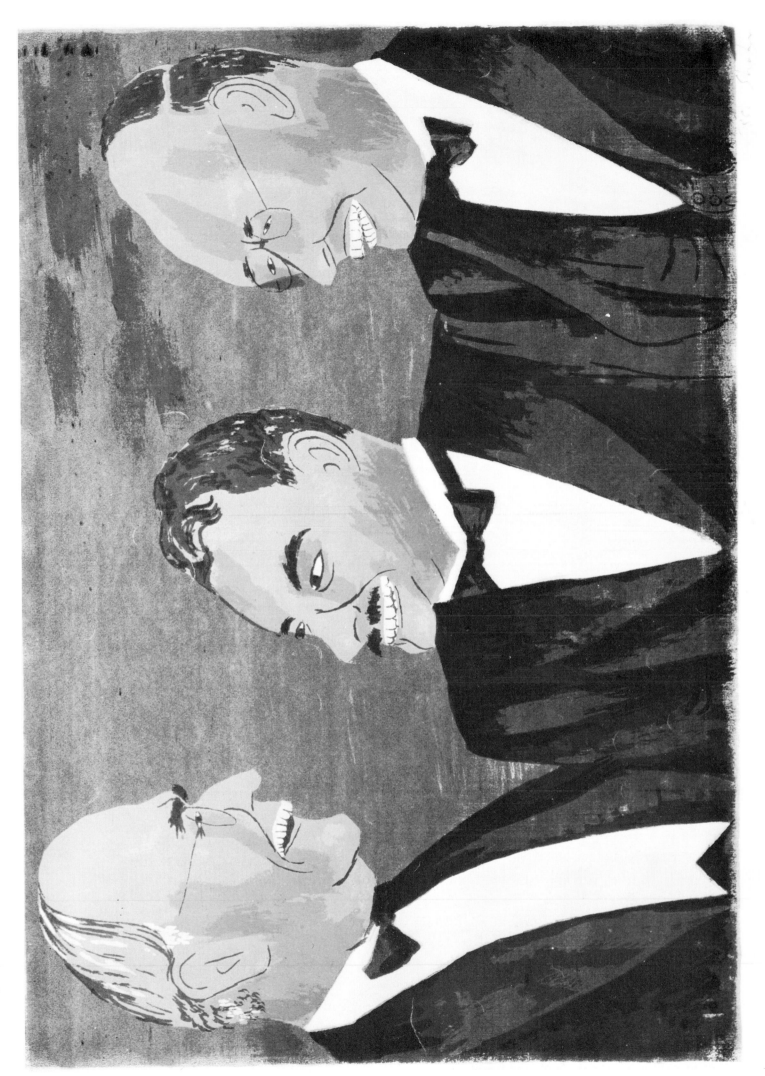

3. Vandenberg, Dewey, and Taft. 1941. 19¼″ × 25¾″.

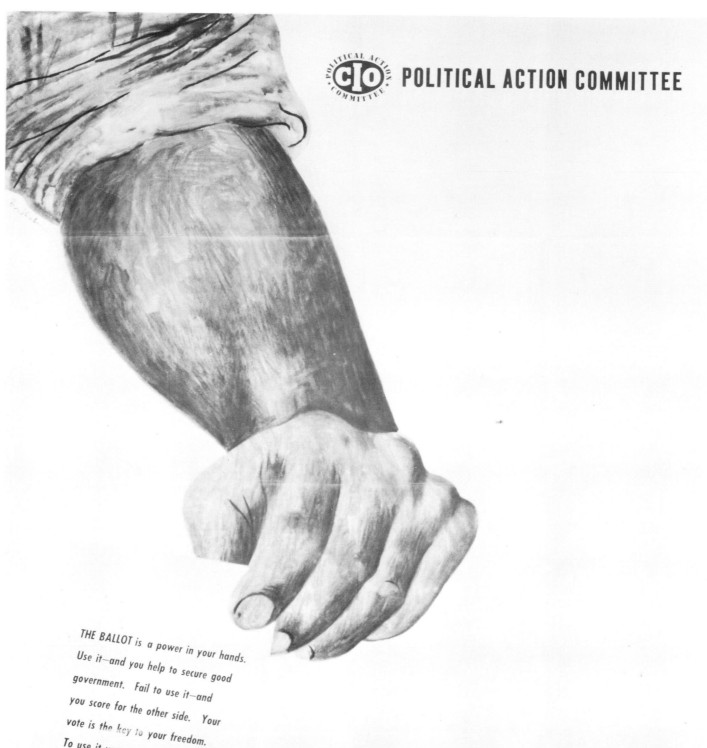

POLITICAL ACTION COMMITTEE

THE BALLOT is a power in your hands. Use it—and you help to secure good government. Fail to use it—and you score for the other side. Your vote is the key to your freedom. To use it you must register. Do it.

REGISTER

4. Register . . . The Ballot is a power in your hands. 1944. 39¾″ × 29⅞″.

5. Silent Night. 1949. 12¼″ × 18⅜″.

6. Silent Music. 1950. 25¼″ × 38⅝″.

I. We Demand the National Textile Act. 1935. 41⅛″ × 27½″.

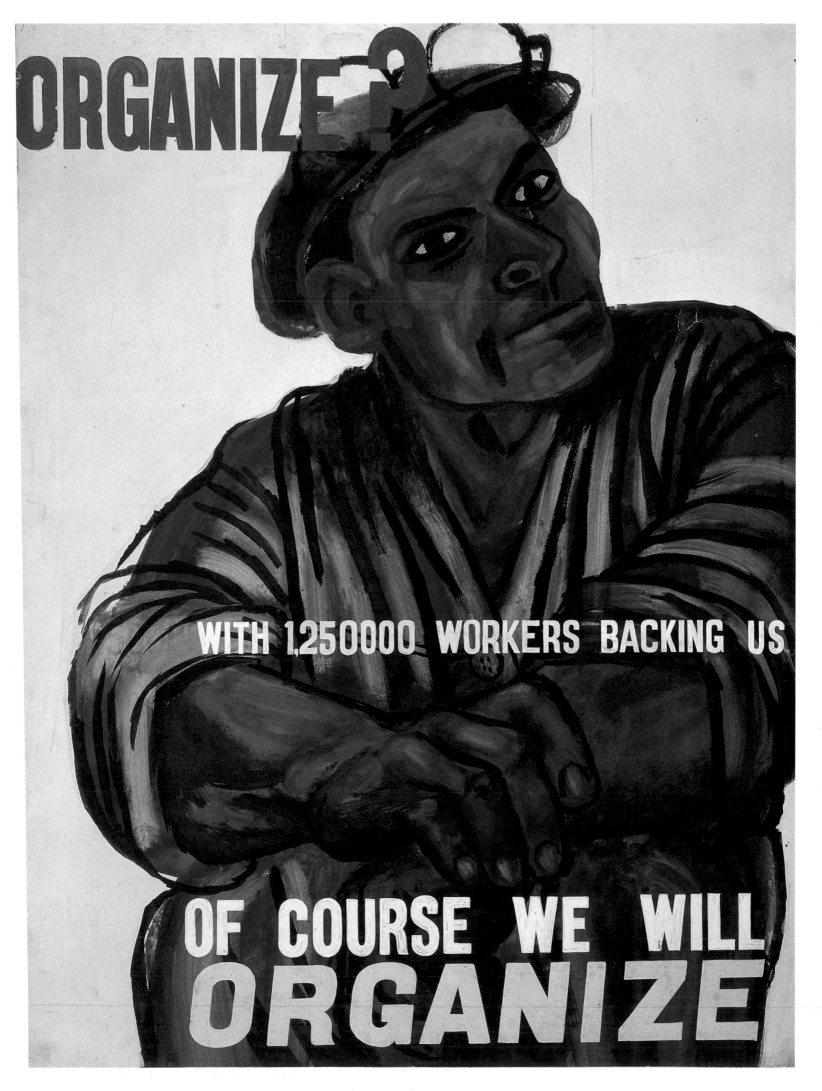

II. Organize? With 1,250000 Workers Backing Us. Late 1930s. 40″ × 29⅞″.

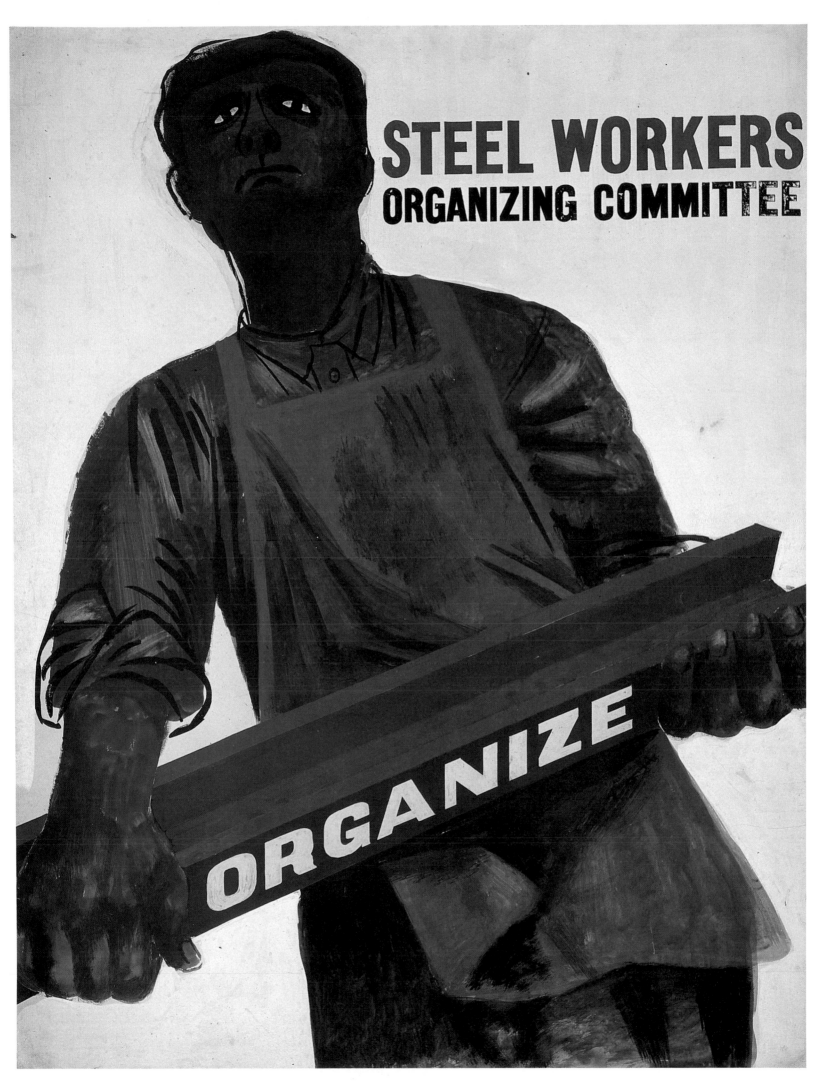

III. Steel Workers Organizing Committee. Late 1930s. 40″ × 29⅞″.

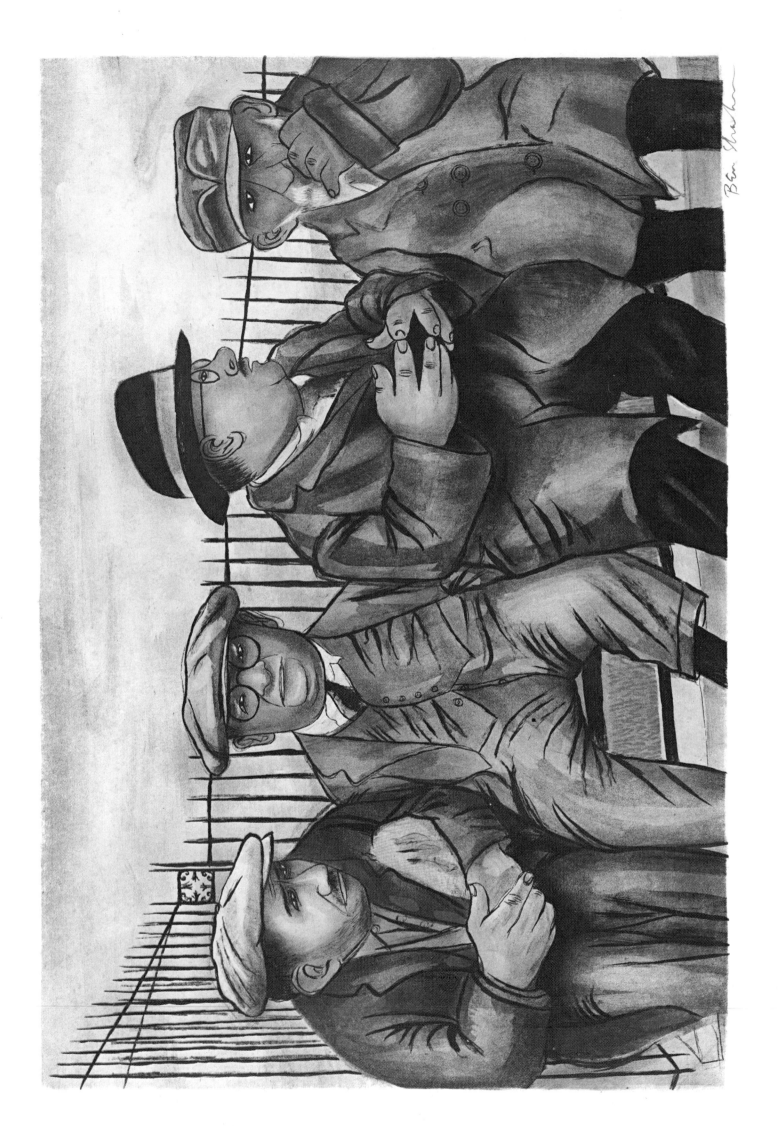

IV. Seward Park. 1936. 15¾″ × 22¾″.

V. Prenatal Clinic. 1941. $15\frac{1}{8}'' \times 22\frac{3}{8}''$.

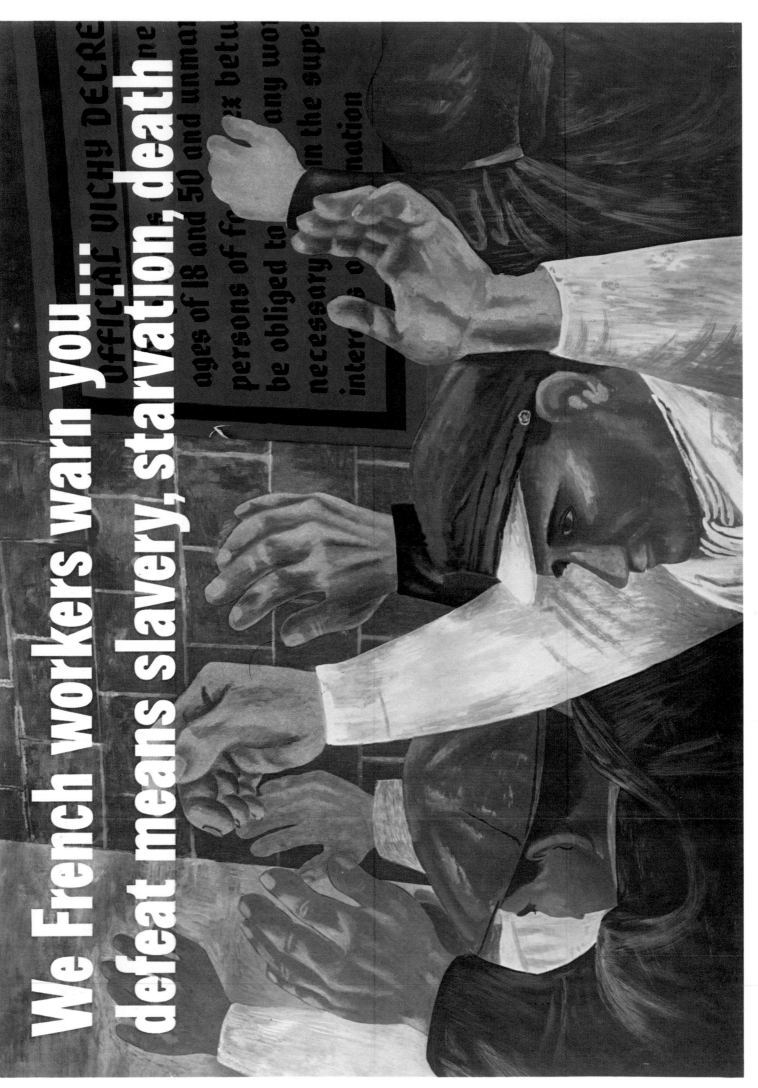

VI. We French workers warn you. 1942. 28¼" × 39¾".

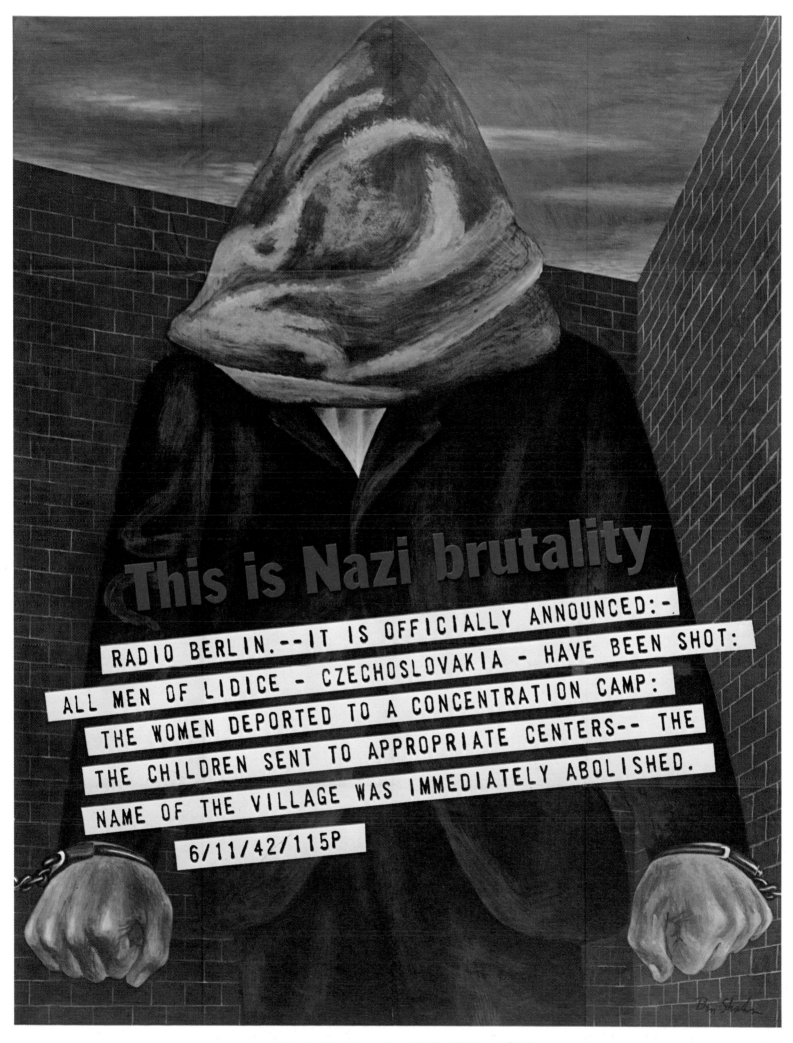

VII. This is Nazi brutality. 1942. 37⅞″ × 28¼″.

VIII. Welders, or, for full employment after the war. 1944. 29¾″ × 39⅜″.

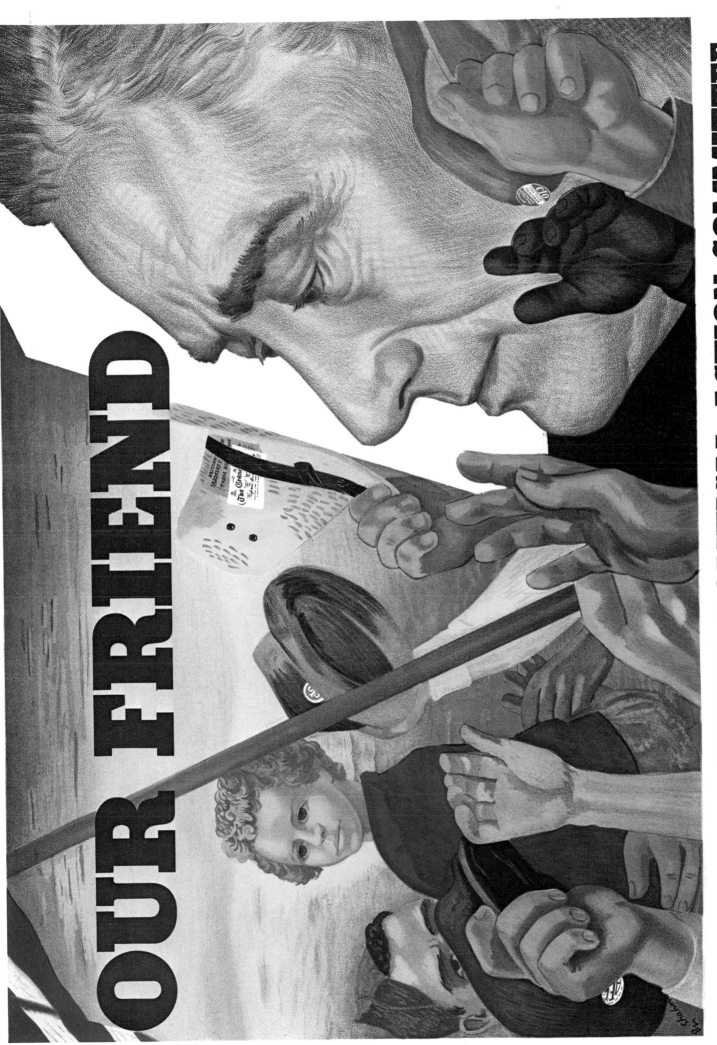

IX. Our Friend. 1944. 30″ × 39¾″.

YEARS OF DUST

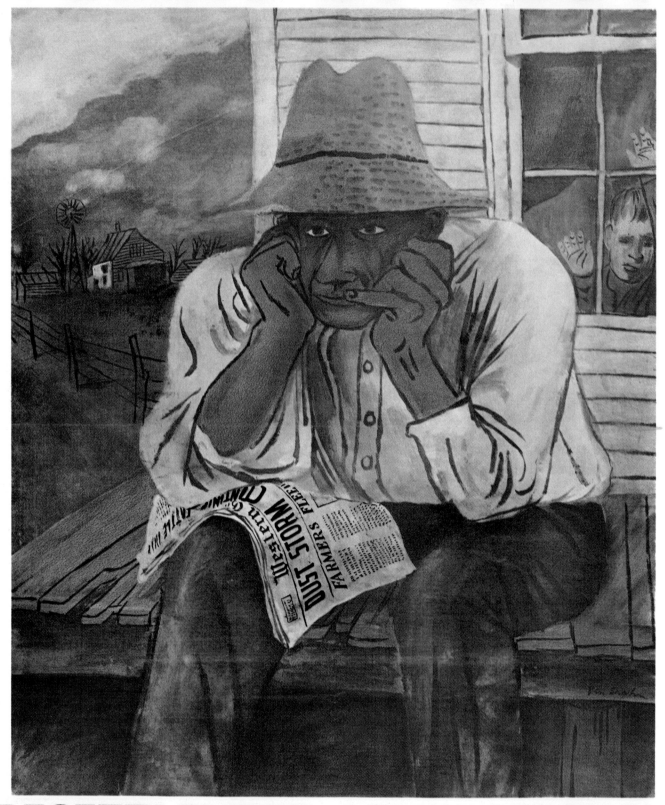

RESETTLEMENT ADMINISTRATION
Rescues Victims
Restores Land to Proper Use

X. Years of Dust. 1936. 38″ × 24⅞″.

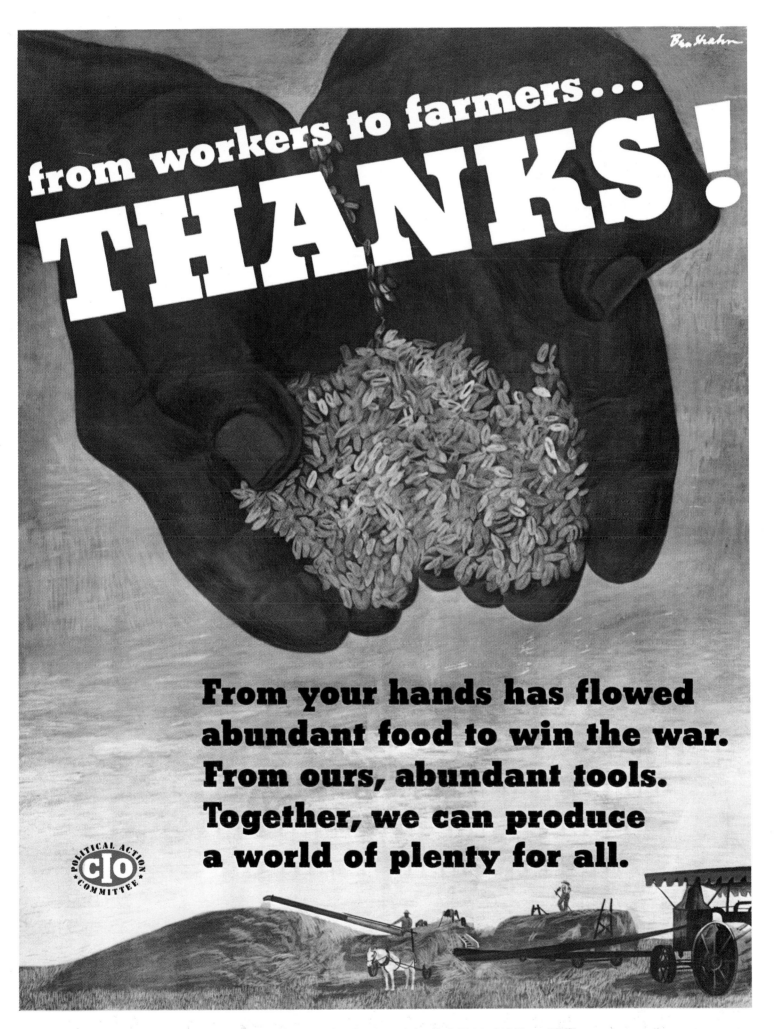

XI. From workers to farmers . . . Thanks! 1944. 39½″ × 29¾″.

BREAK REACTION'S GRIP

Ben Shahn

REGISTER VOTE

XII. Break Reaction's Grip. 1946. 41¼″ × 29″.

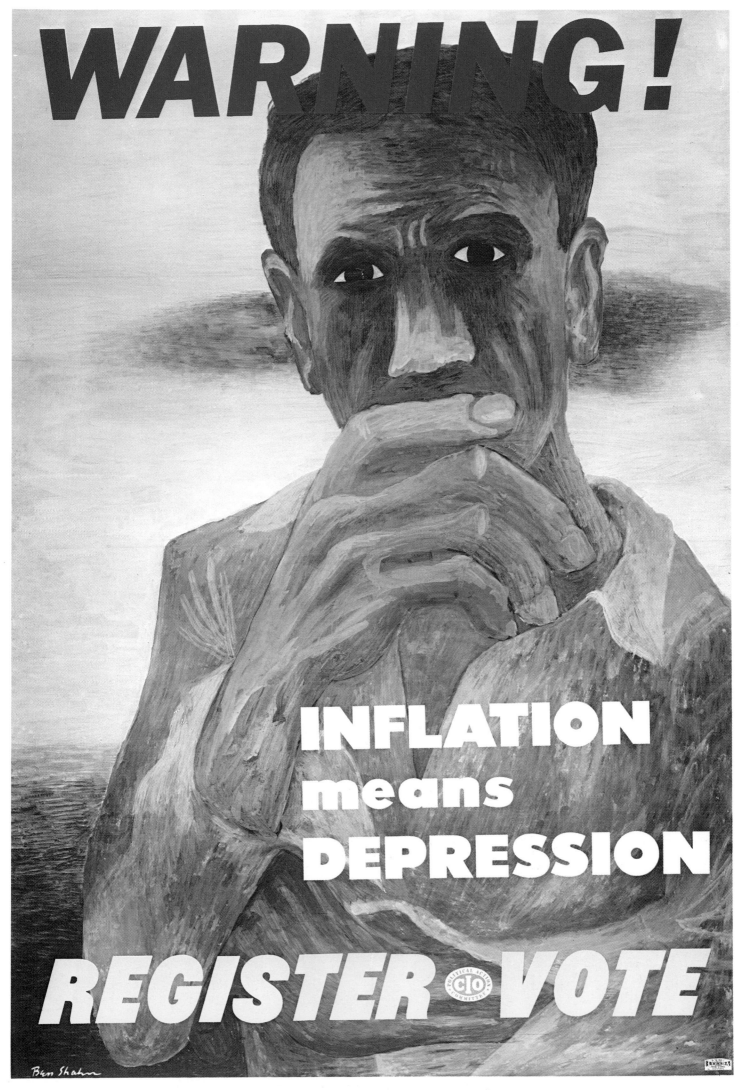

XIII. Warning! Inflation means Depression. 1946. 41⅛″ × 27¾″.

for all these rights
we've just begun to fight

REGISTER VOTE

XIV. For all these rights we've just begun to fight. 1946. 28⅞" × 38¼".

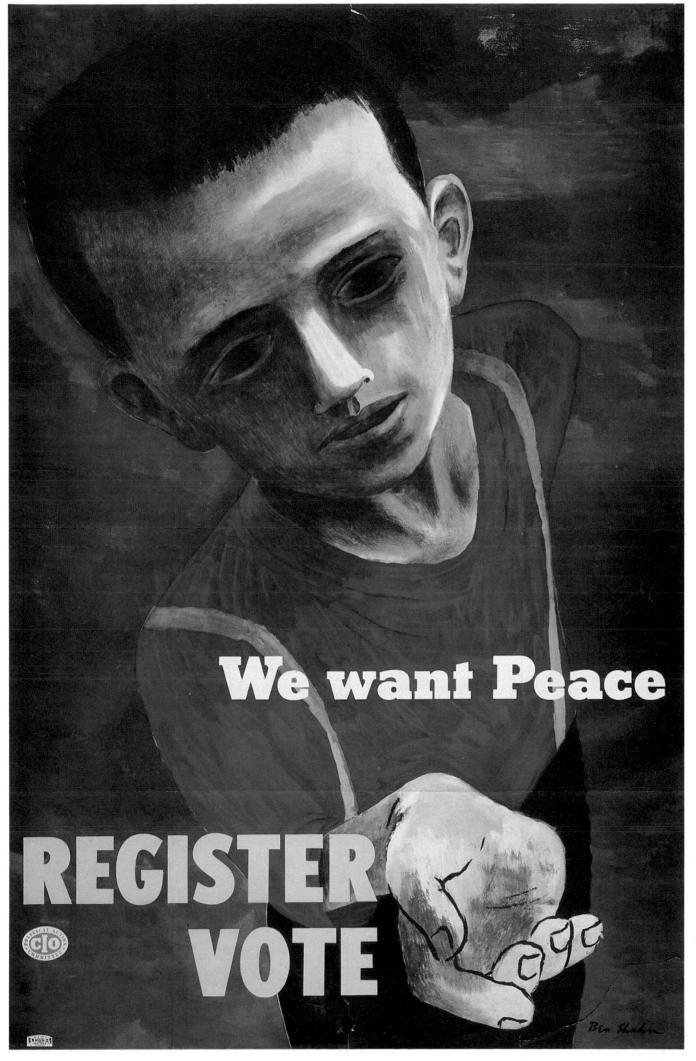

XV. We Want Peace. 1946. 41⅜″ × 26⅞″.

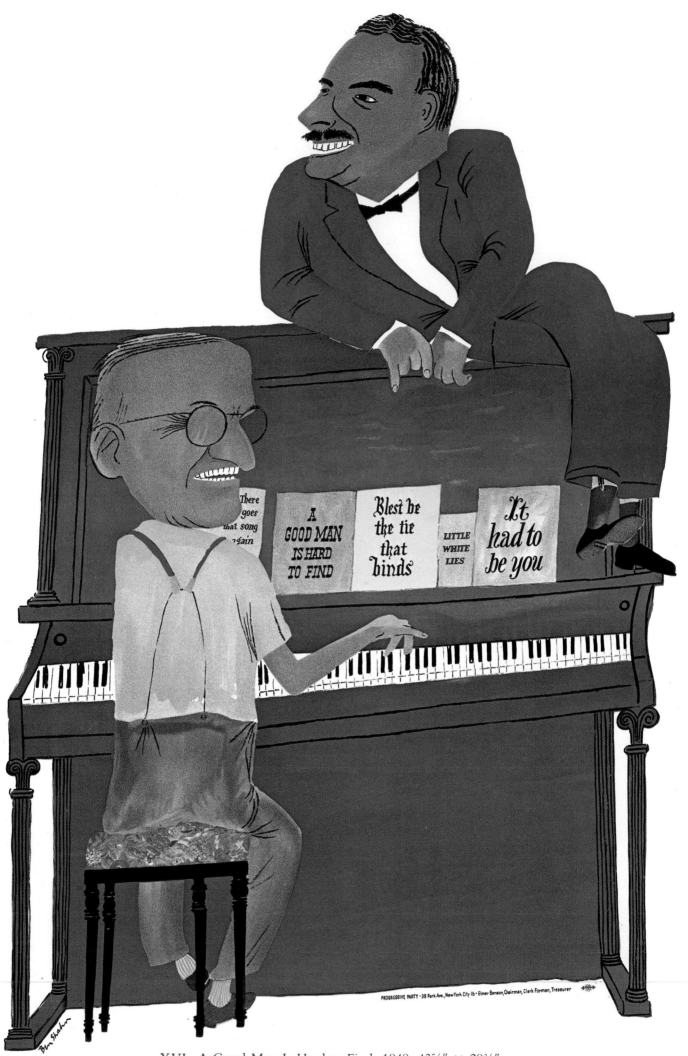

XVI. A Good Man Is Hard to Find. 1948. 43⅝″ × 29¾″.

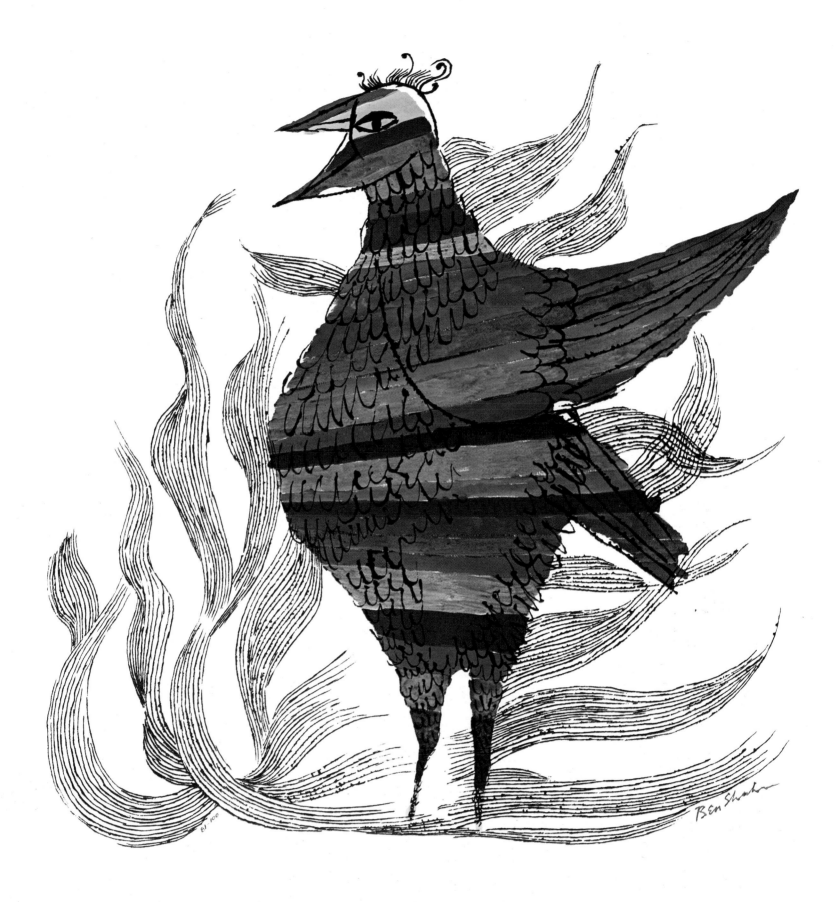

XVII. Phoenix. 1952. 30¾″ × 22⅜″.

XVIII. Triple Dip. 1952. 34⅜″ × 27¼″.

PAVILLON VENDOME
AIX EN PROVENCE

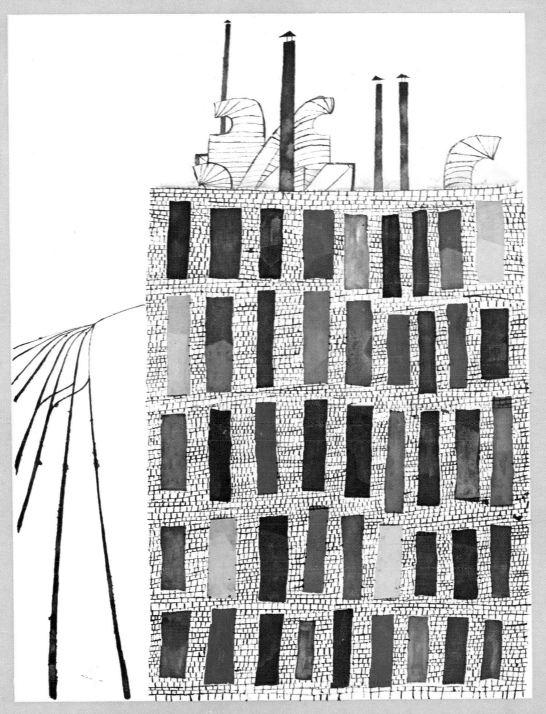

LE DESSIN CONTEMPORAIN
AUX ÉTATS UNIS

JUILLET - AOUT 1954

XIX. Pavillon Vendôme. 1954. 25¼″ × 17½″.

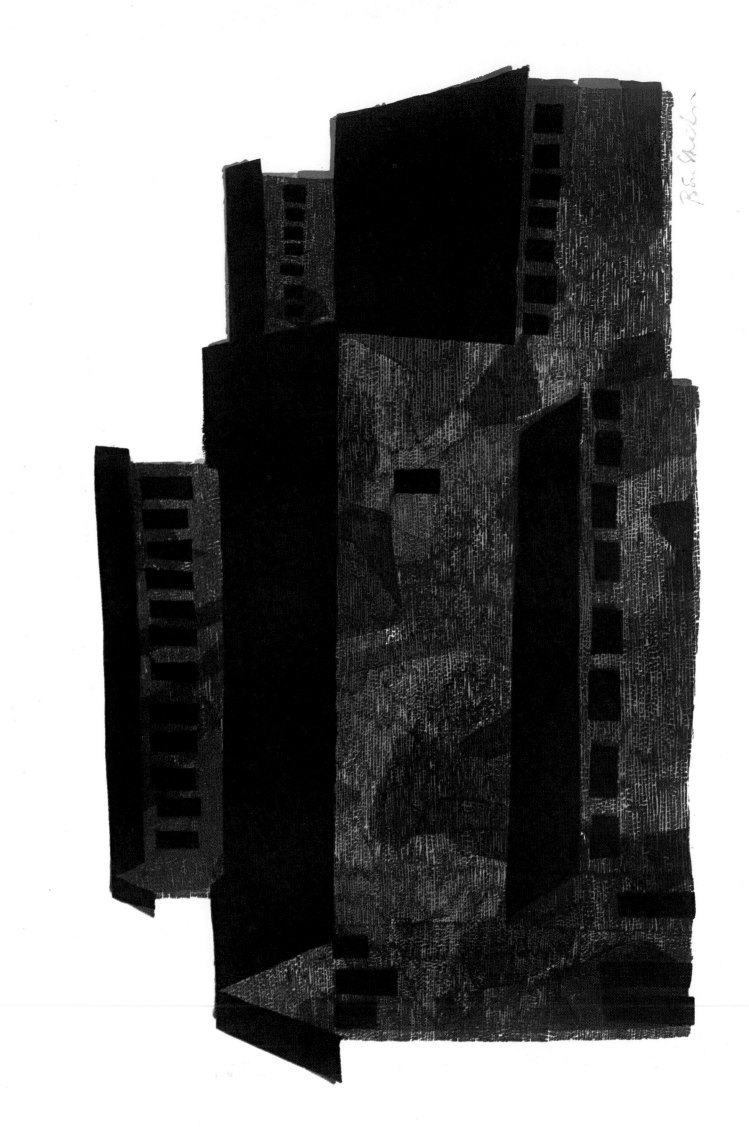

XX. Mine Building. 1956. 22⅜″ × 30¾″.

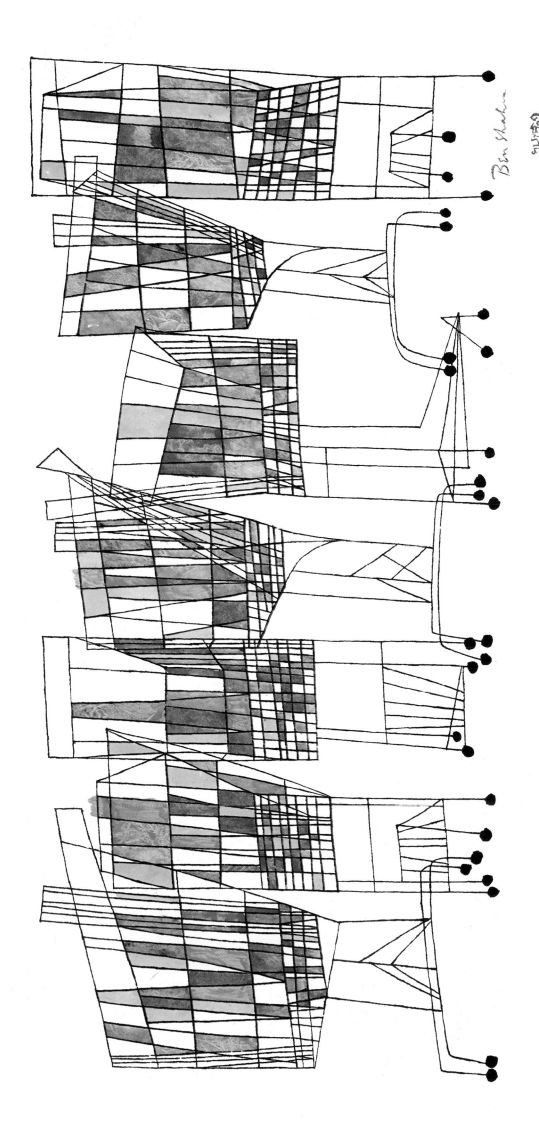

Ben Shahn

XXI. Supermarket. 1957. 25¼″ × 38⅝″.

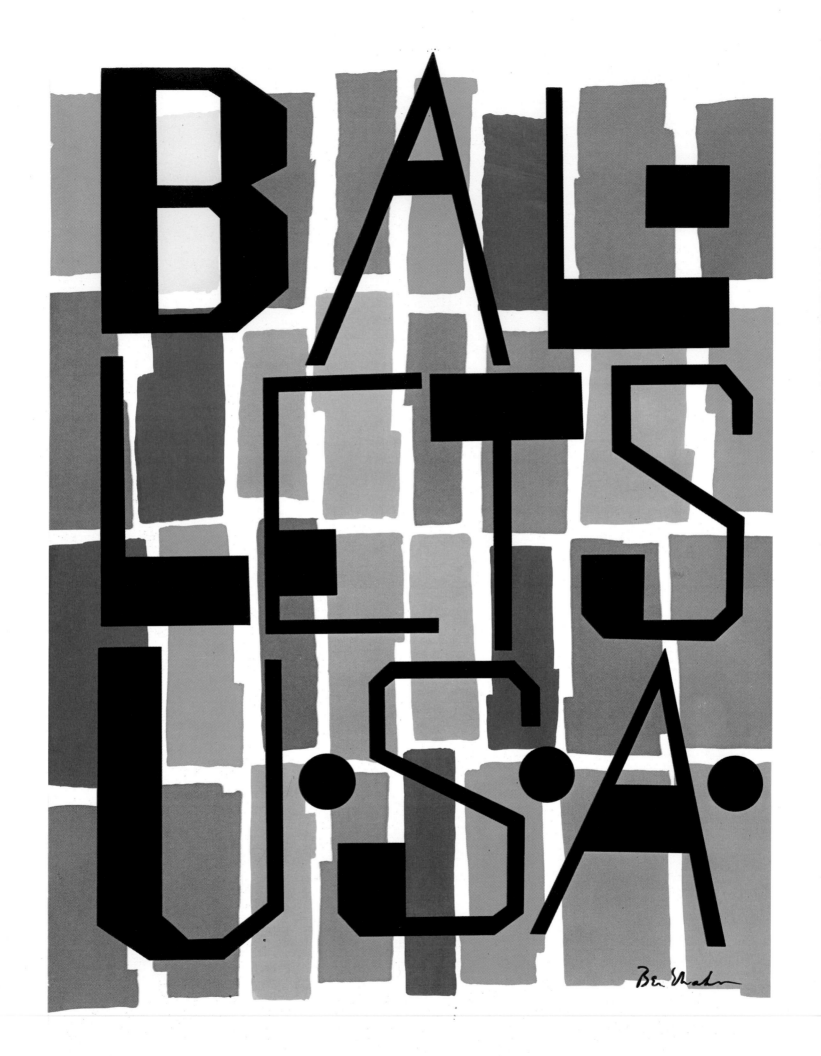

EXHIBIT-JEROME ROBBINS "BALLETS U.S.A."-U.S.I.S. GALLERY 41 GROSVENOR SQ. LONDON W.1. SEPT. 15-OCT. 23, 1959

XXII. Ballets U.S.A. 1959. 31⅜" × 21⅜".

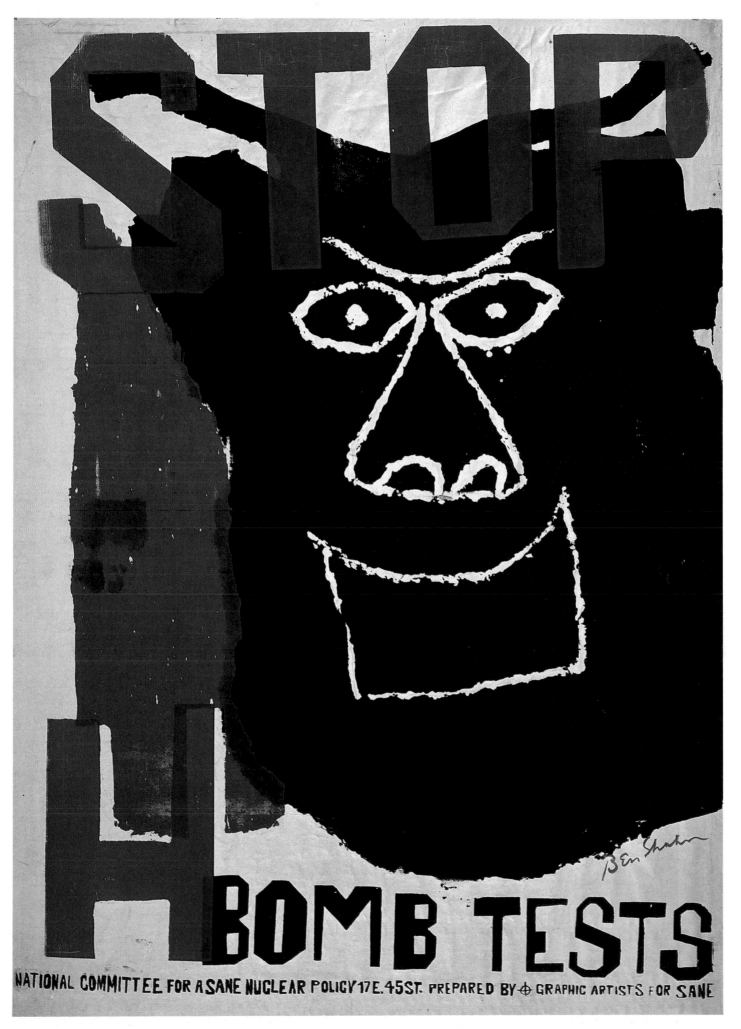

XXIII. Stop H Bomb Tests. 1960s. 43⅜″ × 29⅝″.

ALL
THAT IS
BEAUTIFUL

BUT FOR REMEMBRANCE SAKE

THE ART OF PHEIDIAS

XXIV. All That Is Beautiful. 1965. 26″ × 38¾″.

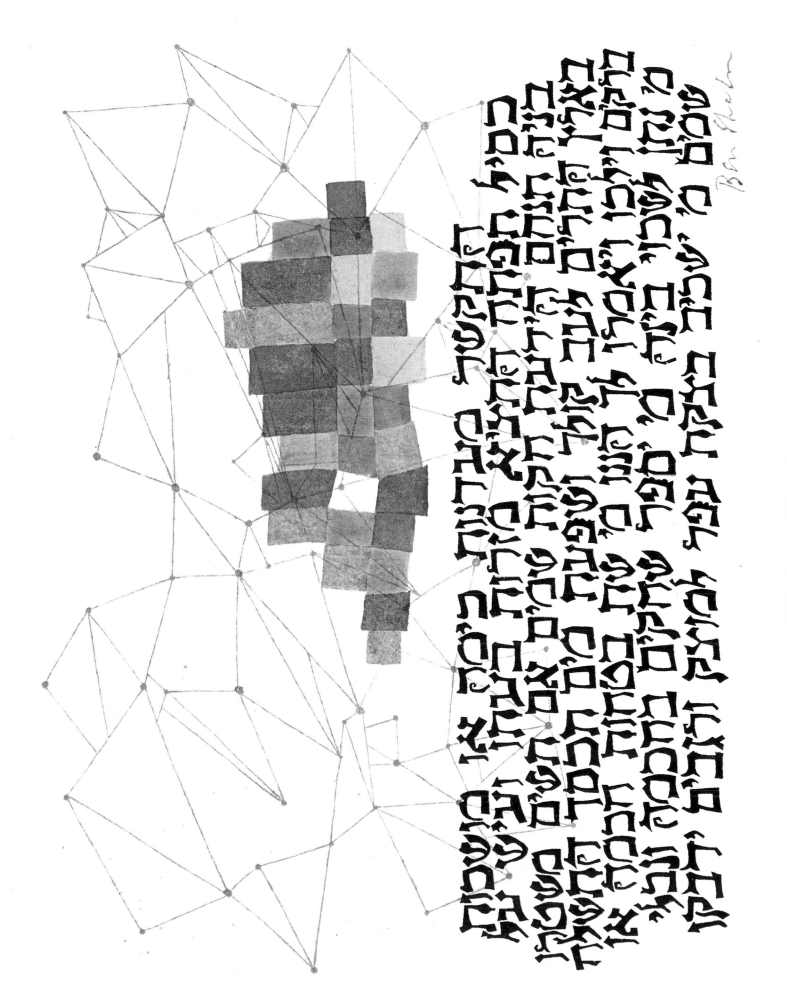

XXV. Pleiades. 1960. 20½" × 26½".

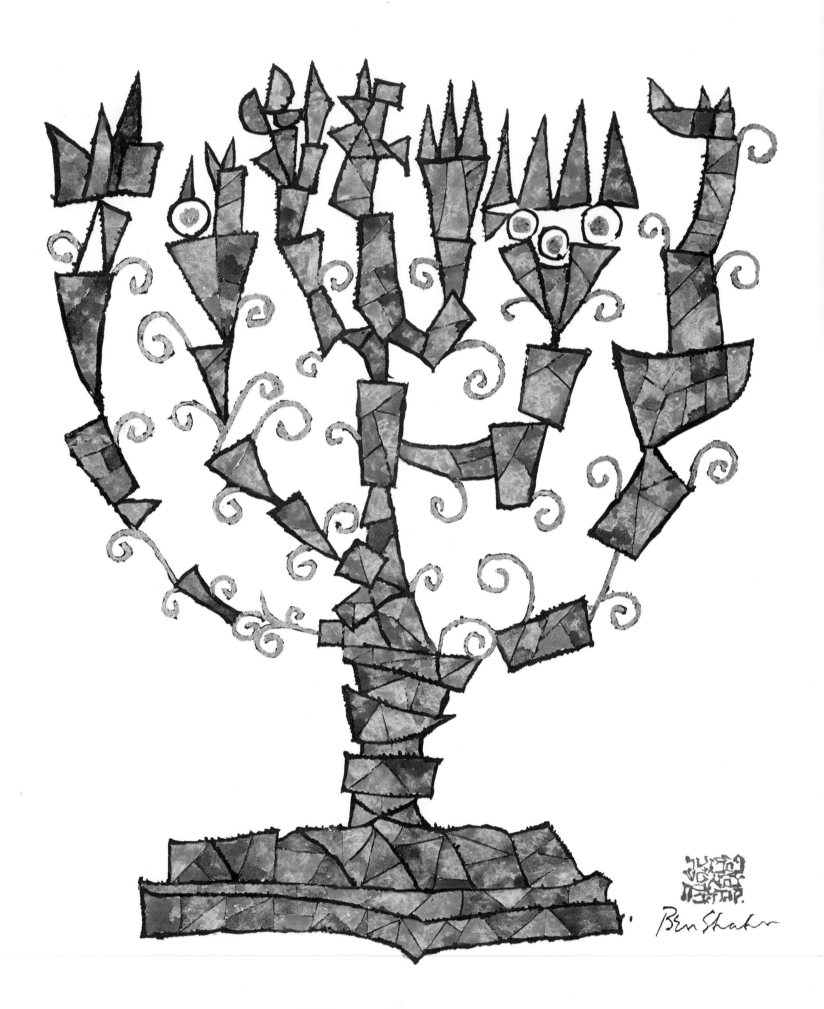

XXVI. Menorah. 1965. 26⅜″ × 20½″.

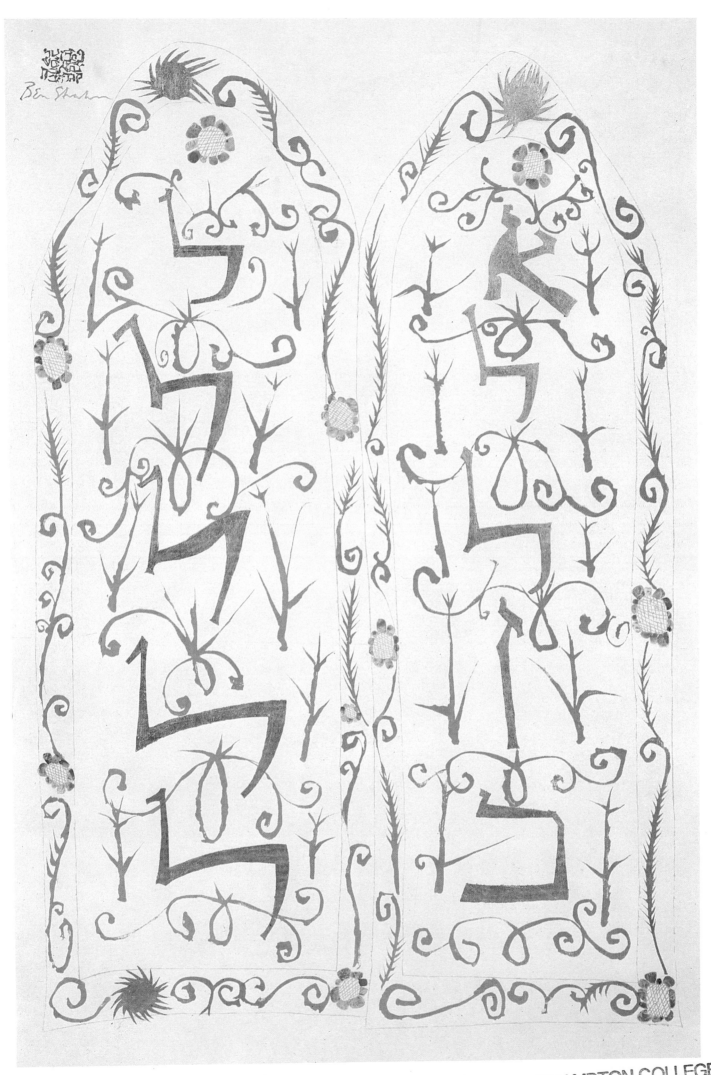

XXVII. Decalogue. 1961. 40″ × 26 1/16″. NORTHAMPTON COLLEGE LIBRARY

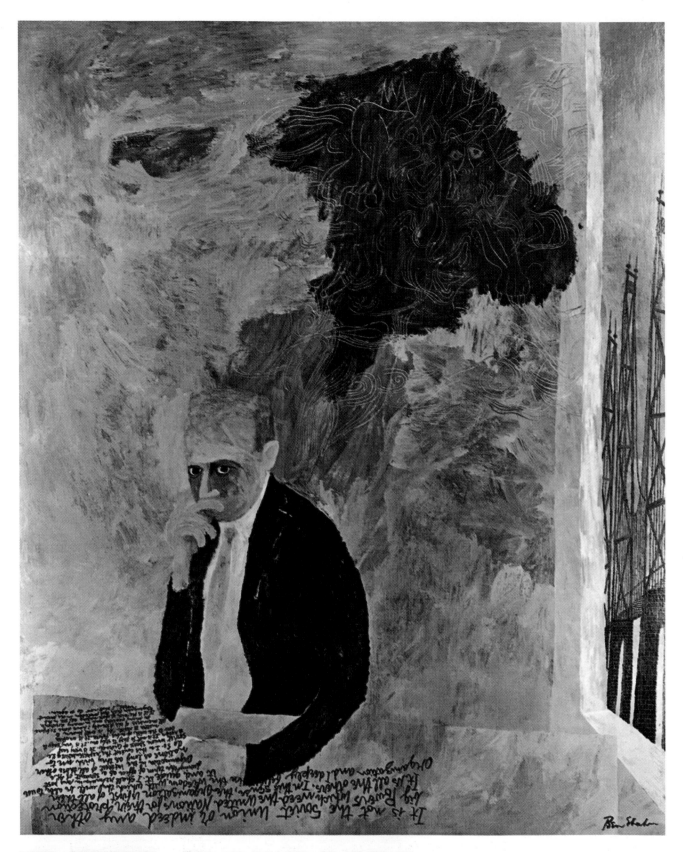

BEN SHAHN

en amerikansk kommentar

Moderna Museet 16 februari—10 mars 1963

XXVIII. Ben Shahn en amerikansk kommentar. 1963. 30¾″ × 19¾″.

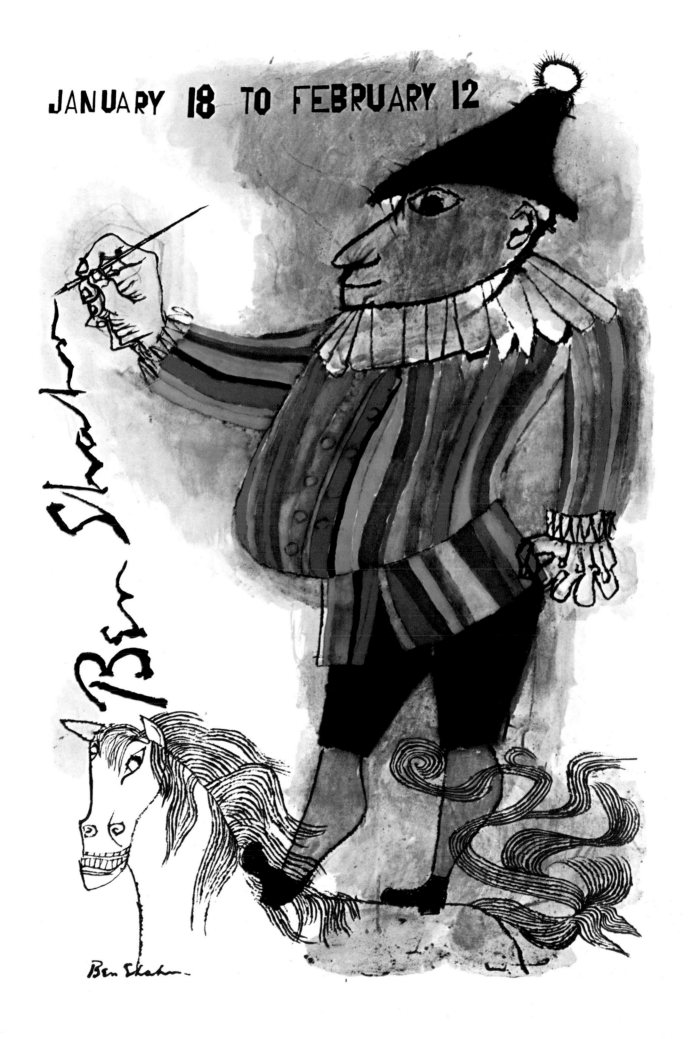

XXIX. Ben Shahn January 18 to February 12. 1964. 28½″ × 22½″.

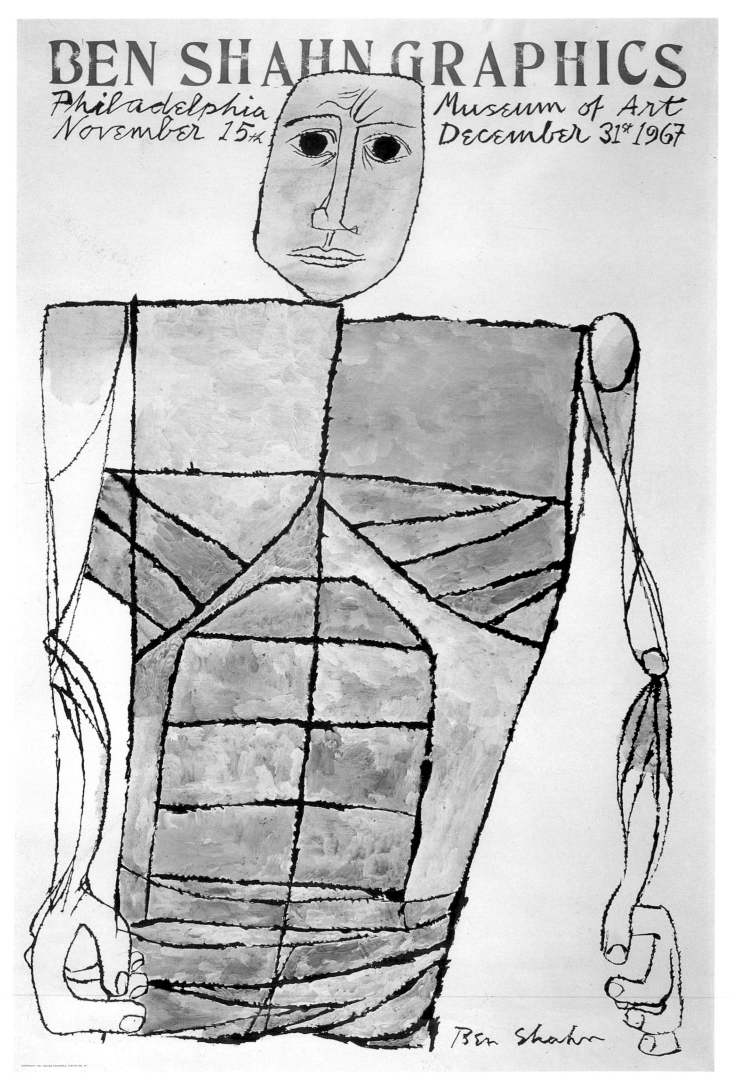

XXX. Ben Shahn Graphics Philadelphia Museum of Art. 1967. 45″ × 30⅛″.

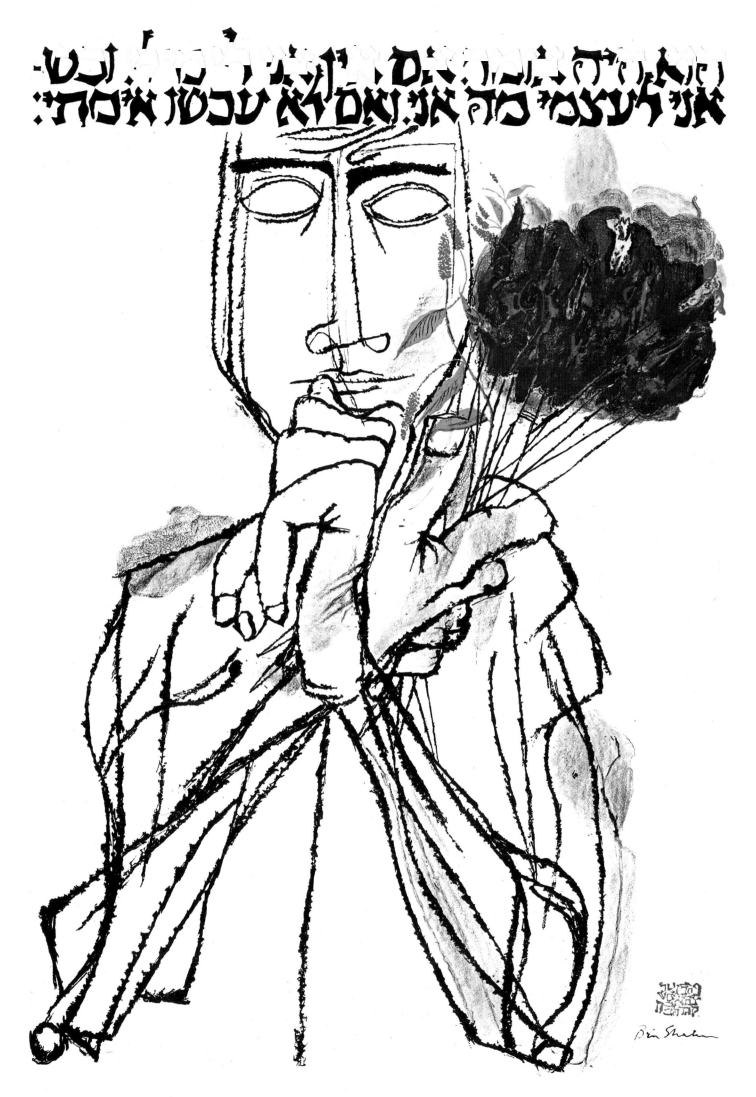

XXXI. Flowering Brushes. 1968. 39⅝″ × 26⅝″.

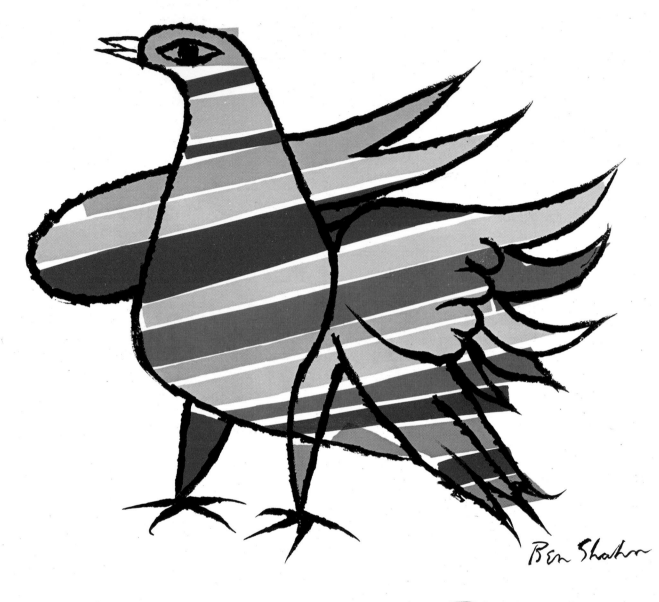

XXXII. McCarthy Peace. 1968. 38⅛″ × 23″.

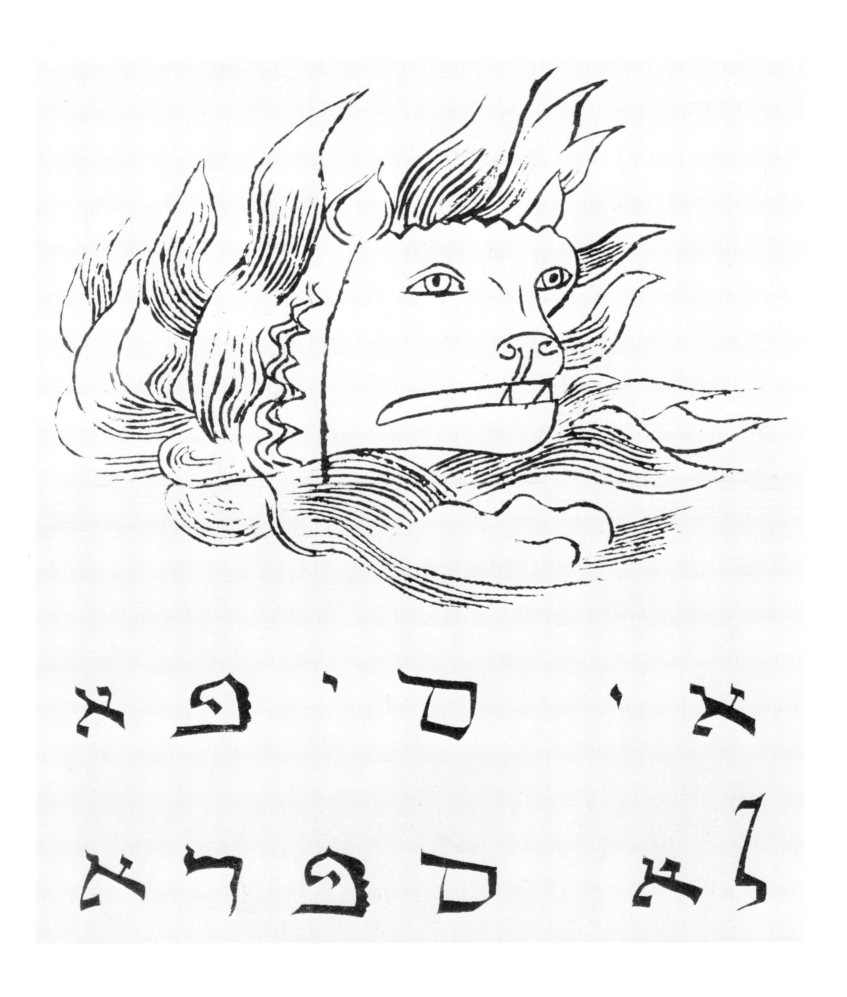

7. Where There Is a Book There Is No Sword. 1950. 21″ × 14½″.

Watch out for The Man on a White Horse!

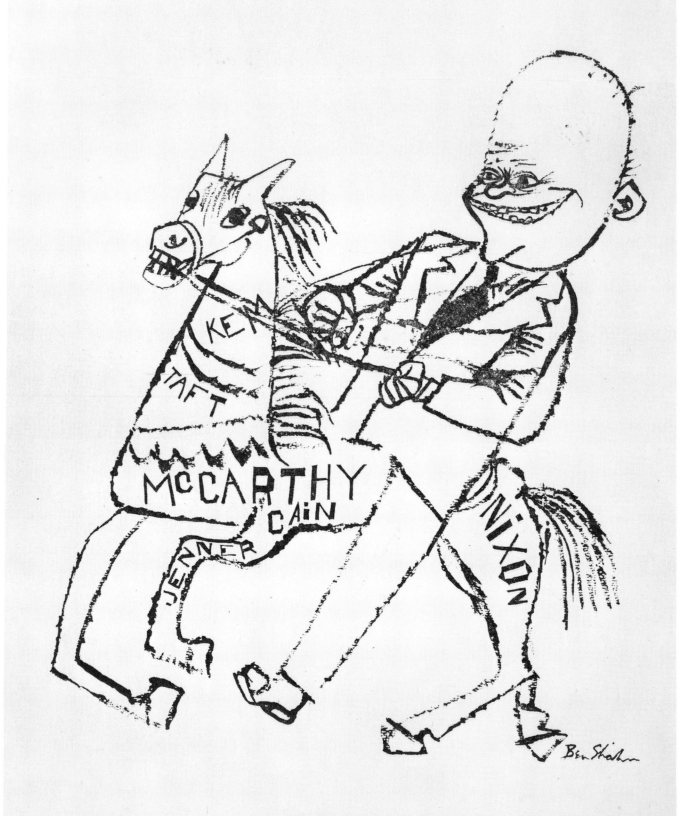

—better vote for Stevenson

8. Watch out for The Man on a White Horse! 1952. 14⅜″ × 10″.

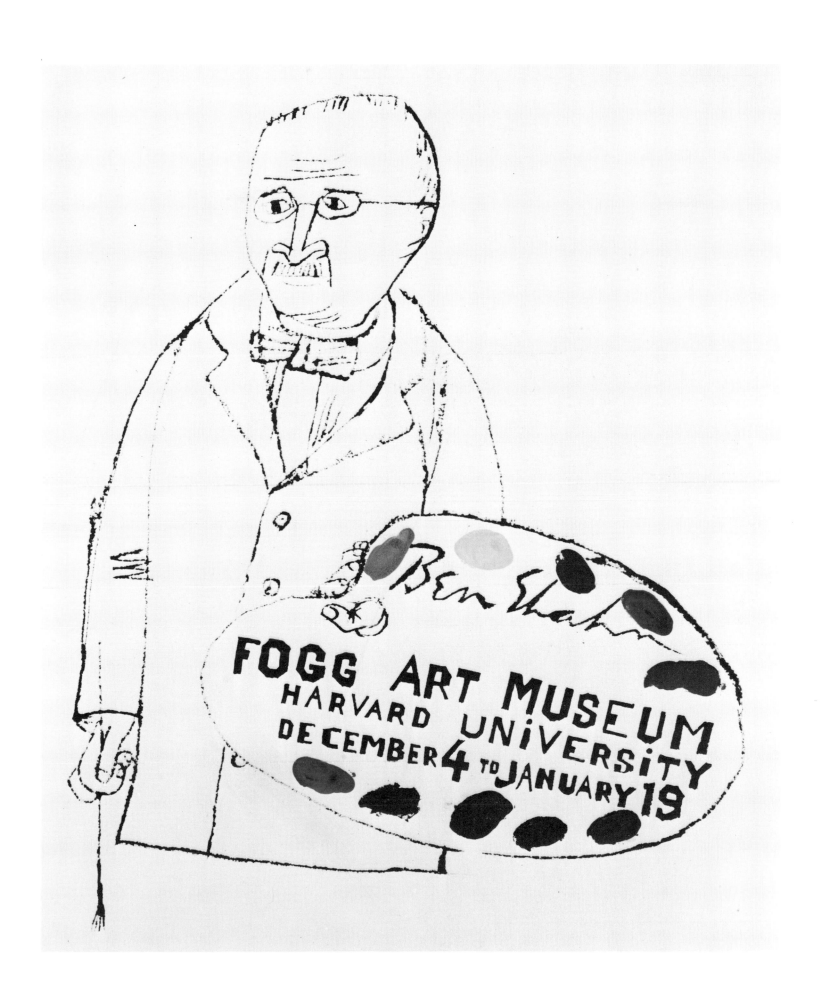

9. Ben Shahn Fogg Art Museum. 1956. 11″ × 9″.

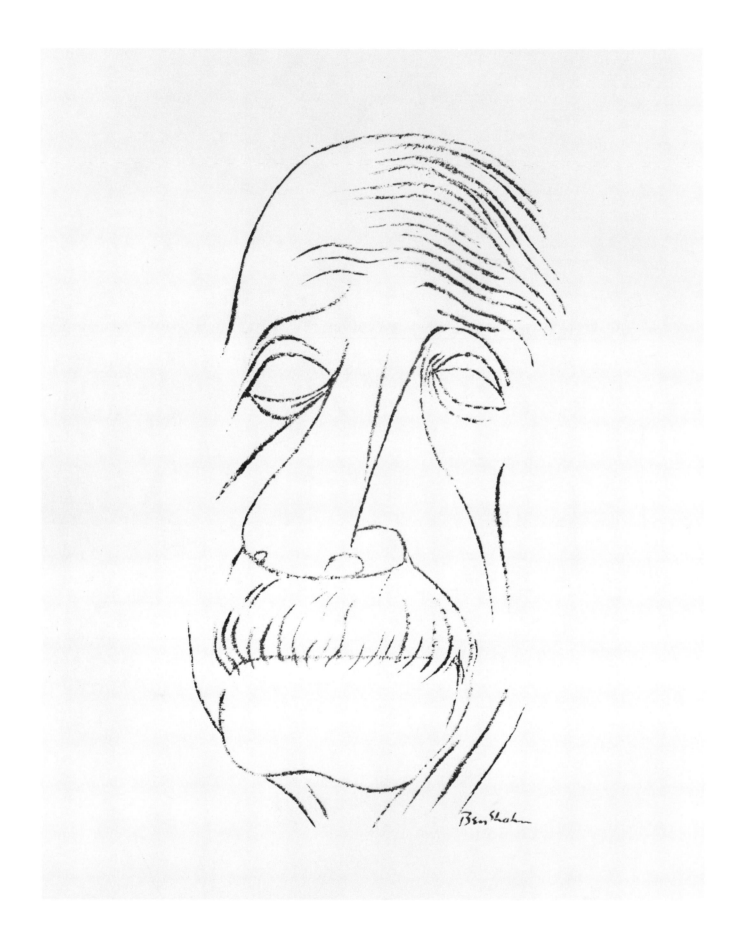

10. Einstein. 1950. 17⅞″ × 12″.

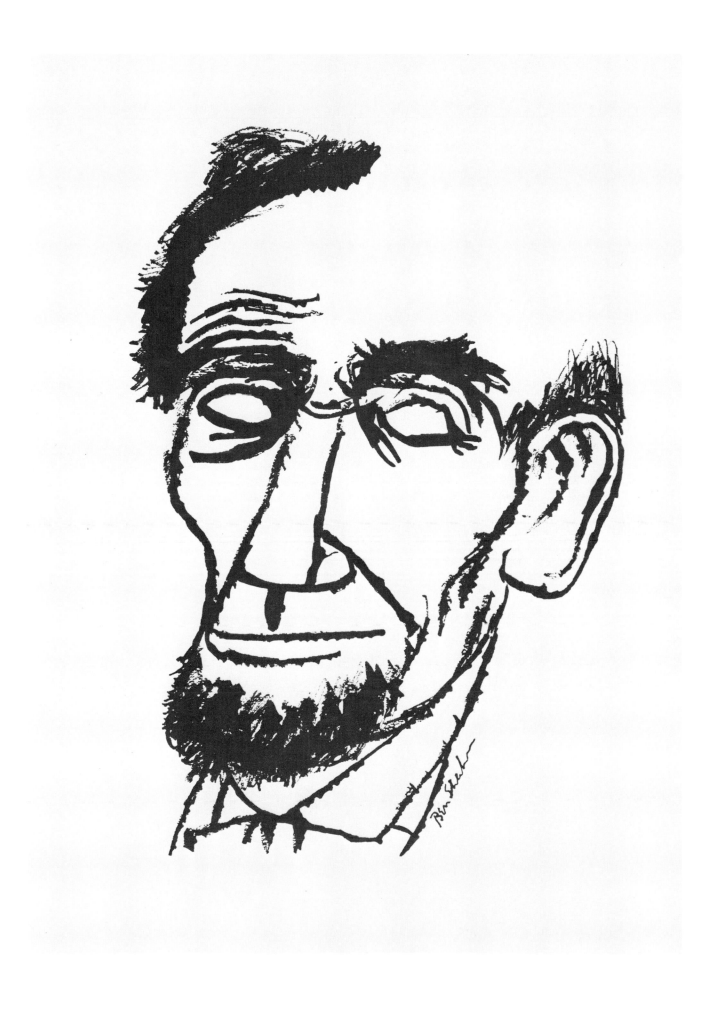

11. Abraham Lincoln. 1955. 16⅛″ × 12¼″.

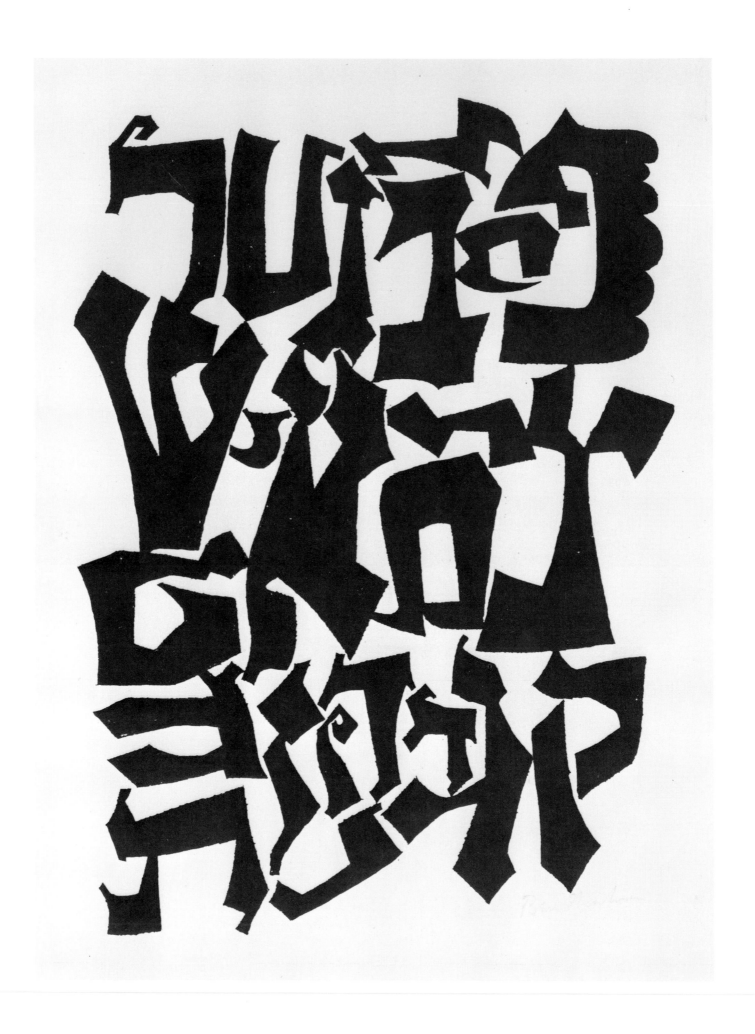

12. Alphabet of Creation. 1957. 38¾" × 27¼".

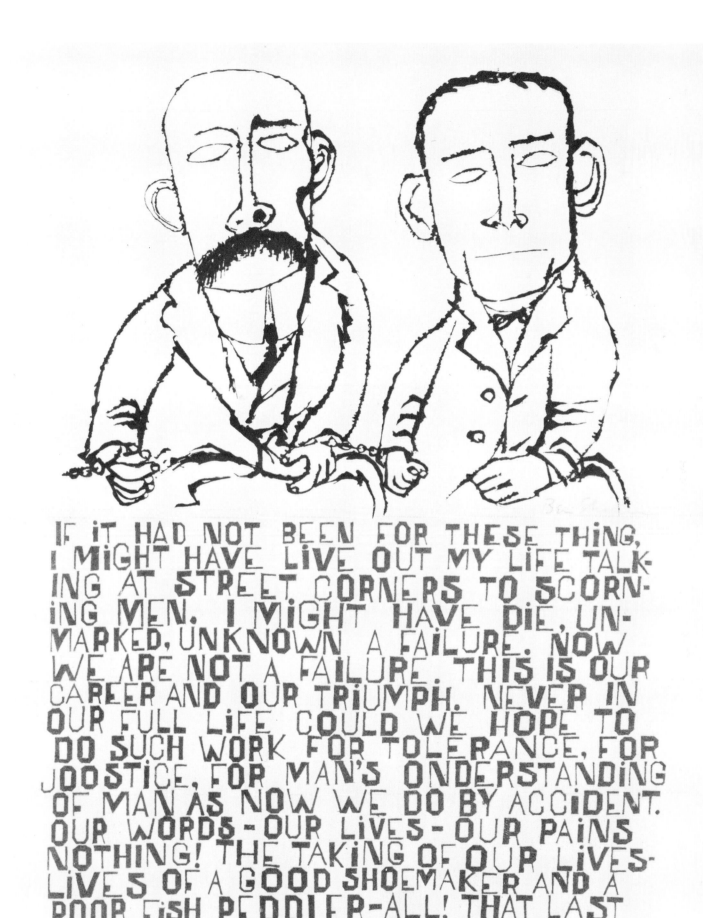

IF IT HAD NOT BEEN FOR THESE THING, I MIGHT HAVE LIVE OUT MY LIFE TALK- ING AT STREET CORNERS TO SCORN- ING MEN. I MIGHT HAVE DIE, UN- MARKED, UNKNOWN A FAILURE. NOW WE ARE NOT A FAILURE. THIS IS OUR CAREER AND OUR TRIUMPH. NEVER IN OUR FULL LIFE COULD WE HOPE TO DO SUCH WORK FOR TOLERANCE, FOR JOOSTICE, FOR MAN'S ONDERSTANDING OF MAN AS NOW WE DO BY ACCIDENT. OUR WORDS - OUR LIVES - OUR PAINS NOTHING! THE TAKING OF OUR LIVES- LIVES OF A GOOD SHOEMAKER AND A POOR FISH PEDDLER - ALL! THAT LAST MOMENT BELONGS TO US - THAT AGONY IS OUR TRIUMPH.

13. Passion of Sacco and Vanzetti. 1958. 30½″ × 22⅝″.

14. Lute and Molecule, No. 2. 1958. 25¼" × 38½".

15. Wheat Field. 1958. 27⅜" × 40⅝".

16. Cat's Cradle. 1959. 20½" × 29⅛".

17. Trees. 1960s. 4⅜″ × 6¼″.

An exciting cross section

of contemporary American

and European art, including

a large selection of specially priced

collector's items—

drawings, watercolors, oils, lithographs

WALDEN SCHOOL ART EXHIBITION & SALE NOV. 6–9

WALDEN SCHOOL
1 WEST 88 STREET NEW YORK CITY

THURSDAY
NOVEMBER 6th *8 to 11 P.M.*

FRIDAY
NOVEMBER 7th *1 to 11 P.M.*

SATURDAY
NOVEMBER 8th *11 A.M. to 11 P.M.*

SUNDAY
NOVEMBER 9th *11 A.M. to 11 P.M.*

FROM A DRAWING BY *Ben Shahn*

18. Walden School Art Exhibition. 1960s. 10⅞" × 14⅝".

WHO iS GOD?★WELL iT iS AN iNViSiBLE
PERSON AND HE LiVES UP iN HEAVEN★
i GUESS UP iN OUTER SPACE★HE
MADE THE ERTH AND THE HEAVEN &
THE STARS AND THE SUN AND THE
PEOPLE★HE MADE LiGHT HE MADE DAY
HE MADE NiGHT★HE HAS SUCH POWER-
FUL EYES HE DOESN'T HAVE MiLiONS
AND THOUSANDS AND BiLiONS AND HE
CAN STiL SEE US WHEN WE'RE BAD★
HE STARTED ALL THE PLANTS GROWiNG★TO
ME i THiNK OF HiM WHO MAKES FLOWERS
& GREEN GRASS & THE BLUE SKY &
THE YELLOW SUN★GOD iS EVERYWHERE
&' i DON'T KNOW HOW HE COULD DO iT

19. Who is God? 1960s. 7" × 12".

20. Poet. 1960. 40⅝″ × 27½″.

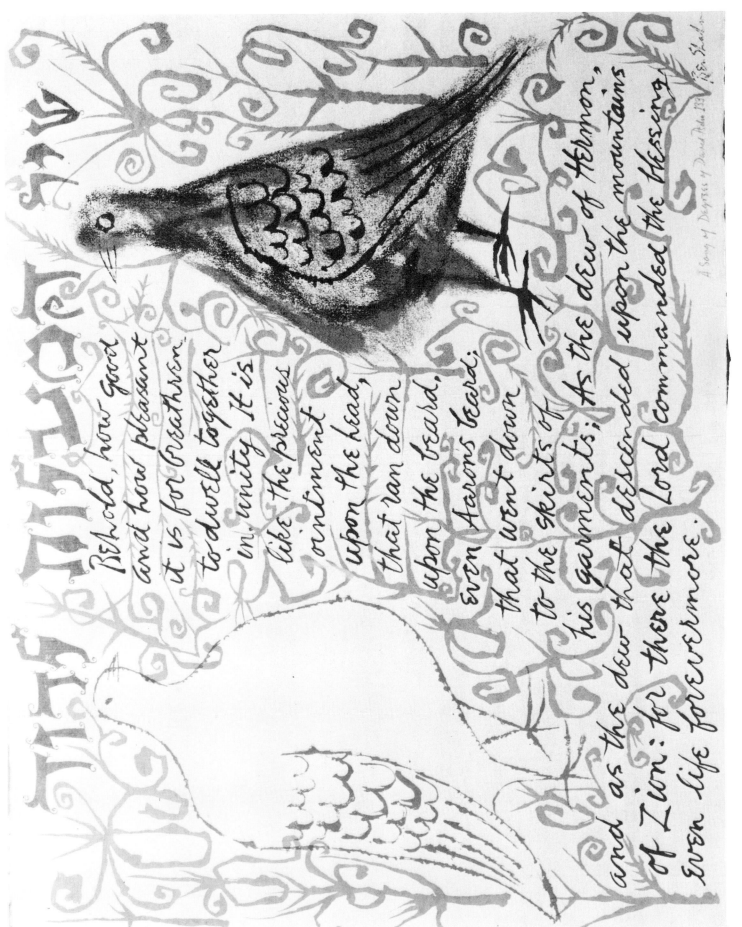

21. Psalm 133. 1960. 20½" × 26½".

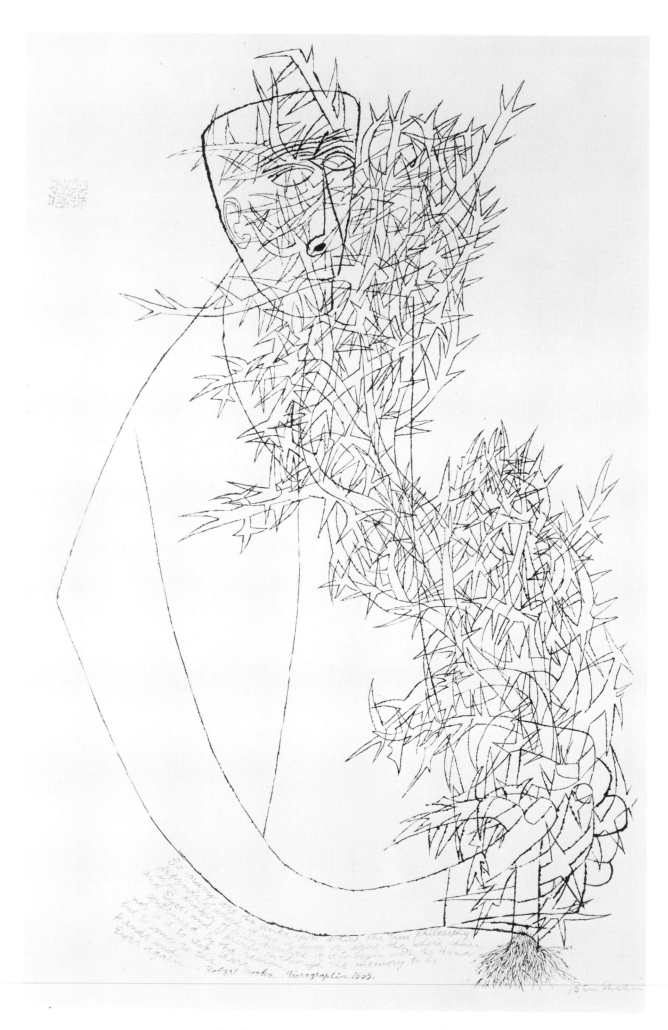

22. Blind Botanist. 1961. 39⅞″ × 25⅜″.

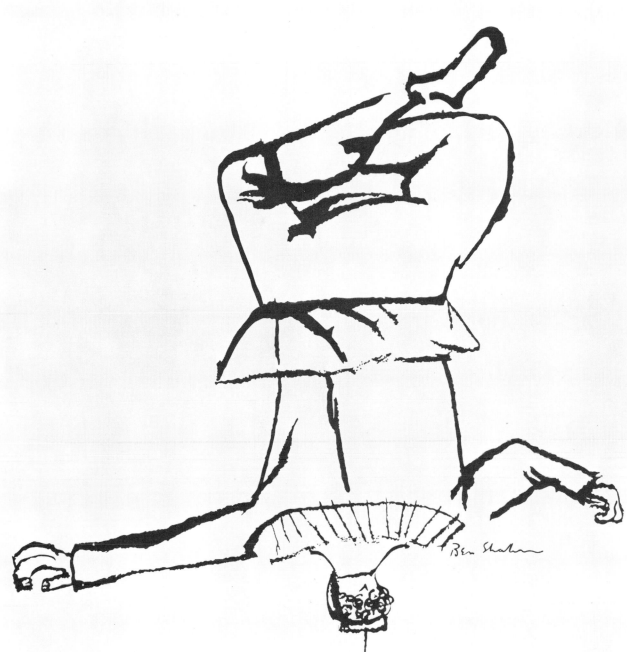

**BOSTON ARTS FESTIVAL
PUBLIC GARDEN
JUNE 20 TO JULY 8**

23. Boston Arts Festival. 1962. 44″ × 27⅞″.

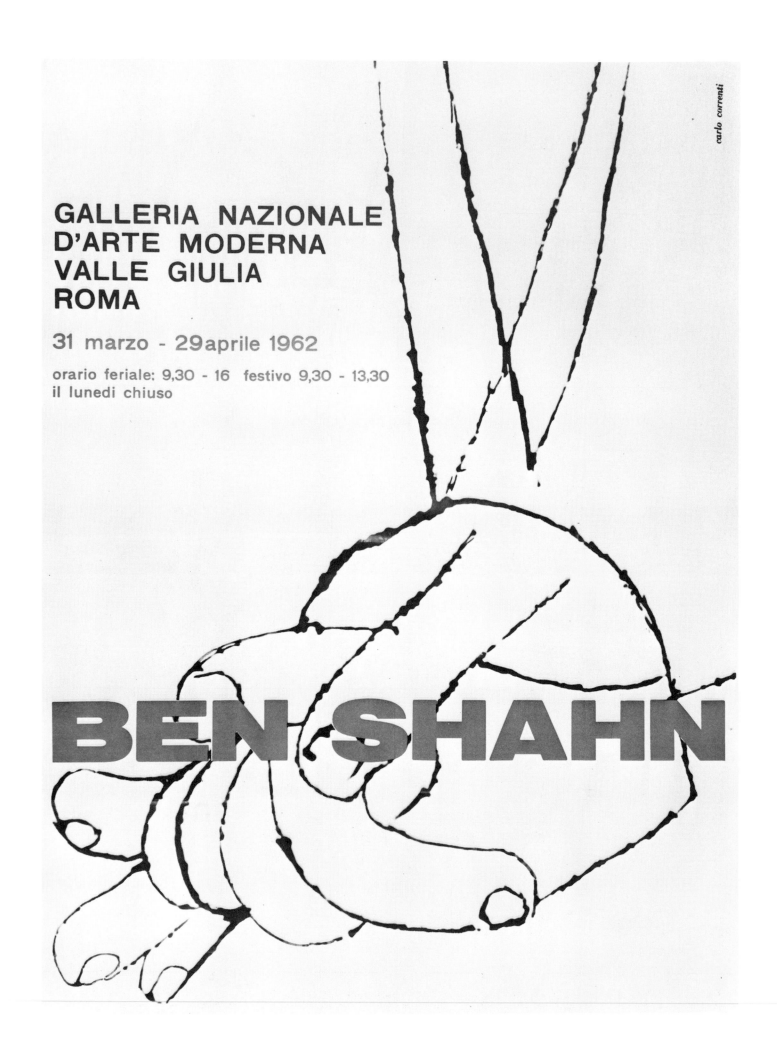

GALLERIA NAZIONALE
D'ARTE MODERNA
VALLE GIULIA
ROMA

31 marzo - 29 aprile 1962

orario feriale: 9,30 - 16 festivo 9,30 - 13,30
il lunedì chiuso

carlo correnti

BEN SHAHN

24. Ben Shahn Galleria Nazionale d'Arte Moderna. 1962. 39¼″ × 27⅜″.

25. Ben Shahn Graphik Baden-Baden. 1962. 33⅞″ × 24″.

26. Lincoln Center for the Performing Arts. 1962. 46″ × 30″.

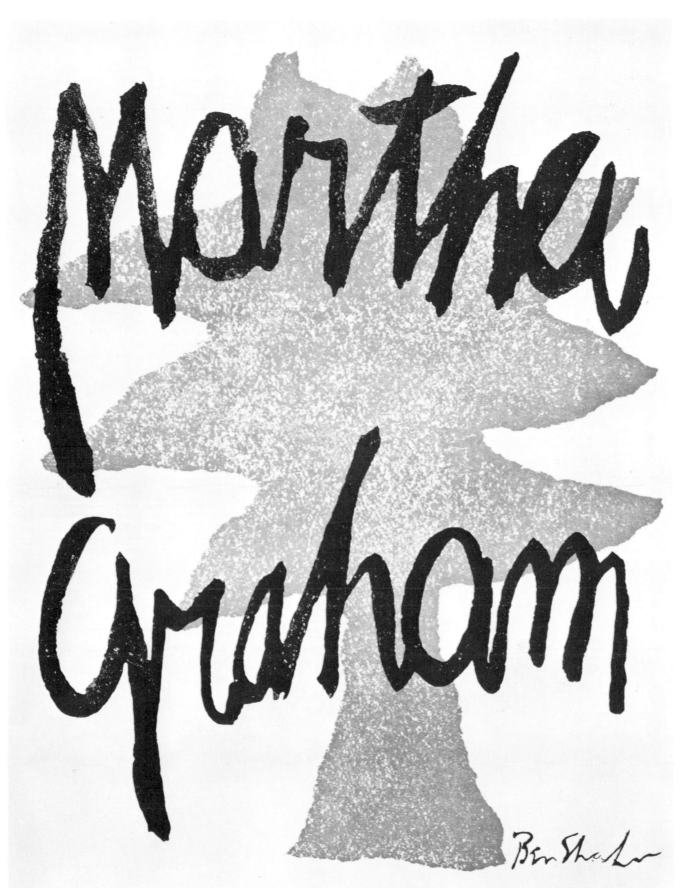

27. Martha Graham Dance Company. 1963. 30″ × 20⅛″.

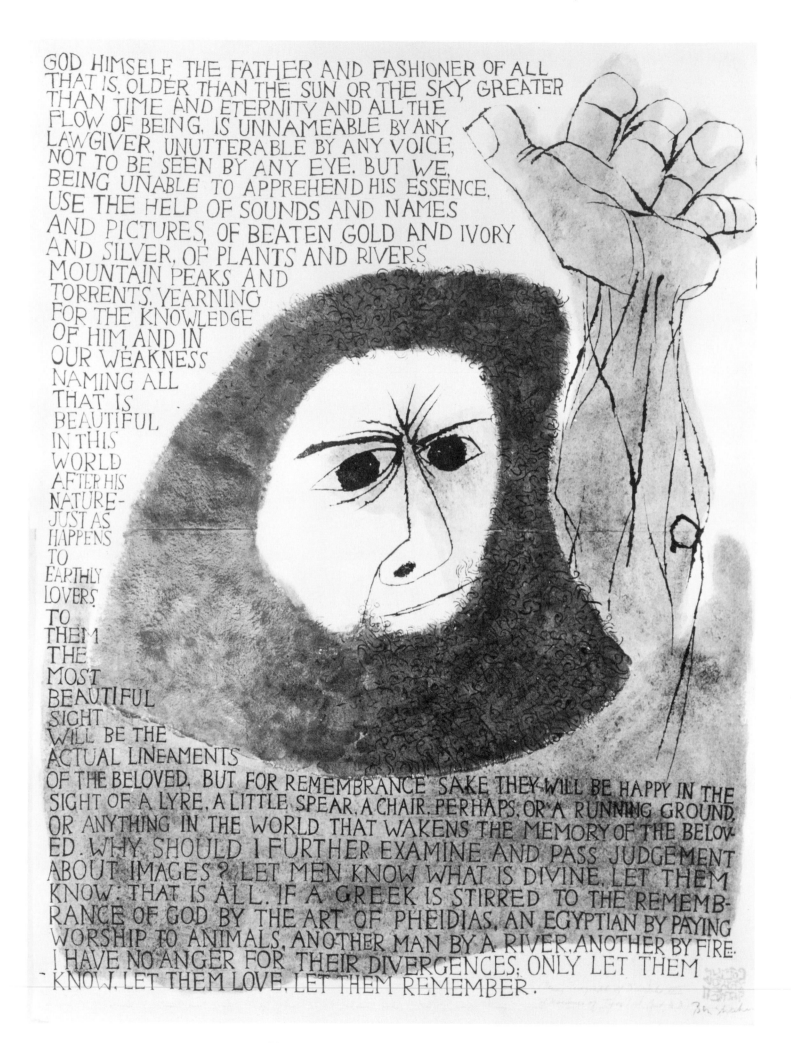

GOD HIMSELF, THE FATHER AND FASHIONER OF ALL
THAT IS, OLDER THAN THE SUN OR THE SKY, GREATER
THAN TIME AND ETERNITY AND ALL THE
FLOW OF BEING, IS UNNAMEABLE BY ANY
LAWGIVER, UNUTTERABLE BY ANY VOICE,
NOT TO BE SEEN BY ANY EYE. BUT WE,
BEING UNABLE TO APPREHEND HIS ESSENCE,
USE THE HELP OF SOUNDS AND NAMES
AND PICTURES, OF BEATEN GOLD AND IVORY
AND SILVER, OF PLANTS AND RIVERS,
MOUNTAIN PEAKS AND
TORRENTS, YEARNING
FOR THE KNOWLEDGE
OF HIM, AND IN
OUR WEAKNESS
NAMING ALL
THAT IS
BEAUTIFUL
IN THIS
WORLD
AFTER HIS
NATURE—
JUST AS
HAPPENS
TO
EARTHLY
LOVERS.
TO
THEM
THE
MOST
BEAUTIFUL
SIGHT
WILL BE THE
ACTUAL LINEAMENTS
OF THE BELOVED. BUT FOR REMEMBRANCE SAKE THEY WILL BE HAPPY IN THE
SIGHT OF A LYRE, A LITTLE SPEAR, A CHAIR, PERHAPS, OR A RUNNING GROUND,
OR ANYTHING IN THE WORLD THAT WAKENS THE MEMORY OF THE BELOV-
ED. WHY SHOULD I FURTHER EXAMINE AND PASS JUDGEMENT
ABOUT IMAGES? LET MEN KNOW WHAT IS DIVINE, LET THEM
KNOW: THAT IS ALL. IF A GREEK IS STIRRED TO THE REMEMB-
RANCE OF GOD BY THE ART OF PHEIDIAS, AN EGYPTIAN BY PAYING
WORSHIP TO ANIMALS, ANOTHER MAN BY A RIVER, ANOTHER BY FIRE,
I HAVE NO ANGER FOR THEIR DIVERGENCES; ONLY LET THEM
KNOW, LET THEM LOVE, LET THEM REMEMBER.

28. Maximus of Tyre. 1963. 36″ × 26¼″.

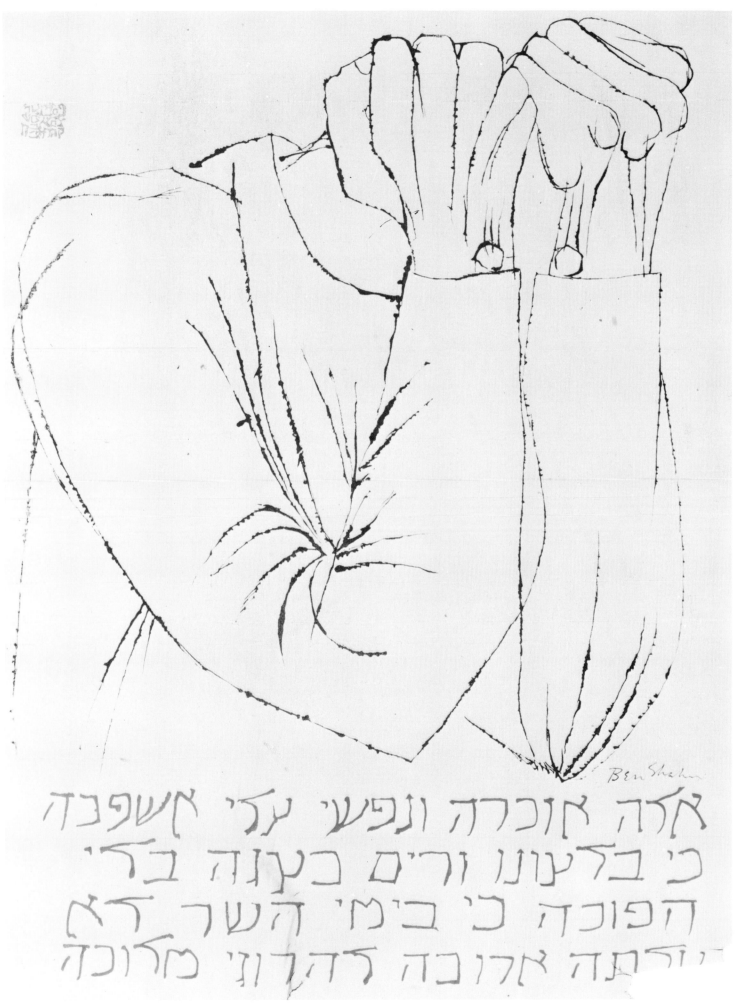

29. Warsaw 1943. 1963. 36¾″ × 28⅛″.

"O Lord our Father, our young patriots, idols of our hearts, go forth to battle—be Thou near them! With them, in spirit, we also go forth from the sweet peace of our beloved firesides to smite the foe. O Lord our God, help us to tear their soldiers to bloody shreds with our shells; help us to cover their smiling fields with the pale forms of their patriot dead; help us to drown the thunder of the guns with the shrieks of their wounded, writhing in pain; help us to lay waste their humble homes with a hurricane of fire; help us to wring the hearts of their unoffending widows with unavailing grief; help us to turn them out roofless with their little children to wander unfriended the wastes of their desolated land in rags and hunger and thirst, sports of the sun flames of summer and the icy winds of winter, broken in spirit, worn with travail, imploring Thee for the refuge of the grave and denied it—for our sakes who adore Thee, Lord, blast their hopes, blight their lives, protract their bitter pilgrimage, make heavy their steps, water their way with their tears, stain the white snow with the blood of their wounded feet! We ask it, in the spirit of love, of Him Who is the Source of Love, and Who is the ever-faithful refuge and friend of all that are sore beset and seek His aid with humble and contrite hearts.

A M E N."

FROM "THE WAR PRAYER" BY MARK TWAIN

30. O Lord our Father. 1964. 21¾″ × 16⅝″.

HE SAYS NO TO CIVILIZATION AND SURVIVAL
HE VOTED AGAINST
NUCLEAR TEST BAN
CIVIL RIGHTS ACT
TAX REDUCTION
MEDICAL CARE FOR THE AGED
MINIMUM WAGE LEGISLATION

SAY NO TO THE NO-SAYER
VOTE JOHNSON

31. Say No to the No-Sayer. 1964. 28¼″ × 22″.

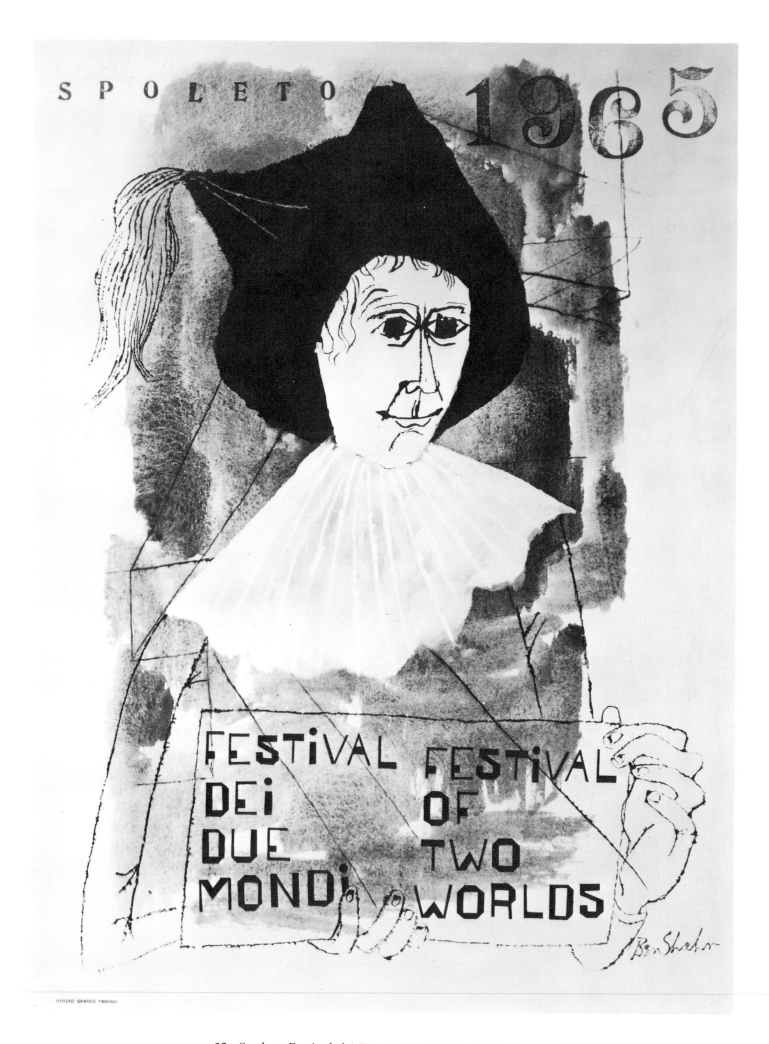

32. Spoleto Festival dei Due Mondi. 1965. 39¼″ × 27⅝″.

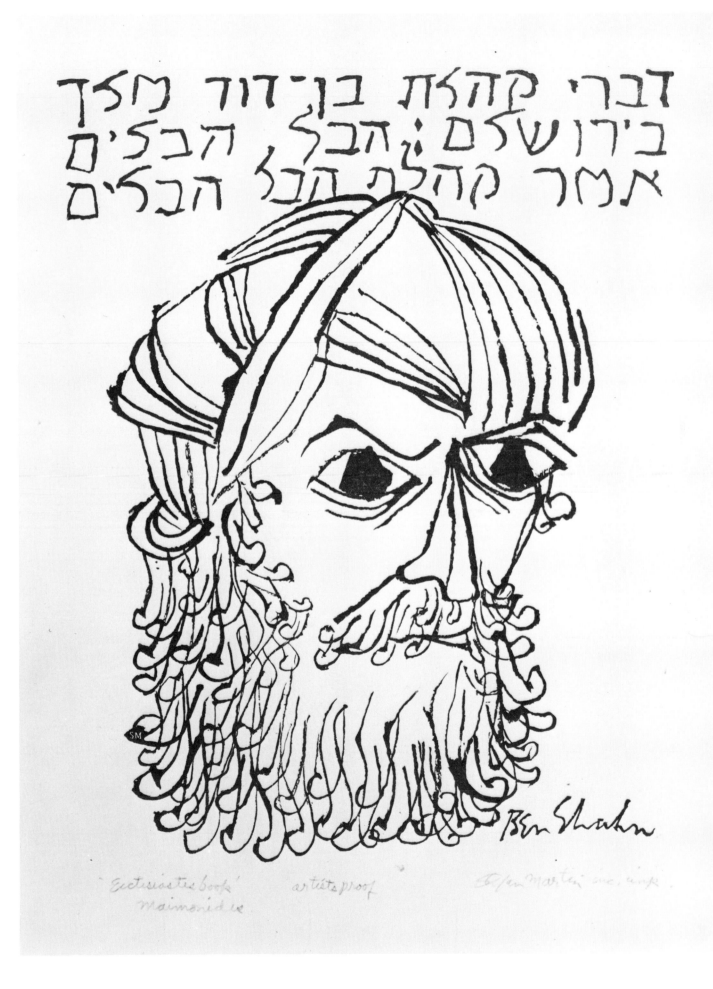

דברי קהלת בן־דוד מלך
בירושלם ; הבל הבלים
אמר קהלת הכל הבלים

"Ecclesiastes book" artist's proof ⅌/₅₀ martin ﹖ ﹖
 Maimonides

33. Maimonides with Calligraphy. 1965. 14½″ × 10½″.

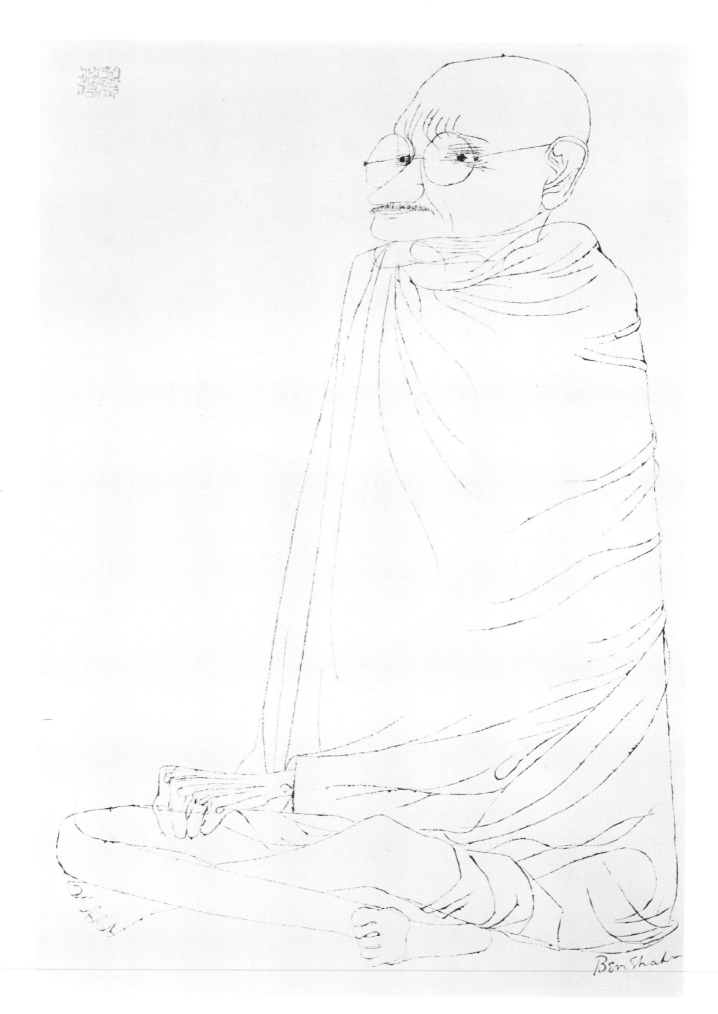

34. Gandhi. 1965. 40⅛″ × 26″.

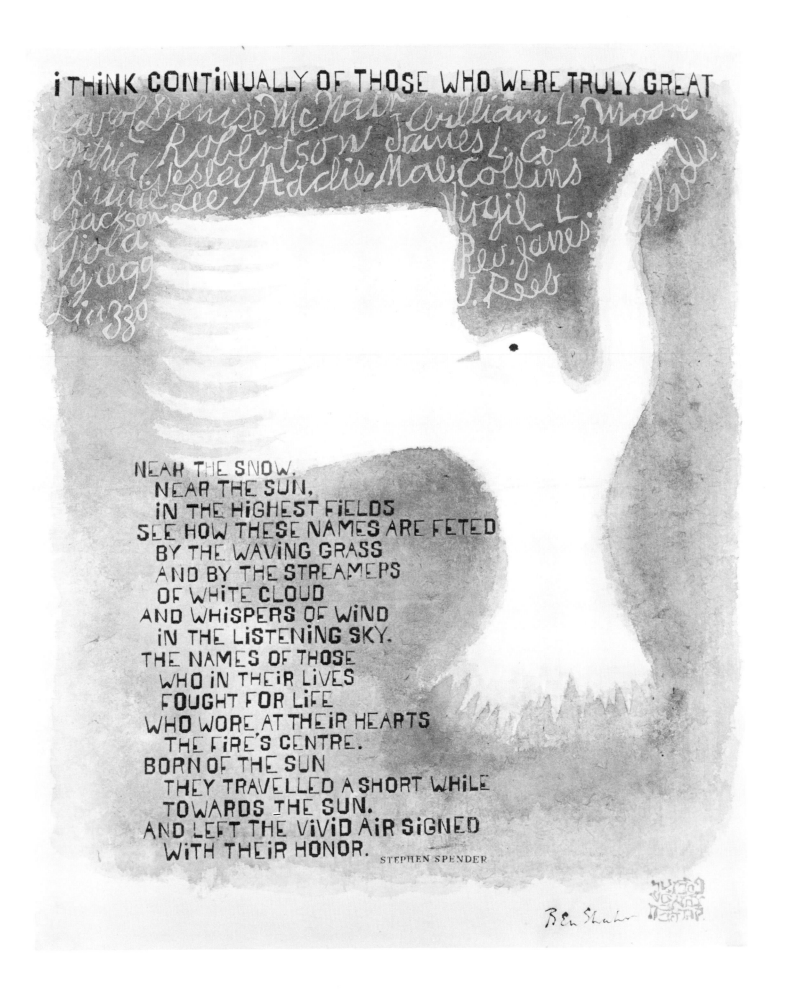

35. I Think Continually of Those Who Were Truly Great. 1965. 26½″ × 20¾″.

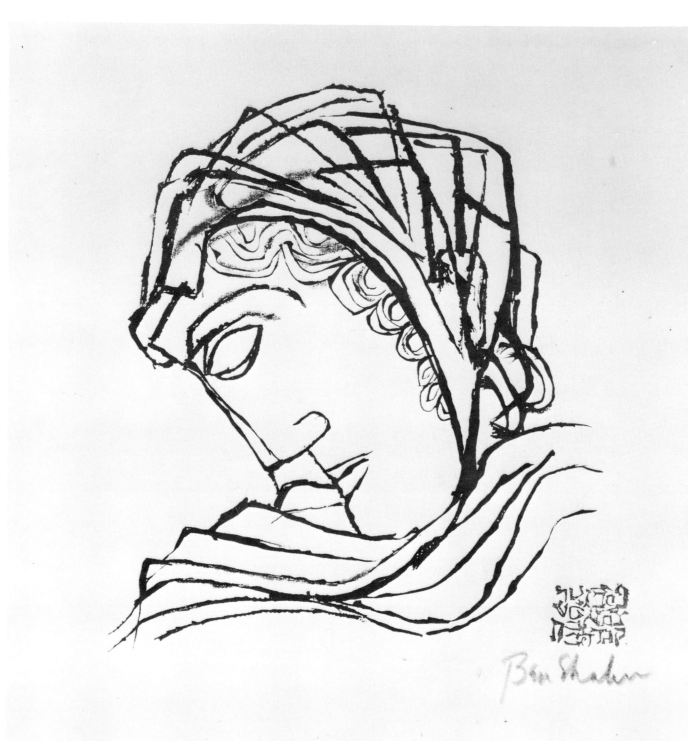

מִי־יִתֵּן רֹאשִׁי מַיִם וְעֵינִי מְקוֹר דִּמְעָה
וְאֶבְכֶּה יוֹמָם וָלַיְלָה אֵת חַלְלֵי בַת־עַמִּי:

36. And Mine Eyes a Fountain of Tears. 1965. 23⅞″ × 17⅞″.

FREDERICK DOUGLASS

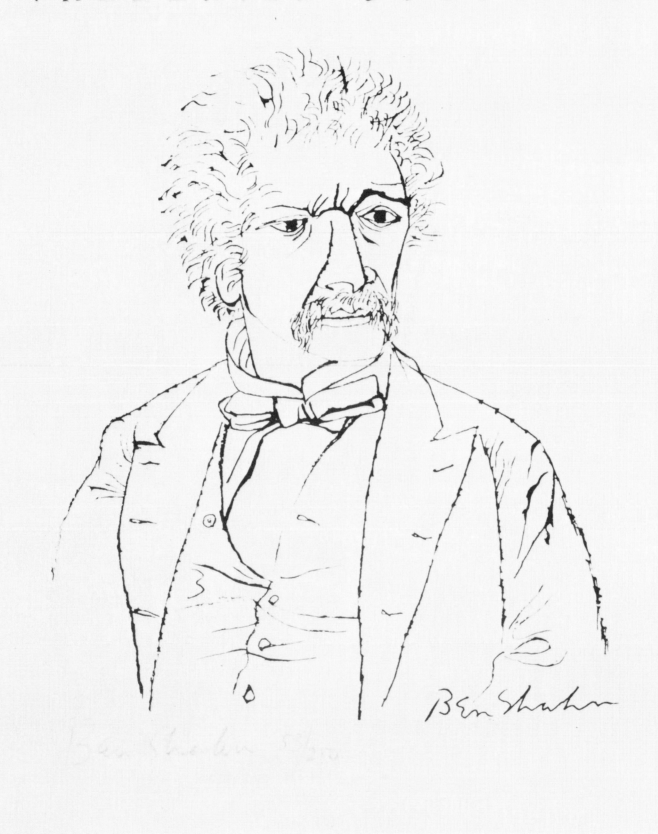

37. Frederick Douglass, II. 1965. 22″ × 16¾″.

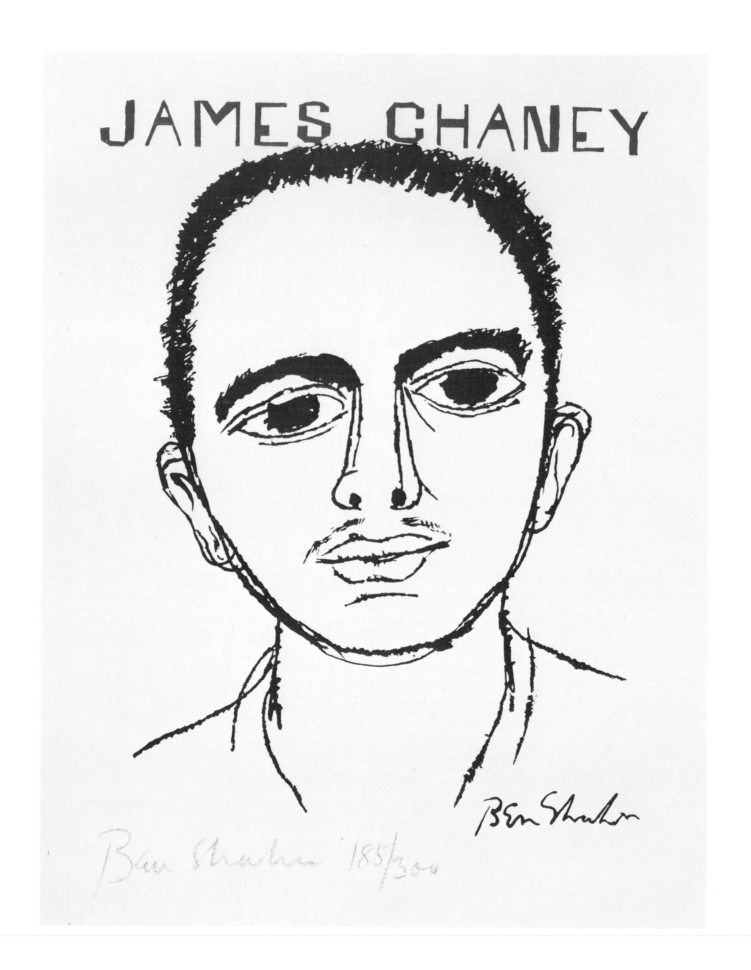

38. James Chaney. 1965. 21⅞″ × 16¾″.

ANDREW GOODMAN

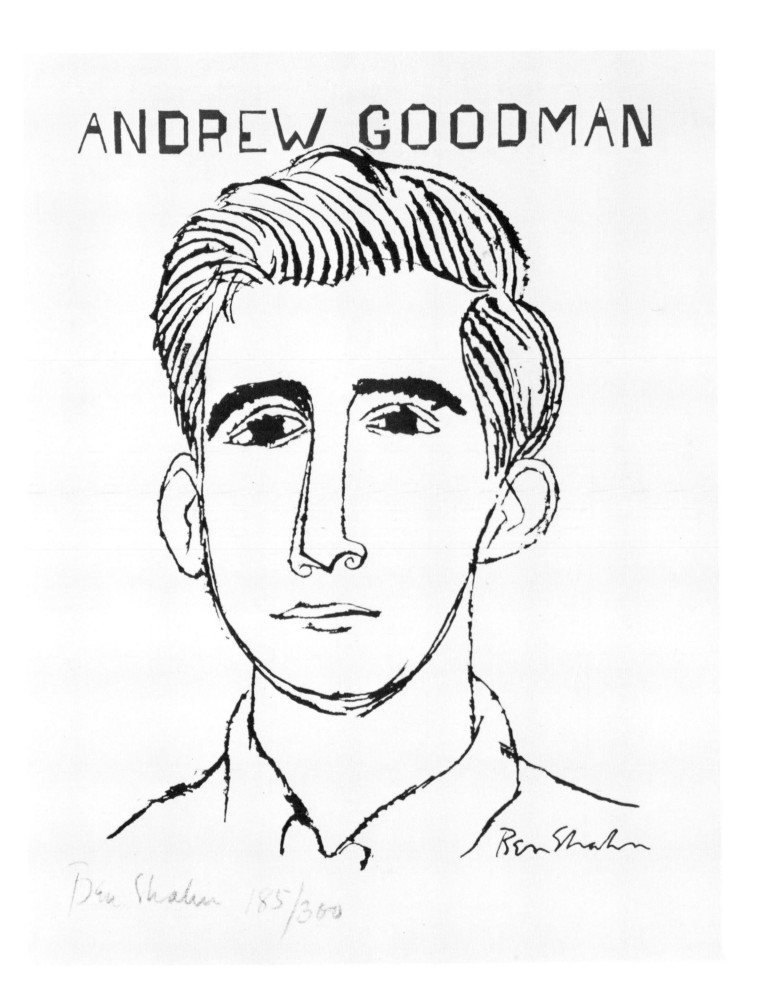

Ben Shahn 185/300

39. Andrew Goodman. 1965. 21⅞″ × 16¾″.

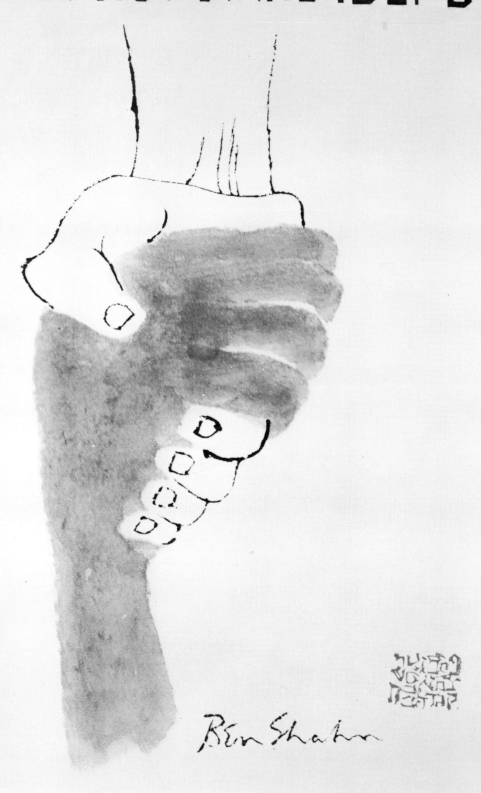

לא תעמד על-דם לעך
"THOU SHALT NOT STAND iDLY BY..."

Ben Shahn

40. Thou Shalt Not Stand Idly By. 1965. 22″ × 16¾″.

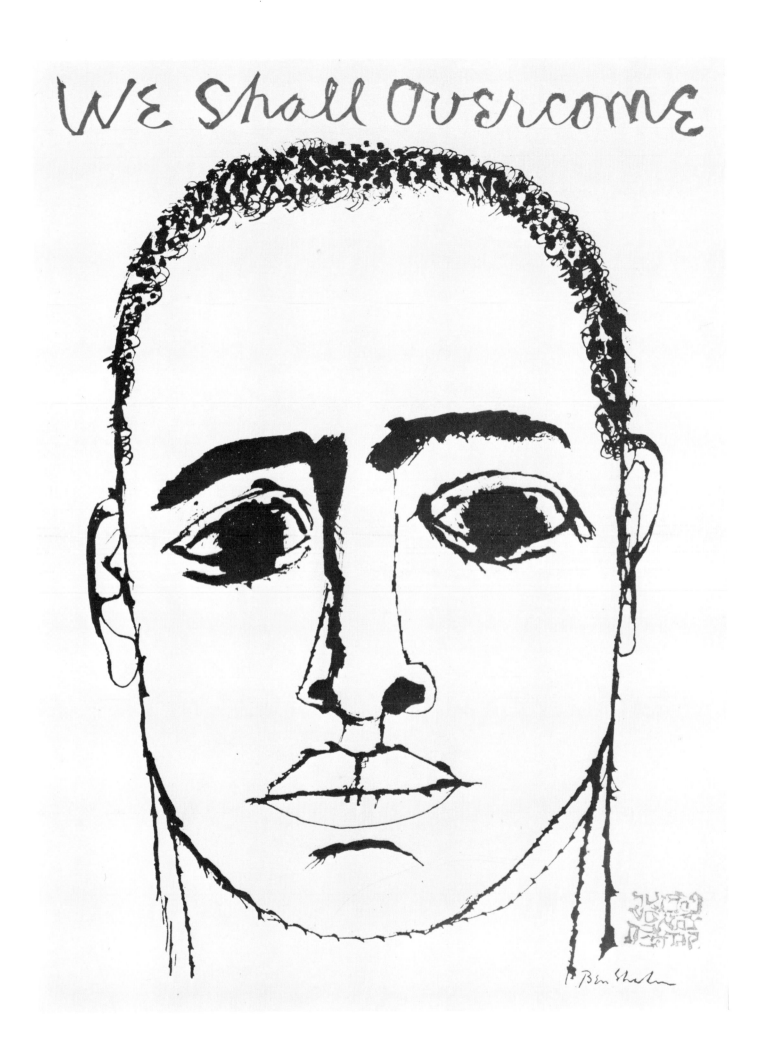

41. We Shall Overcome. 1965. 22″ × 16¾″.

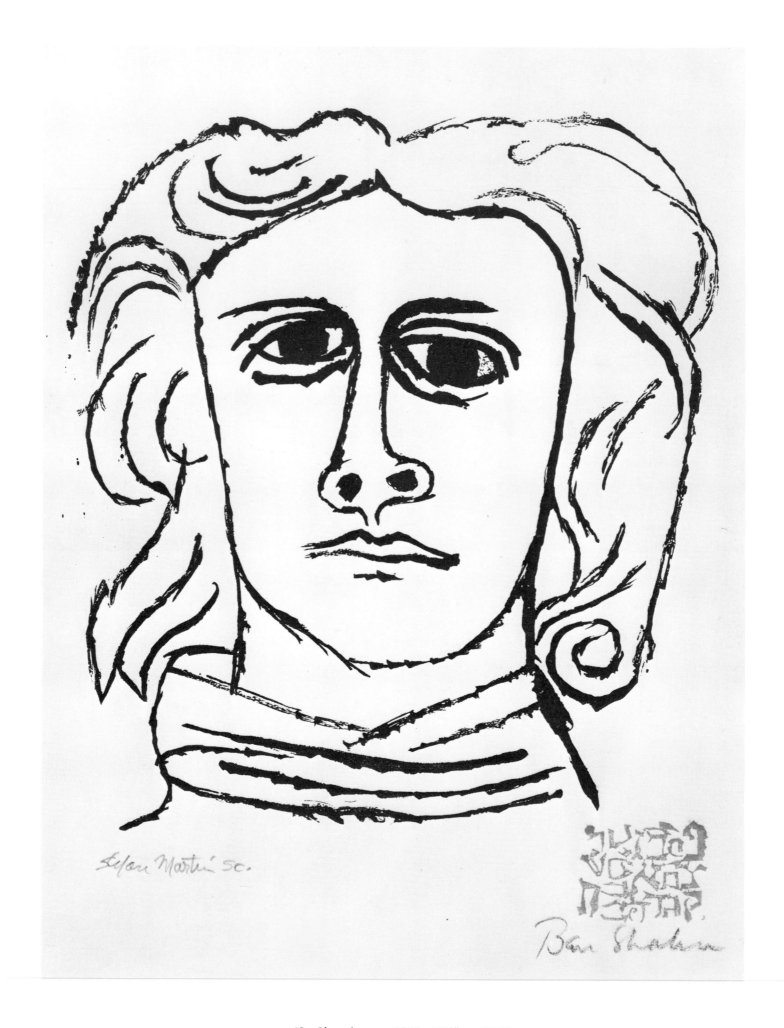

42. Skowhegan. 1965. 16¼″ × 12⅛″.

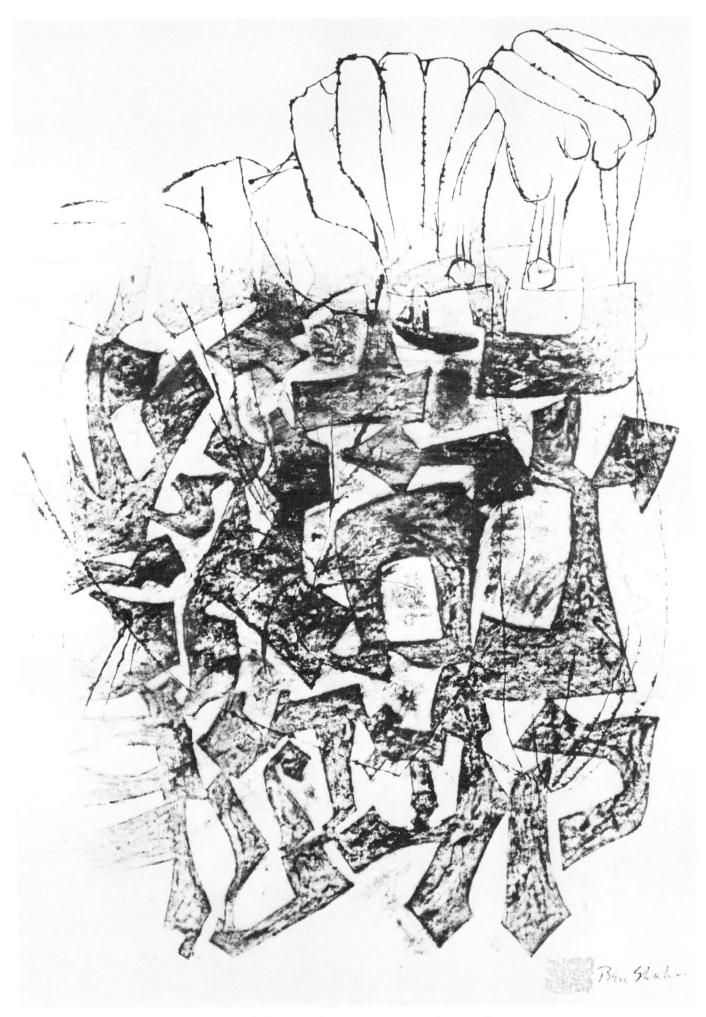

43. Alphabet and Warsaw. 1966. 35″ × 23½″.

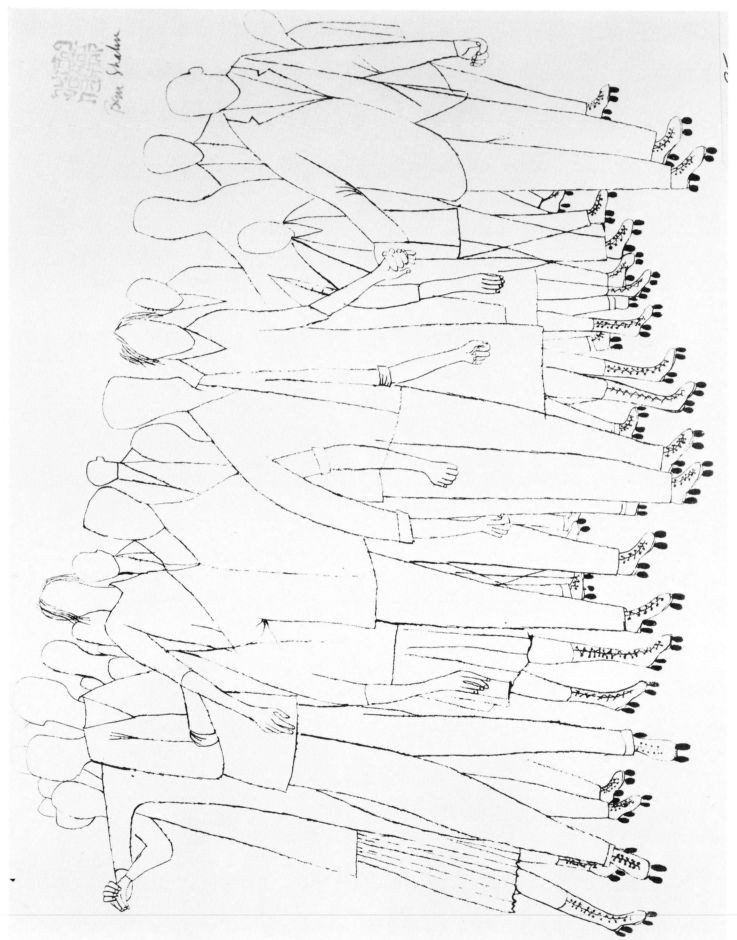

44. Andante. 1966. 18½" × 23¾".

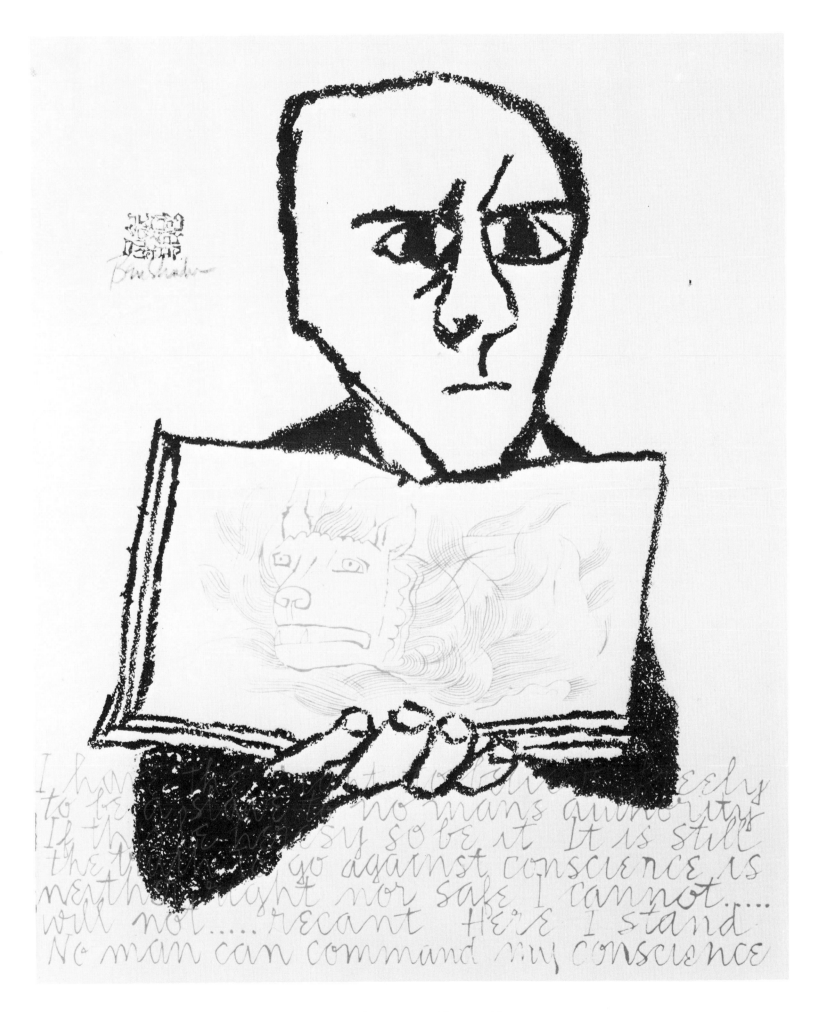

I have the right to believe freely
to be upstore of no mans authority
If this be heresy so be it It is still
the truth to go against conscience is
neither right nor safe I cannot.....
will not.....recant HERE I stand
No man can command my conscience

45. Credo. 1966. 26½″ × 20⅞″.

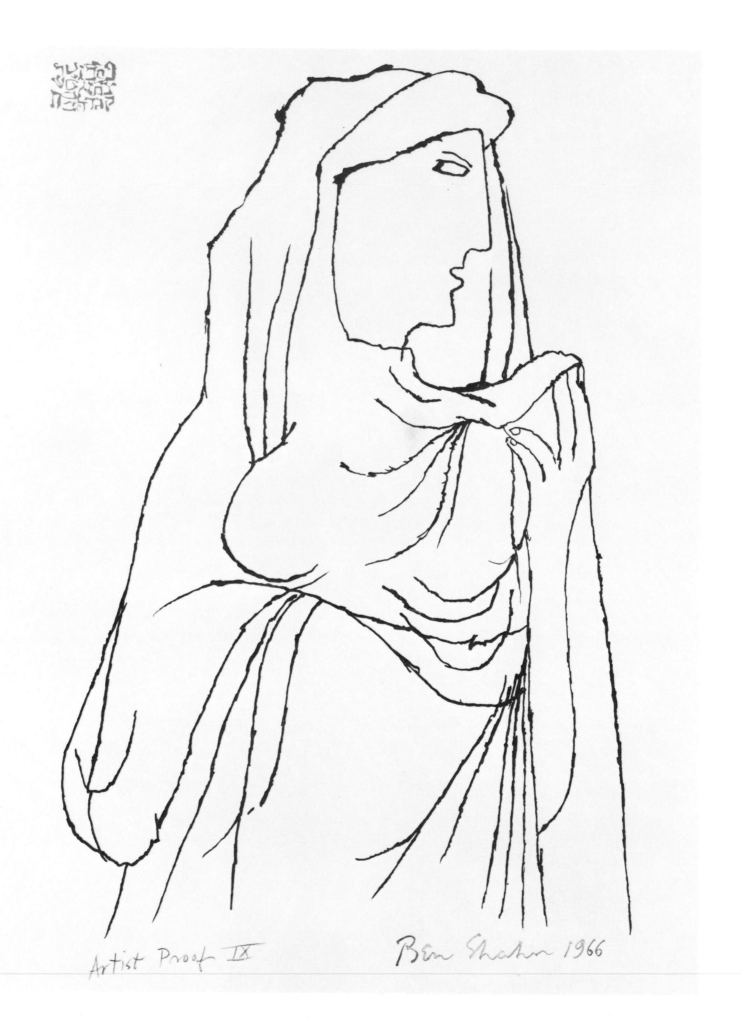

Artist Proof IX Ben Shahn 1966

46. Levana. 1966. 30″ × 22⅛″.

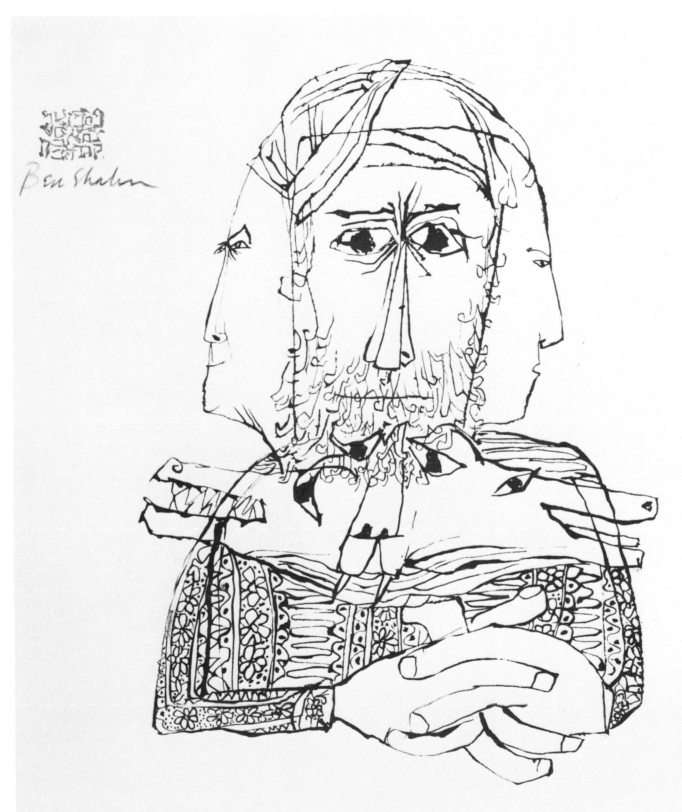

שמח בחור בילדותך ויטיבך לבך בימי בחורותיך והלך בדרכי
לבך ובמראי עיניך ודע כי על-כל-אלה יביאך האלהים במשפט

47. Ecclesiastes. 1966. 26½″ × 20½″.

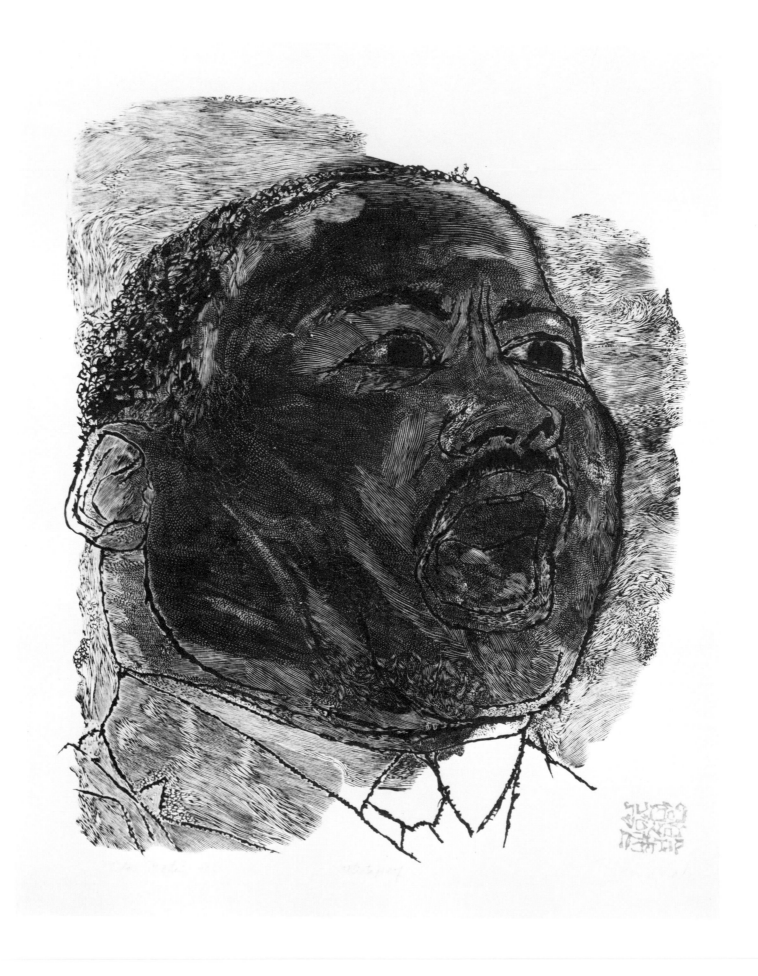

48. Martin Luther King. 1966. 25″ × 20⅛″.

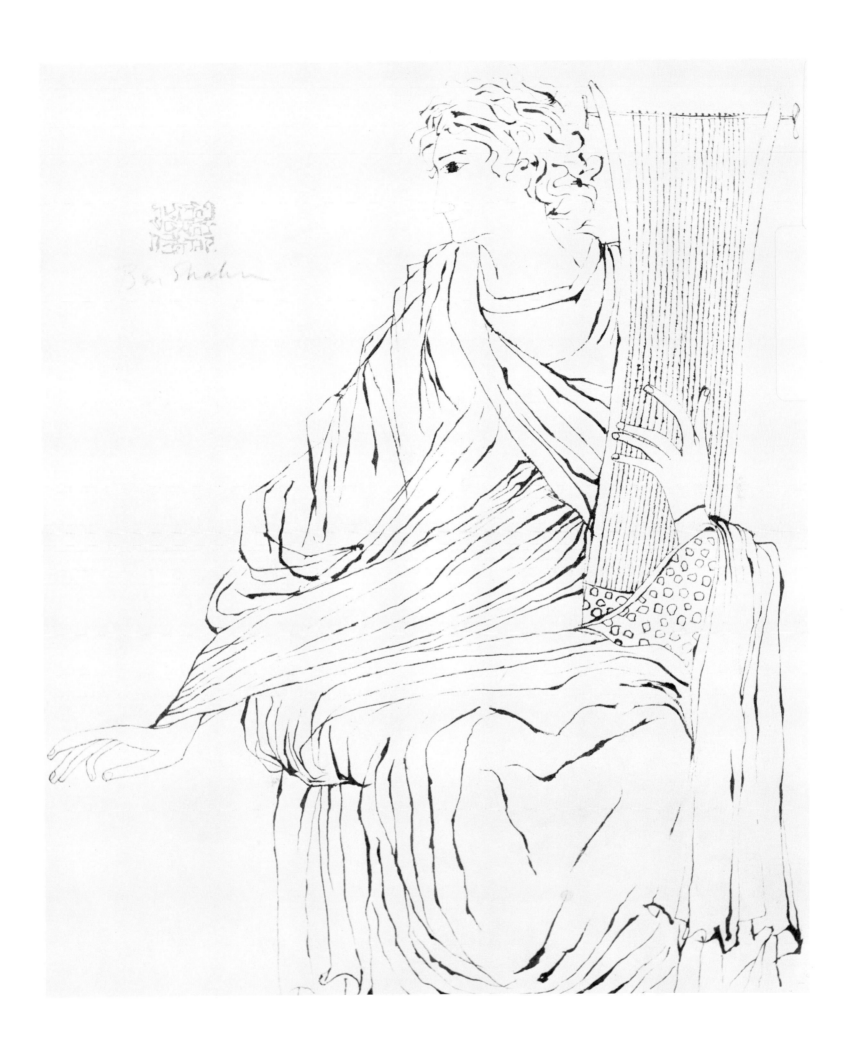

49. Praise Him with Psaltery and Harp. 1966. 24″ × 24¾″.

50. Ecclesiastes Woman. 1967. 15⅛″ × 11⅛″.

51. Ecclesiastes Man. 1967. 15⅛″ × 11⅛″.

52. Ben Shahn Santa Barbara Museum of Art. 1967. 19⅝″ × 10¾″.

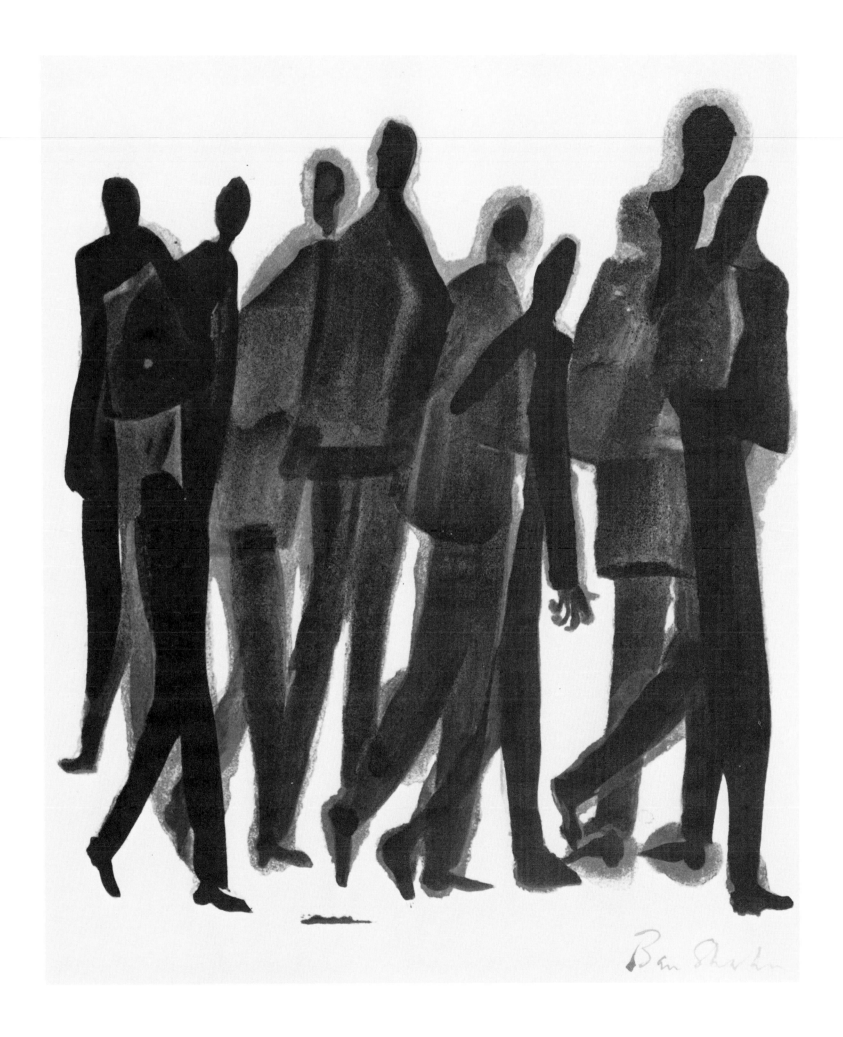

53. Many Men. 1968. 22½″ × 17¾″.

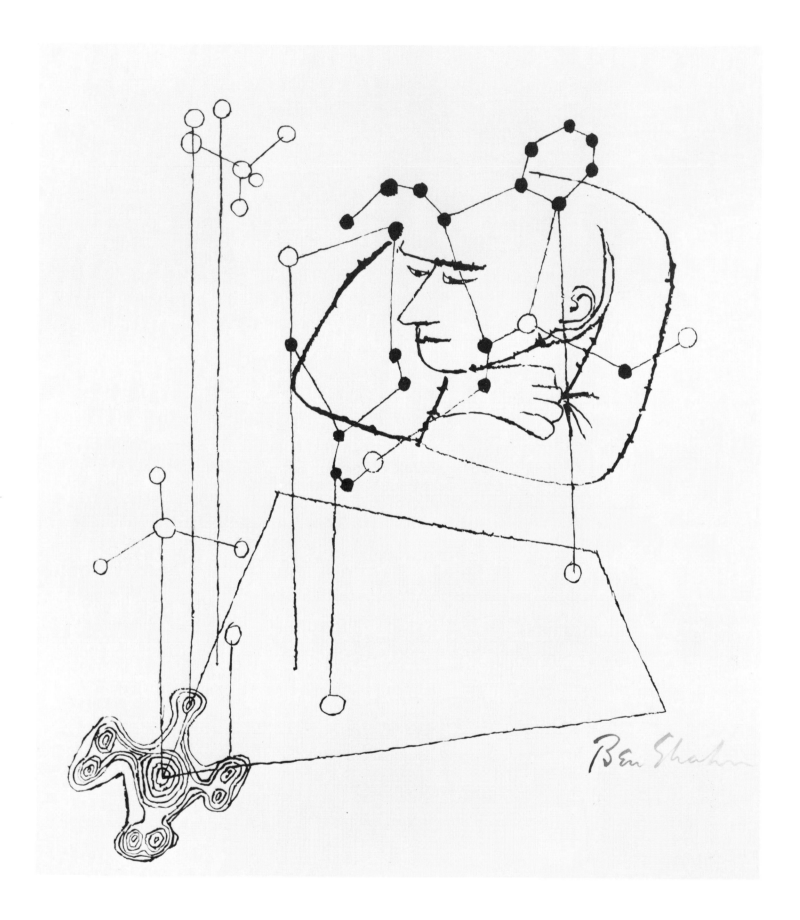

54. Many Things. 1968. 22½″ × 17¾″.

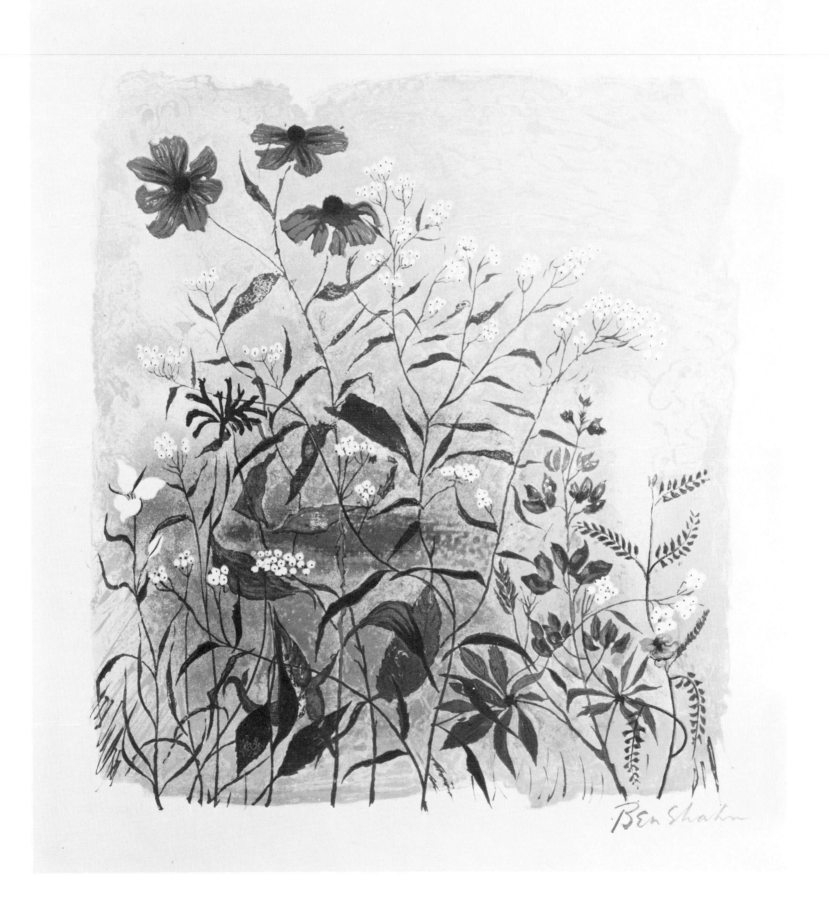

55. The gestures of the little flowers. 1968. 22½″ × 17⅝″.

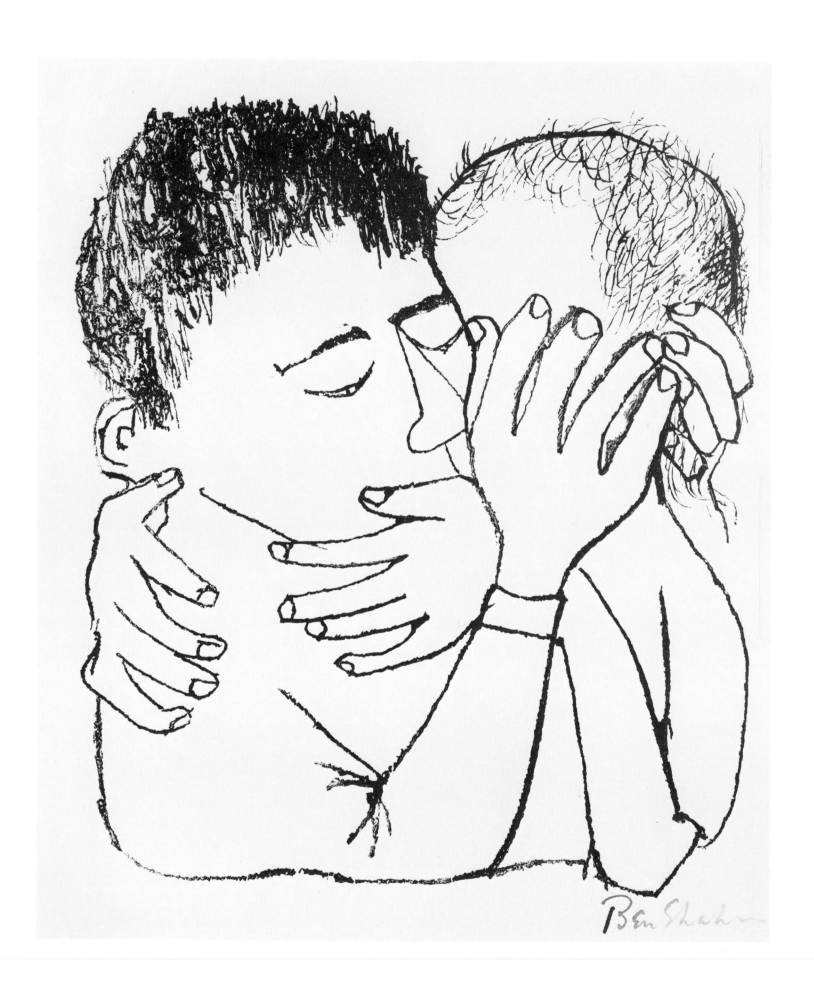

56. Memories of Many Nights of Love. 1968. 22½″ × 17¾″.

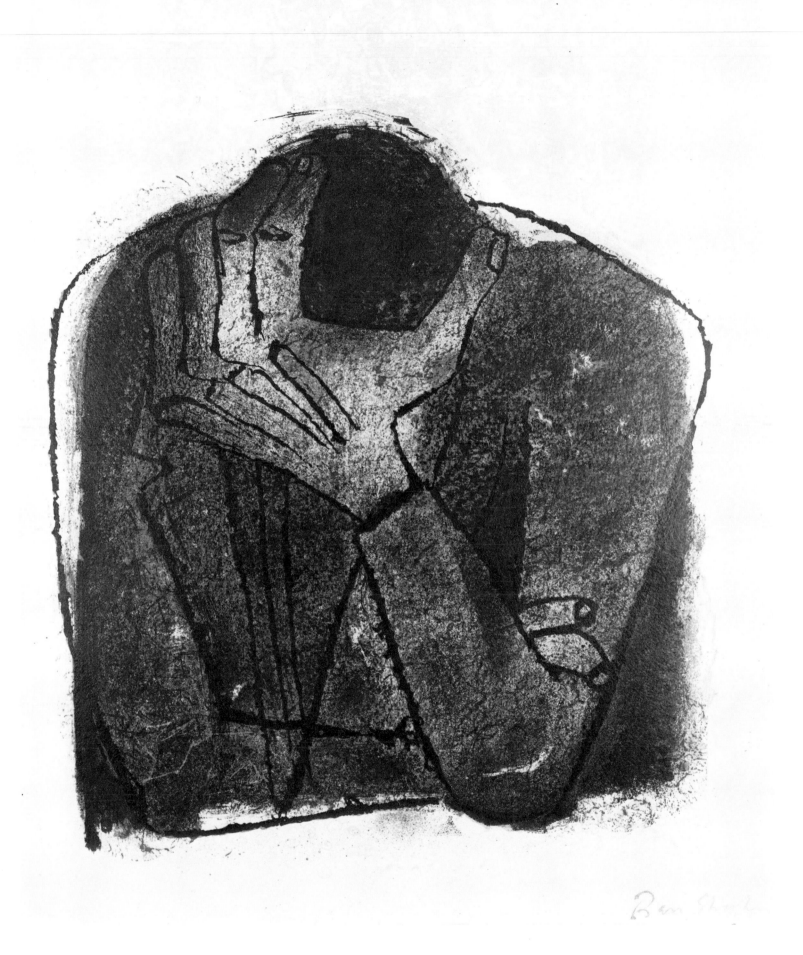

57. Beside the Dead. 1968. 22½″ × 17¾″.

58. The First Word of Verse Arises. 1968. 22½″ × 17¾″.

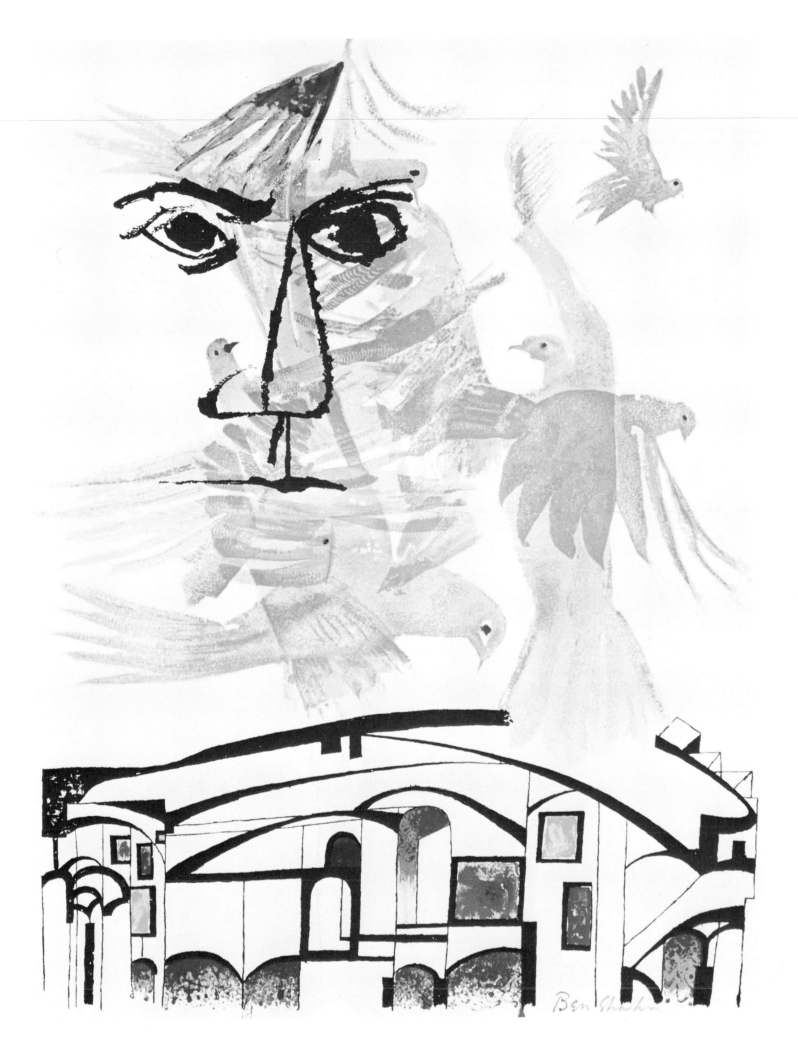

59. Birds Over the City. 1968. 29″ × 21⅝″.

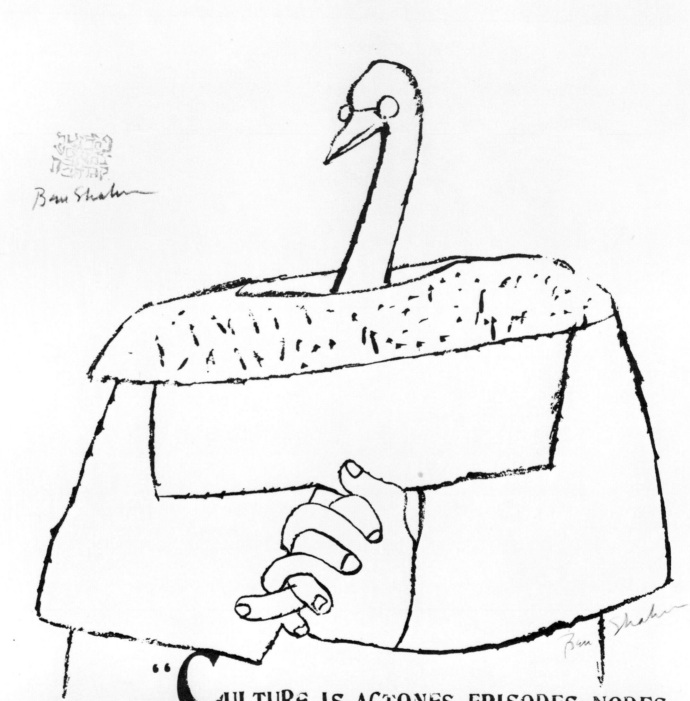

"CULTURE IS ACTONES, EPISODES, NODES, NODAL CHAINS, SCENES SERIALS, NOMOCLONES, PERMA- CLONES, PARAGROUPS, NOMOCLONIC TYPES, PERMACLO- NIC TYPES, PERMACLONIC SYSTEMS & PERMACLONIC SUPERSYSTEMS. CULTURE Is Also PHONEMES, MORPH- EMES, WORDS, Semantically Equivalent UTTERANCES, BEHAVIOR PLANS, & many other EMIC Things."

60. Culture. 1968. 26½″ × 20¾″.

61. Headstand on Tricycle. 1968. 36¼″ × 24⅜″.

62. Oppenheimer. 1970. 40¼″ × 28⅝″.

63. Owl No. 1. 1968. 26⅜″ × 20⅜″.

68. Dancing Virgin. 1970–71. 16½″ × 35″.

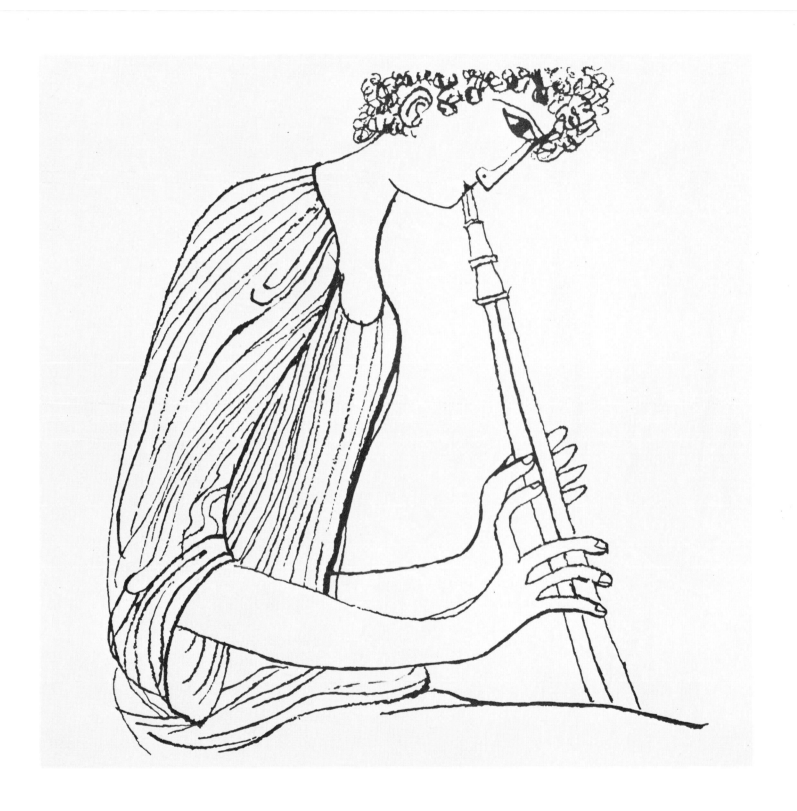

69. Young Man Playing Double Oboe. 1970–71. 16¼″ × 35″.

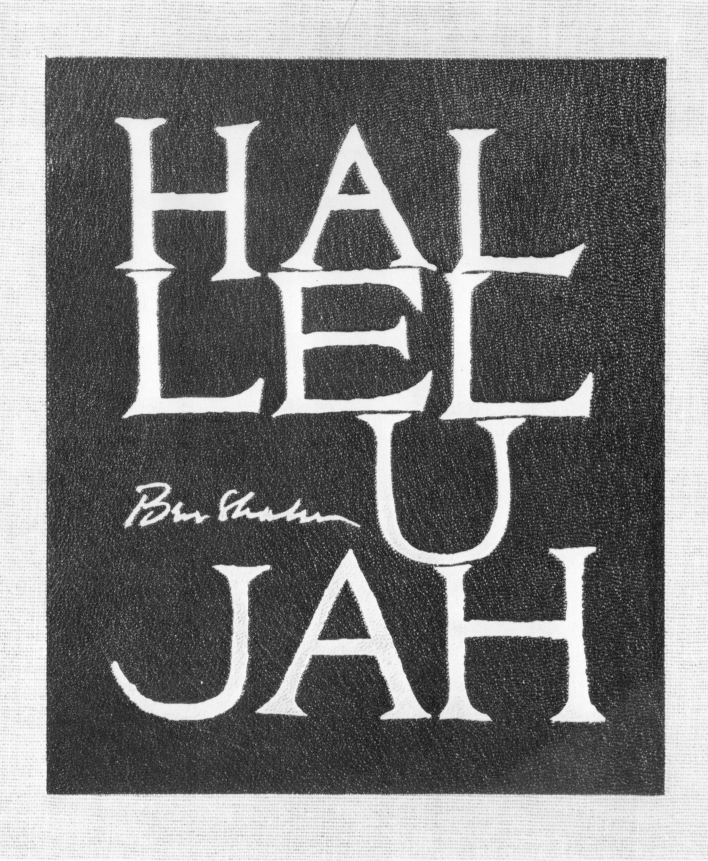

70. English Hallelujah. 1970–71. 16¼″ × 35″